ESSAYS ON
ART AND SCIENCE

ERIC R. KANDEL

ESSAYS ON
ART AND SCIENCE

Columbia University Press

New York

Columbia University Press

Publishers Since 1893

New York Chichester, West Sussex

cup.columbia.edu

Library of Congress Cataloging-in-Publication Data

Names: Kandel, Eric R., author.

Title: Essays on art and science / Eric R. Kandel.

Description: New York : Columbia University Press, [2024] | Includes
bibliographical references and index.

Identifiers: LCCN 2023048445 (print) | LCCN 2023048446 (ebook) |
ISBN 9780231212564 (hardback) | ISBN 9780231559454 (ebook)

Subjects: LCSH: Art—Psychology.

Classification: LCC N71 .K3545 2024 (print) | LCC N71 (ebook) |
DDC 701/.15—dc23/eng/20231117

LC record available at https://lccn.loc.gov/2023048445

LC ebook record available at https://lccn.loc.gov/2023048446

Printed in the United States of America

Cover design: Henry Sene Yee

To my wife, Denise, who has been a constant source
of inspiration for my creative efforts.

CONTENTS

PREFACE

The greatest enterprise for the human mind has been and always will be the attempted linkages between the sciences and the humanities.

—E. O. Wilson

This collection of essays brings together my lifelong passion for art and my life's work in neuroscience to explore the question of how we experience art. Central to that exploration is my specific fascination with the art and culture of Vienna 1900. This was an era in which the free exchange of ideas among artists, art historians, and scientists gave rise to modernism and to the concept of the "beholder's share": the realization that art is incomplete without the perceptual and emotional involvement of the viewer.

From that concept, we have begun to learn how our brain uses universal, specialized rules to construct the visual world, such as the image we see in a painting. But the brain also brings to bear on that image our individual personal experiences, memories, and emotions. Understanding how these higher-order processes interact to create the beholder's share is one of the great challenges confronting brain science in the twenty-first century. Artists themselves realize the importance of these unconscious processes—their own and the viewer's—and may deliberately play upon them or challenge them in creating their art.

Each essay in this book was written for or presented to a different audience over the past decade. Some of the essays appear in the catalogue accompanying a specific gallery or museum exhibit, others are a chapter in a book

or a talk given at a museum. The most recent essay presents research on the viewer's response to figurative versus abstract art, rewritten for the general reader. Because the essays were written for different audiences, some included similar descriptions of the brain science underlying our responses to art—particularly our response to faces, a central component of the beholder's share. These have been edited to eliminate as much of the repetition as possible. In such cases, the reader is referred back to earlier discussions. In addition, because each essay focuses on a particular aspect of the links between art and science, the collection represents only a part of the large and increasing body of research on how we experience art.

I want to thank several persons who helped me in the production of this book, in particular Blair Burns Potter, who edited the essays, and my wife, Denise, who assisted me throughout.

ESSAYS ON
ART AND SCIENCE

THE PRODUCTIVE INTERACTION OF CHRISTIANS AND JEWS THAT LED TO THE CREATION OF MODERNISM IN VIENNA 1900

The name of this symposium, "The Long Shadow of Anti-Semitism [*Der Lange Schatten des Antisemitismus*] at the University of Vienna Dating Back to 1870," is a wonderful example of the transparency that has come to characterize Austria's new attitude toward its past. But anti-Semitism didn't begin in Vienna in 1870. Historically, Austria has been one of the most anti-Semitic countries in Europe: its culture was dominated by the Catholic Church, and until recently, anti-Judaism was part of the church's culture.

Although Jews have lived in Vienna for over a thousand years—since 996—and have been instrumental in developing the city's vibrant culture, anti-Semitism has been endemic to its social and political life. The small but remarkably productive and important Jewish community living in Vienna in the fifteenth century was annihilated in 1420 by Kaiser Albert V. It was reconstituted in the sixteenth century, only to be expelled again in 1671 by Kaiser Leopold. Periodic expulsions continued into the eighteenth century, when Queen Maria Theresa became the last ruler of a great European nation to expel Jews from parts of her lands.

Not until the second half of the nineteenth century, under Kaiser Franz Josef (r. 1848–1916), were Austrian Jews accorded the same civil rights as Christians—rights that allowed them to enjoy political and religious

freedom, as well as the freedom to travel. As a result of Franz Josef's policies, many talented, ambitious young Jews from the eastern countries of the Hapsburg Empire were inspired to move to Vienna. The number of Jews in Vienna grew from 2,617, or 1.3 percent of the total population, in 1857 to 147,000 in 1900 and finally to 175,000, or 8.6 percent of the population, in 1910—the largest Jewish population of any city in Western Europe. During this time, a remarkably productive interaction sprang up between Jewish and Christian artists, scientists, and intellectuals, leading to the explosion of culture in 1900 that gave birth to modernism, the movement that defines the age in which we live.

I published a book on this period, *Das Zeitalter der Erkenntnis—The Age of Insight* (2012). In writing it, I was acutely aware of the unprecedented interaction between Jews and Christians and its effects on their individual creativity and on Viennese culture. But a discussion of that interaction was tangential to my subject: understanding the unconscious in art, mind, and brain from Vienna 1900 to the present.

In this essay, I return to Vienna 1900 and take up some of those fruitful interactions, beginning with Carl von Rokitansky, an influential and liberal leader of the modernist movement in Vienna, who openly defended the position of Jews and other foreigners in the University of Vienna School of Medicine. In exploring these interactions, I emphasize how greatly they benefited the emergence of modernism in the world in general and in Vienna in particular.

THE ORIGINS OF MODERNISM

Modernism in Vienna, as elsewhere, was a mid-nineteenth-century response not only to the restrictions and hypocrisies of everyday life, especially as they related to women, but also to the Enlightenment idea that human action is governed by reason and that our mind can control our emotions and feelings.

The immediate catalyst for the Enlightenment, the Age of Reason, in the eighteenth century was the scientific revolution of the sixteenth and seventeenth centuries, which included three momentous discoveries in astronomy: Johannes Kepler's delineation of the rules that govern the movement of the planets, Galileo Galilei's discovery that the sun is at the center of the universe, and Isaac Newton's discovery of gravity. In using the calculus he had invented to describe the three laws of motion, Newton joined physics and astronomy and showed that even the deepest truths in the universe can be revealed by the methods of science.

These contributions were celebrated in 1660 with the formation of the world's first scientific society, The Royal Society of London for Improving Natural Knowledge, which elected Newton its president in 1703. The founders of the Royal Society thought of God as a mathematician who had designed the universe to function according to logical and mathematical principles. The role of the scientist—the natural philosopher—was to employ the scientific method to discover the physical principles underlying the universe and thereby decipher the codebook that God had used in creating the cosmos.

Success in the realm of science led eighteenth-century thinkers to assume that other aspects of human action, including political behavior, creativity, and art, could be improved by the application of reason, ultimately leading to an improved society and better conditions for all humankind. This confidence in reason and science affected all aspects of political and social life in Europe and soon spread to the North American colonies. There, the Enlightenment ideas that society can be improved through reason and that rational people have a natural right to the pursuit of happiness contributed to the Jeffersonian democracy that we enjoy today in the United States.

The modernist reaction to the Enlightenment came in the aftermath of the Industrial Revolution and reflected a new understanding of the world. As astronomy and physics inspired the Enlightenment, so biology inspired modernism.

Charles Darwin's book *On the Origin of Species by Means of Natural Selection*, published in 1859, introduced the idea that all animal life is related. We were not created uniquely by God but are biological beings that evolved from simpler animal ancestors. In this and later books, Darwin discussed the role of sexual selection in evolution. He argued that the primary biological function of any organism is to reproduce itself and therefore that sex is central to human behavior. Sexual attraction and mate selection are critical in evolution: males compete with each other for females, and females choose some males rather than others. These ideas later found expression in Sigmund Freud's emphasis on the sexual instincts as the driving force of the unconscious and on the central role of sexuality in human behavior. Darwin also held that since we evolved from simpler animals, we must have the same instinctual behaviors they do, not only in regard to sex but also in regard to eating and drinking. Freud saw in Darwin's concept of instinctual behavior a way of explaining much of our innate behavior.

Finally, in his last great work, *The Expression of the Emotions in Man and Animals*, published in 1872, Darwin points out that our emotions are part of a primitive, virtually universal approach-avoidance system that is designed to seek out pleasure and decrease exposure to pain. This system exists across cultures and is conserved throughout evolution, and it is the basis of Freud's pleasure principle—the hedonistic seeking of pleasure and avoidance of pain. Thus, Freud—often referred to as the Darwin of the Mind—extended Darwin's revolutionary ideas about natural selection, instincts, and emotions to his own ideas about the unconscious mind.

THE DISTINCTIVE FEATURES OF VIENNESE MODERNISM

Modernism took root in Germany, Italy, and France as well as in the Austro-Hungarian Empire, but between 1890 and 1918, modernist thought and culture were centered in Vienna. The Viennese modernists not only confronted conventional attitudes and values with new ways of thought and feeling, they also questioned what constitutes reality, what lies beneath

the surface appearances of people, objects, and events. By exploring what lies below surface appearances, Viennese modernism assumed attitudes that characterize the world in which we live today: in particular, the view of ourselves as not truly rational, but rather as being driven by unconscious sexual and aggressive drives; and the attempt, driven by science, to integrate and unify knowledge.

These elements of Viennese modernism developed over three intellectually and chronologically distinct phases. I discuss those phases at length in *The Age of Insight* and explain here how each of them was advanced by the interaction of Christians and Jews.

The first phase is the independent discovery of unconscious emotion by the psychologist Sigmund Freud, the writer Arthur Schnitzler, and the three Viennese modernist painters, Gustav Klimt, Oskar Kokoschka, and Egon Schiele. Those independent discoveries can be traced to a common source: the Vienna School of Medicine and the teachings of Carl von Rokitansky, its intellectual and scientific leader. The Vienna School of Medicine was a driving force in the emergence of Austrian Expressionism because of Rokitansky's emphasis on discovering the cause of disease—the truth lying deep beneath the surface of the body. The dramatic explorations of our unconscious emotional life by Freud, Schnitzler, and the Austrian Expressionists stemmed from Rokitansky's teachings and contributed to the modernist view of ourselves as not truly rational and to the idea that self-examination is a first step in discovering the rules that govern mind.

The second phase of Viennese modernism is the bringing together of art and science, initiated by Alois Riegl, a professor at the University of Vienna and a leader of the Vienna School of Art History in the 1890s. Riegl focused on psychology as the scientific discipline to which art naturally relates and argued that art, in particular modern art, invites the viewer's participation. The emotions and experiences each person brings to a work of art are essential to the completion of the work. Understanding the viewer's response to art is the natural bridge between psychology and art. Two students of Riegl's, Ernst Kris and Ernst Gombrich, asked the logical next question: To what extent is reality shaped by the way it is perceived by the viewer?

To what degree is beauty in the eye of the beholder? The insights of cognitive psychology into the viewer's response to modernist art led to the third phase of Viennese modernism.

The third phase integrates the psychology of the beholder's share with its underlying biology, an advance made possible by the advent of a new biology of perception, emotion, and empathy. This advance began in the 1950s and continues to this day in the discipline of neuroaesthetics. Pioneering work in the science of vision was carried out by Stephen Kuffler, a contemporary of Gombrich and Kris, who trained at the Vienna School of Medicine in the 1930s.

THE VIENNA SCHOOL OF MEDICINE AND THE ORIGINS OF MODERNIST THOUGHT

In 1745, Queen Maria Theresa recruited the great Dutch physician Gerhardt van Swieten to lead the medical faculty of the University of Vienna. Van Swieten began, and Rokitansky completed, the transformation of Viennese medical practice from therapeutic quackery to scientific medicine. By 1840, the Vienna School of Medicine had acquired such international prominence that Rudolf Virchow called it the "Mecca of Medicine." The medical school achieved this renown by creating a scientific basis for medicine at the Vienna General Hospital, Das Allgemeine Wiener Krankenhaus (fig. 1.1). The hospital was part of the medical school and shared its high academic standards.

The Vienna School of Medicine was the first to use the insights of pathology to develop a rational and objective method of diagnosis. The key to this development was the collaboration between Rokitansky (fig. 1.2), the great head pathologist at the Vienna General Hospital who became a professor at the University of Vienna in 1844, and his brilliant clinician colleague Joseph Škoda (fig. 1.3). The Vienna General Hospital provided a unique opportunity for this collaboration. Unlike other hospitals in Europe, in which each physician carried out autopsies on his own patients, the Vienna General

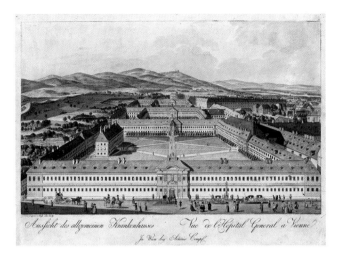

Ausficht des allgemeinen Krankenhauses Vue de l'Hôpital Général à Vienne

Zu Wien bey Artaria Compf.

1.1 *Das Allgemeine Wiener Krankenhaus der Stadt Wien*, 1784

Public domain, Wikipedia

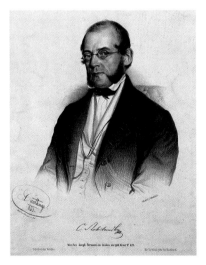

1.2 Carl von Rokitansky (1804–1878)

Public domain, Wikimedia Commons

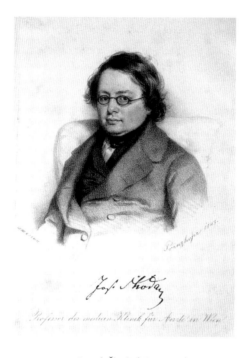

1.3 Joseph Škoda (1805–1881)

Public domain, Wikimedia Commons

Hospital sent every patient who died to Rokitansky for autopsy. As a result, Rokitansky is thought to have performed some 60,000 autopsies!

Based on this wealth of material, Rokitansky argued that before a physician can treat a patient, the physician must have an accurate diagnosis of the patient's disease. A bedside examination of the patient is not sufficient, because the same symptoms and signs can be produced by very different illnesses. The physician must understand the biological substratum of the disease. Rokitansky therefore insisted not only that every patient who died in the Wiener Allgemeine Krankenhaus be studied at autopsy but also that the results of those postmortem studies be correlated with the clinical picture of the patient, which had often been obtained by Škoda.

The systematic correlation of clinical and pathological findings enabled physicians to diagnose disease in live patients. This revolutionary idea made "natural-philosophical" explanations of disease obsolete and laid the foundation for a scientific medicine.

This flowering of biological research in the service of clinical care still characterizes academic medicine. Vienna's seminal ideas—that research and clinical practice are inseparable and inspire each other; that the patient is an experiment of nature and the bedside is the doctor's laboratory; and that the teaching hospital of the university is nature's school—are the basis of modern scientific medicine.

Rokitansky emerged as a leader of and public spokesman for science. In this role, he brought his liberal and humanitarian beliefs to bear on the resolution of conflicts among the university, the government, and the church. Moreover, his insistence on seeking the truth below surface appearances was an essential influence in the rise of modernist thinking. But another aspect of his character—and his actions—was equally important. Felicitas Seebacher documents this in her book *Das Fremde im 'deutschen' Tempel der Wissenschaften* (*The Foreigner in the "German" Temple of Sciences*) (2011). The University of Vienna in Rokitansky's era tended toward a purely German version of academic life, largely as a result of the incendiary writings of Theodor Billroth, an extraordinary physician and the greatest surgeon of the time, who helped raise the University of Vienna School of Medicine to an even higher level of scientific excellence. Billroth thought that Jewish culture, especially Eastern European Jewish culture, was lowering the quality of medical practice, and he wanted to limit the access of Jews to the medical school. His writings ignited an anti-Semitic reaction within the university, leading to violent clashes between German Christian and Jewish students at the University of Vienna School of Medicine.

Rokitansky stood up against this idea. He insisted that access to medical education be open to all, based only on scholarly excellence. Billroth, a powerful force in university politics, attacked Rokitansky's tolerance and his multicultural attitude. Having the courage to challenge Billroth, who was almost as powerful as Rokitansky himself and whom

Rokitansky had recruited to the School of Medicine, required remarkable strength of character.

SIGMUND FREUD

Two notable Jewish students who trained as physicians at the Vienna School of Medicine and were influenced by Rokitansky's thinking were Sigmund Freud and Arthur Schnitzler. Freud, who was trained as a neuroscientist (fig. 1.4), attended the School of Medicine during the last years of Rokitansky's tenure as dean. When Rokitansky died, Freud went to his funeral and wrote to his friends about the tragic loss this represented for Viennese

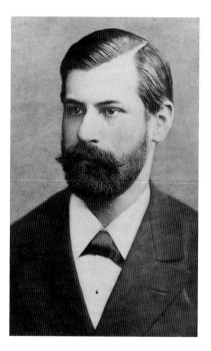

1.4 Sigmund Freud (1856–1939)

Mary Evans Picture Library, Bridgeman Images Germany

medicine. When Freud died, a number of his obituaries pointed out how fortunate he had been to have come under Rokitansky's influence. Psychoanalysis is a theoretical and speculative science, and Freud's strong scientific background was essential to its early development into a respected field.

Freud wanted to be a full-time research scientist, but in his era an independent income was necessary to a scientific career. He did not have such an income, so he turned to clinical practice. Influenced by his senior colleague Josef Breuer, Freud became interested in psychiatry, particularly the emerging field of psychoanalysis, which Breuer was just beginning to develop. Freud expanded on Breuer's analysis of mental processes by applying Rokitansky's principle to mental illness: to understand a mental illness, the analyst must go below the symptoms to the underlying unconscious conflicts that cause the disease.

In addition to introducing the concept of the unconscious, Freud introduced three other themes that contributed to the modernist outlook. First, he emphasized that human beings are not rational creatures but are driven by irrational, unconscious mental processes. Second, he argued that adult character, including unconscious sexuality and aggression, can be traced to the child's mind. Finally, he argued that no mental events occur by chance: they adhere to scientific laws and follow the principle of psychic determinism. This was a critical point. Before Freud, psychology was thought of as an extension of philosophy. Freud was the first practitioner to insist that psychology is an independent science, and by applying Rokitansky's principles to psychology, Freud essentially developed a cognitive psychology. He realized that the analyst has to try to understand the unconscious motivations leading to a patient's illness.

Still, Freud missed a number of important points.

One of the interesting things about Vienna 1900 is that Freud was not the only person developing insights into unconscious mental processes. There were Schnitzler, on the one hand, and Klimt, Kokoschka, and Schiele, on the other. All of them were exploring the human mind at the same time, living in the same zeitgeist, and they brought to bear upon the examination of human psychology a number of new insights that Freud lacked.

ARTHUR SCHNITZLER'S CHALLENGE TO FREUD

Although trained as a physician, Schnitzler became a writer (fig. 1.5). He had many affairs with women, and these led him to develop insights into female sexuality that Freud lacked. Schnitzler kept a detailed log not only of the women with whom he had affairs but also of the number of orgasms he had with each one. Thus, whereas Freud thought that women had a very limited sexual life, that they were passive and did not enjoy sex as much as men did, Schnitzler knew that women could have a rich sexual life. He wrote an attack on Freud's case study of Dora and the narrow and naïve view of women's attitudes toward sexuality it presented.

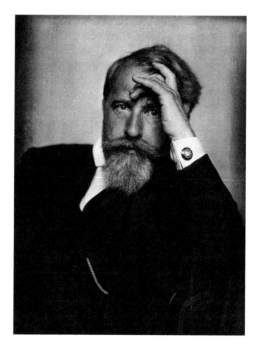

1.5 Arthur Schnitzler (1862–1931)

alamy.com

In "Fragment of an Analysis of a Case of Hysteria" (1905), Freud wrote about "Dora," a sixteen-year-old girl named Ida Bauer, and her interaction with Mr. K. Ida's parents were very friendly with Mr. and Mrs. K, and in time Ida's father began to have an affair with Mrs. K. In retaliation, Mr. K made advances to Ida, who was fourteen years old at the time and deeply offended by his attentions. Ida complained to her father, who then spoke to Mr. K. Mr. K insisted that Ida was making the whole thing up. She is a young girl. She has a rich fantasy life. She reads pornographic literature. There is nothing to it! Mr. Bauer, not wanting to start any trouble because he was sleeping with Mr. K's wife, went along with Mr. K's story and ignored Ida's complaints.

With time, Ida became more and more depressed. Her father took her to see Freud, who took her into treatment. As the therapy progressed, Freud began to side with Ida's father, thinking that Ida must be imagining Mr. K's advances. Freud could not understand why a fourteen-year-old girl would not be flattered by the fact that a mature man was sexually interested in her.

Schnitzler criticized Freud's lack of insight into a young woman's sensitivity in *Fräulein Else*, a novella in which a young, upper-class woman is put into a somewhat similar situation by her parents (1924).

Else's father had accumulated a serious gambling debt that he could not pay, and he was going to be thrown into prison. Else's mother wrote to her daughter, who was on holiday at a resort, saying that the only way Else's father could be saved was by Else's asking an old friend of the family, who was wealthy and also vacationing at the resort, to lend her father money. Else went to see the family friend, who implied that he would lend her father money if she would sleep with him. Else was horrified. The family friend compromised: "I'll lend the money if you just stand in front of me, nude, for half an hour."

Else was repelled, but she ultimately prepared to yield to his request—and to commit suicide afterward. She dressed only in her coat and went to the man's room. He wasn't there, so Else went to look for him. She found him in a small room, attending a concert with other people. In trying to catch his attention, Else accidentally exposed her naked body to everyone present. Mortified, she subsequently committed suicide.

Schnitzler clearly shows the reader that the responsibility for this tragic outcome rests with Else's parents and their preposterous request.

GUSTAV KLIMT AND THE LIBERATION OF FEMALE SEXUALITY

Austrian modernist art represents an extension of the intellectual search for deeper meaning that was introduced into medicine by Rokitansky and elaborated in psychology by Freud and in literature by Schnitzler. The artists penetrated the Victorian veneer of middle-class Viennese life—particularly society's restrictive and hypocritical attitudes toward mental life, sex and aggression, and women and their sexuality—to reveal the reality that lies beneath the surface.

Klimt (fig. 1.6) focused on becoming a psychological painter of women. Over the course of his life, he replaced the angelic feminine types of his earlier pictures with portraits of women as sensual creatures developing their full potential for pleasure and pain, life and death. In a long series of drawings, Klimt tried to capture the feeling of femaleness. In his exploration of the erotic, he banished the sense of sin surrounding sex that had plagued his father's generation and portrayed the variety of sexual pleasures women can achieve, alone or with a male or female partner (fig. 1.7). In capturing the fullness of female sexuality that had eluded Freud and many of his contemporaries, Klimt became a great liberator of women's sensuality.

Klimt introduced a new dimension to eroticism in Western art—he portrayed real women with no regard to the viewer. The traditional nude (figs. 1.8–1.11) was characterized by three features. First, she is a mythological creature: Venus, Maja, Olympia. Second, she looks at the beholder as if her only satisfaction is the satisfaction of the (usually male) viewer. Third, she often covers her pubic region with her hand. In two of the paintings shown here, the purpose of covering her genitalia is ambiguous (figs. 1.8 and 1.9). Is she being modest, or is she masturbating? With Klimt there is never any doubt (figs. 1.7 and 1.12).

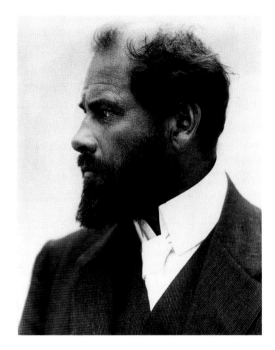

1.6 Gustav Klimt (1862–1918)

Bridgeman Images

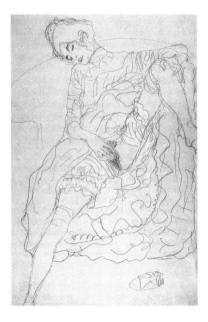

1.7 Gustav Klimt, *Seated Woman in Armchair* (c. 1913). Pencil and white chalk on paper.

Private collection. Courtesy Neue Galerie New York

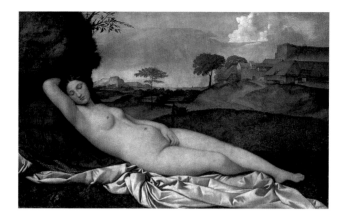

1.8 Giorgione da Castelfranco, *The Sleeping Venus* (1508–10). Oil on canvas.

Gemäldegalerie Alte Meister, Dresden. Wikimedia Commons

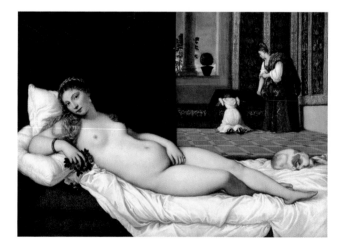

1.9 Titian, *Venus of Urbino* (before 1538). Oil on canvas.

Galleria degli Uffizi, Florence. Art Resource, artres.com

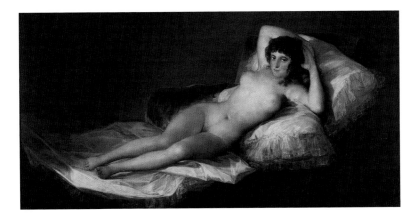

1.10 Francisco José de Goya y Lucientes, *The Naked Maja* (c. 1800). Oil on canvas.

Public domain, Wikimedia Commons

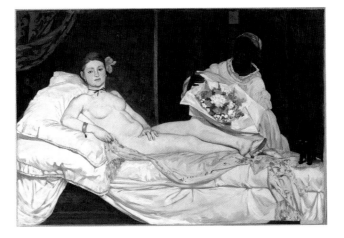

1.11 Édouard Manet, *Olympia* (1863). Oil on canvas.

Musée d'Orsay, Paris. Art Resource, artres.com

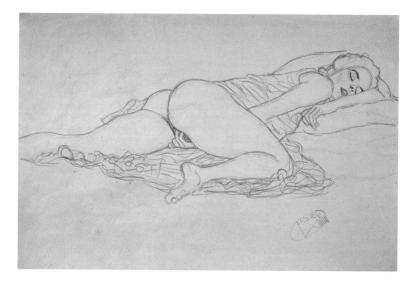

1.12 Gustav Klimt, *Reclining Nude Facing Right* (1912–13). Pencil and red and blue pencil.

Private collection. Courtesy Neue Galerie New York

In addition, Klimt sensed that a fear of sex haunted many of the men of his generation. He recognized that the liberation of female sensuality carried with it an anxiety about death. In his painting *Judith* (fig. 1.13), a major example of his erotic art, Klimt introduces the themes of aggression and castration, in this case disguised as decapitation. Judith, fresh from killing Holofernes after seducing him, glories in her voluptuousness. Klimt pictures her as a young, extravagantly made-up woman, her semi-clothed body handled with great sophistication. She faces the viewer, whom she regards sensually, through half-open eyes. She is absent-mindedly stroking the head of a man in the lower part of the picture.

Although we know from the title of the painting that this woman is the Jewish heroine Judith and therefore that the head is that of her people's nemesis Holofernes, this dangerous beauty is clearly contemporary. Her jewelry is archaic in style but obviously of modern production, while the

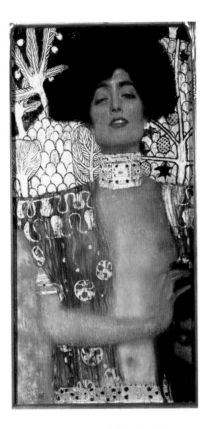

1.13 Gustav Klimt, *Judith* (1901). Oil on canvas.

Belvedere, Vienna. Art Resource, artres.com

dress recalls the fine materials that were the hallmark of the Wiener Werk-stätte. Klimt portrays Judith in the same way as the elegant ladies of the contemporary Viennese upper class whom he painted and with whom he had affairs. In fact, she looks like Adele Bloch-Bauer.

Judith is a true femme fatale. She evokes both lust and fear. Nevertheless, the murder of Holofernes is presented in sublime form: there is no trace of blood or violence in the picture. Although Judith is a murderess, the murder is symbolic only.

THE ZUCKERKANDL SALON

Klimt, a Christian, had extensive interactions with the Jewish community in Vienna. Most of his patrons were Jews, and two of his Jewish supporters and friends, Emil and Berta Zuckerkandl (figs. 1.14 and 1.15), introduced him to Rokitansky's ideas. Emil, an anatomist and an important scientist in his own right, was an associate of Rokitansky. Berta ran the greatest salon in Vienna, which attracted scientists, businesspeople, writers, and physicians, including her husband. As she liked to say, "On my divan, Austria comes alive." The idea of bringing together art and science in his work was something that Klimt achieved by visiting the Zuckerkandls.

Berta Zuckerkandl was a journalist who wrote about art. In that role she became a great defender of Klimt. When the faculty of the University of Vienna refused to display Klimt's murals on Philosophy, Medicine, and

1.14 Emil Zuckerkandl (1849–1910)

Getty Images

1.15 Berta Zuckerkandl (1864–1945)

alamy.com

Jurisprudence, attacking them as "pornography," Berta wrote strong articles in his defense. When the legal and medical faculties deemed the murals ugly, Berta pointed out that the function of modern art is to convey truth and that some aspects of truth are in fact ugly.

Through Emil Zuckerkandl, Klimt became interested in biology. He began to read Darwin and Rokitansky. Emil showed him slides of sperm cells and egg cells and invited him to his lectures. Klimt not only attended himself, he encouraged other artists to attend Zuckerkandl's seminars.

Klimt began to incorporate biological symbols into his art: rectangles symbolized sperm and ovals symbolized eggs. We see this in *Danaë*, a portrait of the Greek princess who was imprisoned by her father and impregnated by Zeus in the form of a golden shower (1.16). If we look closely at the painting, we can see rectangles in the golden raindrops. On the other side of *Danaë*, we see oval shapes. These are embryos, fertilized ova. Klimt shows us Danaë, through her generative power, transforming sperm into the

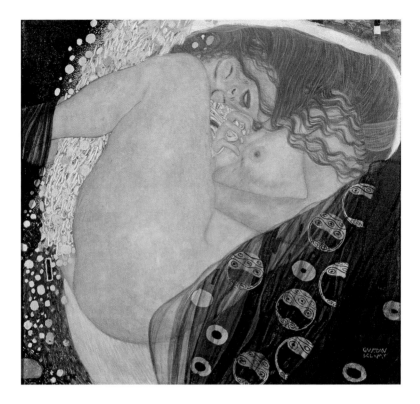

1.16 Gustav Klimt, *Danaë* (1907–8). Oil on canvas.

Bridgeman Images

earliest stage of life. These biological symbols, which Klimt used for the first time in this painting, recur throughout his later work.

The apex of this symbolism is *The Kiss* (fig. 1.17), probably the most popular of Klimt's paintings. Klimt intensifies the sensuousness of the painting by expanding the use of symbols at the expense of realistic ornamentation. Thus, in the lovers' clothing, as well as in the flowery base, the symbols serve as ornament. The rectangle that Klimt used in his painting of Danaë as a phallic symbol is proliferated in *The Kiss* on the man's cloak, while the woman's dress is alive with ovular and floral symbols. These two defined

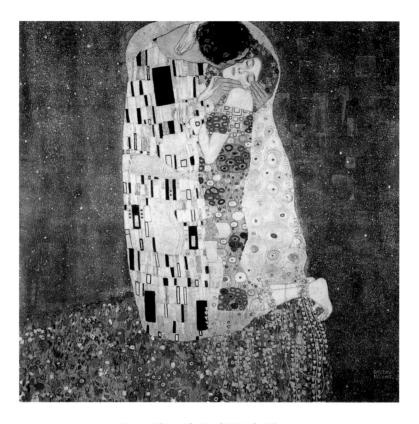

1.17 Gustav Klimt, *The Kiss* (1907–8). Oil on canvas.

Public domain, Wikimedia Commons

fields of sexual symbols are brought into a union of opposites in the vibrant cloth of gold that is their common ground. Here again, Klimt has indirectly portrayed strong and harmonious erotic feelings.

BRINGING PSYCHOLOGY AND ART TOGETHER

The second phase of Viennese modernism, the bringing together of science and art, resulted from the interaction of the extraordinarily gifted

1.18 Alois Riegl (1858–1905)

Public domain, Wikipedia

art historian Alois Riegl (fig. 1.18), who was Christian, and two of his students, Ernst Kris (fig. 1.19) and Ernst Gombrich (fig. 1.20), both of Jewish origin.

Riegl was the first art historian to apply scientific thinking systematically to art criticism. He and his colleagues at the Vienna School of Art History attained international renown at the end of the nineteenth century for their efforts to establish art history as a scientific discipline by grounding it in psychology and sociology.

Riegl discovered a new, psychological aspect of art: namely, that art is incomplete without the perceptual and emotional involvement of the viewer. Not only does the viewer collaborate with the artist in transforming a two-dimensional likeness on a canvas into a three-dimensional depiction of the visual world, the viewer also interprets what he or she sees on the canvas in personal terms, thereby adding meaning to the picture. Riegl called this phenomenon the "beholder's involvement." (Gombrich later elaborated on this concept and referred to it as the "beholder's share.")

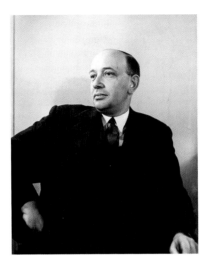

1.19 Ernst Kris (1900–1957)

Public domain, Wikipedia

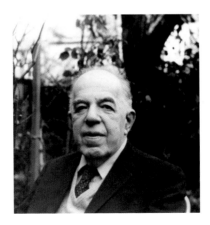

1.20 Ernst Gombrich (1909–2001)

Public domain, Wikimedia Commons

Based on ideas derived from Riegl and from contemporaneous schools of psychology and psychoanalysis, Kris and Gombrich devised a new approach to the mysteries of visual perception and incorporated that approach into art criticism.

Kris studied ambiguity in visual perception, and those studies led him to elaborate on Riegl's insight that the viewer completes a work of art. Kris argued that every powerful image is inherently ambiguous because it arises from experiences and conflicts in the artist's life. The viewer responds to this ambiguity in terms of his or her own experiences and conflicts. The extent of the viewer's contribution depends on the degree of ambiguity in the image.

The idea of ambiguity as Kris used it was introduced by the literary critic William Empson, who held that ambiguity exists when "alternative views [of a work of art] might be taken without sheer misreading." Empson implied that ambiguity allows the viewer to read the aesthetic choice, or conflict, that exists within the artist's mind, whereas Kris held that ambiguity enables the artist to transmit his sense of conflict and complexity to the viewer's brain.

Gombrich extended Kris's ideas about ambiguity to visual perception per se. This led him to realize that the brain is not simply a camera, it is a creativity machine. It takes incomplete information from the outside world and makes it complete. Our brain has evolved to do this. Many things we take for granted are built into our brain by evolution. For example, the brain realizes that the sun is always above us, no matter where we are. We therefore expect light to come from above. If it does not—as in a visual illusion—our brain can be tricked. Gombrich was fascinated by how the brain responds to such illusions.

Perception also incorporates knowledge based on learning, hypothesis testing, and goals—and this knowledge is not necessarily built into the developmental program of our brain. Because much of the sensory information that we receive through our eyes can be interpreted in a variety of ways, we must use inference to resolve this ambiguity. We must guess, based on experience, what the image in front of us is.

Hermann von Helmholtz, one of the most important physicists of the nineteenth century, first discovered this top-down processing in visual perception. Helmholtz realized that the images our eyes transmit to our brain contain poor-quality, incomplete information. To reconstruct the dynamic, three-dimensional world from these static, two-dimensional images, the brain needs additional information. He therefore concluded that perception is also a process of guessing and hypothesis testing in the brain, based on our past experiences. Such educated guessing enables us to infer what an image represents.

Since we normally are not aware of constructing visual hypotheses and drawing conclusions from them, Helmholtz called this top-down process of hypothesis testing *unconscious inference*. The importance of top-down processing in visual perception was later established by Freud. He described people who could accurately detect features of an object, such as edges and shapes, but could not put them together to recognize the object.

Helmholtz's remarkable insight is not restricted to perception: top-down processing applies to emotion and empathy as well. The noted cognitive psychologist Chris Frith, of the Wellcome Center for Neuroimaging at University College London, has summarized Helmholtz's insight: "We do not have direct access to the physical world. It may feel as if we have direct access, but this is an illusion created by our brain."

The influence of top-down processing on perception convinced Gombrich that there is no "innocent eye": all visual perception is based on classifying concepts and interpreting visual information. We cannot perceive that which we cannot classify, he argued.

Riegl, Kris, and Gombrich realized that each of us brings to a work of art our memories, in addition to our bottom-up, built-in visual processes. We remember other works of art that we have seen. We remember scenes and people that have meaning to us. And when we look at a work of art, we relate it to those memories. In a sense, to see what is actually painted on a canvas, we have to know beforehand what we might see in a painting. In this way the artist's modeling of physical and psychic reality parallels the intrinsically creative operations of our brain in everyday life.

These psychological insights into perception were to serve as a solid footing for a bridge between the visual perception of art and biology.

THE BRAIN AS A CREATIVITY MACHINE

As Gombrich's fascination with visual perception deepened, he became intrigued by Kris's ideas about ambiguity in art and began to study the ambiguous figures and illusions made famous by Gestalt psychologists. Simple illusions allow for two distinctly different readings of an image. Such illusions are uncomplicated examples of the nature of ambiguity, which Kris held was the key to all great works of art and to the beholder's response to great art. Other illusions contain ambiguous images that can lure the brain into making perceptual errors. Gestalt psychologists used these errors to explore the cognitive aspects of visual perception. In the process, they deduced several principles of the brain's perceptual organization before neuroscientists discovered them.

Ambiguous figures and illusions intrigued Gombrich because he knew that in viewing a portrait or a scene, the viewer has multiple choices. Often, several ambiguities are embedded in a great work of art, and each may present the beholder with a number of different decisions. Gombrich was particularly interested in ambiguous figures and illusions that cause perception to flip between two rival interpretations. One such figure is the drawing of a duck-rabbit (fig. 1.21) created in 1892 by the American psychologist Joseph Jastrow and used by Gombrich in his book *Art and Illusion* (1960). The viewer cannot see both animals at the same time. If we focus on the two horizontal bands at the left that look like long ears, we see the image of the rabbit; if we focus on the right, we see the duck, and the two bands at the left become a beak. We can initiate the switch between rabbit and duck with a movement of our eyes, but that eye movement is not essential for the switch.

What impressed Gombrich about this drawing was that the visual data on the page do not change. What changes is our interpretation of the data. We see the ambiguous image and unconsciously infer, based on our

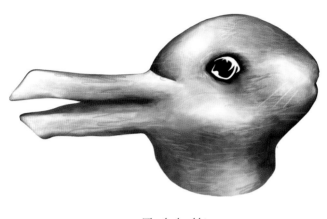

1.21 The duck-rabbit

Art Resource, artres.com

expectations and past experiences, that the image is a rabbit or a duck. This is the top-down process of hypothesis testing that Helmholtz described. Once we have formed a hypothesis about the image, it not only explains the visual data, it also excludes alternatives. In other words, once the image of the duck or the rabbit is dominant, nothing remains to be explained; the image is no longer ambiguous. It is either a duck or a rabbit, but never both.

This principle, Gombrich realized, underlies all of our perceptions of the world. Rather than seeing the image and then consciously interpreting it as a duck or a rabbit, we unconsciously interpret the image as we view it. Thus interpretation is inherent in visual perception itself. Simply by seeing the image, we recognize it as either a duck or a rabbit. We can consciously flip from one interpretation to the other, but we cannot see both animals in the image at the same time.

The Rubin vase (fig. 1.22), devised by the Danish psychologist Edgar Rubin in 1920, while also an example of perception flipping between two rival interpretations, relies on unconscious inferences made by the brain. Unlike the rabbit-duck illusion, the Rubin vase requires the brain to construct an image by differentiating an object (figure) from the background

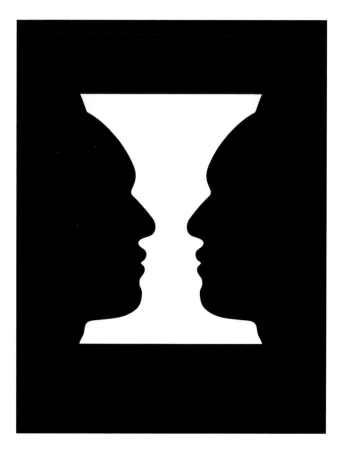

1.22 The Rubin vase

Creative Commons

(ground). The Rubin vase also requires that the brain assign "ownership" of the outline, or contour, that separates the figure from the ground. Thus, when our brain assigns ownership of the contour to the vase, we see the vase, and when it assigns ownership to the faces, we see the faces. The reason the illusion works, according to Rubin, is that the contours of the vase match the contours of the faces, thus forcing us to select one image or the other.

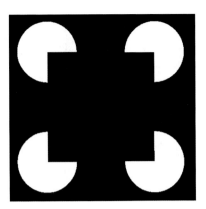

1.23 The Kanizsa square

Chris Wilcox, inspired by Kanizsa triangle

The Kanizsa square (fig. 1.23) is still another example of the visual system constructing a reality that is not there. In this illusion, created in 1950 by the Italian artist and psychologist Gaetano Kanizsa, the brain constructs an image of a black square lying on top of four white circles. It seems perfectly clear; however, there is no black square there at all. The brain is making it up! What we actually see is four white, 270° semicircles. There are no lines at all.

If we turn the semicircles around, the illusion of the square disappears completely (fig. 1.24). This is one of many examples that Gombrich used to show how much of the information that we take in is fantasy.

Semir Zeki, a professor of neuroaesthetics at University College London, has argued that the Kanizsa square is an example of the brain trying to complete, and thereby make sense of, an incomplete or ambiguous image. Zeki's brain imaging experiments indicate that several areas of our brain become active when we look at implied lines, including an area of the cortex that is critical for object recognition. Presumably, our brain completes lines because nature often presents us with occluded contours that must be completed in order to perceive an image correctly—the sort of thing that

1.24 Semicircles forming the Kanizsa square, now rotated

Chris Wilcox

might happen when we see someone coming around a corner. As Richard Gregory reminds us, "our brains create much of what we see by adding what 'ought' to be there. We only realize that the brain is guessing when it guesses wrongly" (2009, 212).

Kris's and Gombrich's studies of ambiguity and of the beholder's share led them to conclude that the brain is creative—it generates internal representations of what we see in the world around us, whether as an artist or as a beholder. Moreover, they held that we are all wired to be "psychologists" because our brain also generates internal representations of other people's minds—their perceptions, motives, drives, and emotions. These ideas contributed greatly to the emergence of a modern cognitive psychology of art.

But Kris and Gombrich realized that their ideas resulted from sophisticated insights and inferences; they could not be examined directly and therefore could not be analyzed objectively. To examine these internal representations directly—to peer into the brain—cognitive psychology had to join forces with brain biology.

THE BEHOLDER'S SHARE: BIOLOGY AND PSYCHOLOGY

The third and final phase in Viennese modernism—discovering the brain mechanisms underlying the beholder's share—also resulted from the interaction of Jews and Christians, specifically, the influence of Riegl on Kris and Gombrich. Had it had not been for Riegl, Kris and Gombrich would never have focused on the beholder's share.

As we look at a portrait, our brain is busy analyzing facial contours, forming a representation of the face, analyzing the body's motion, forming a representation of the body, experiencing empathy, and forming a theory of the person's mind. These are all components of the beholder's share, and modern biology makes it possible for us to explore them.

Theory of mind is the idea that someone else has a mind of his or her own, with separate feelings, aspirations, and ideas (Saxe and Kanwisher, 2003; Goldman, 2012). For example, when you look at a painting of someone walking toward you, you may feel an urge to move and walk toward the person. When you look at a portrait of a person who is really interesting, you have empathy for that person; you understand his or her aspirations and goals. You try to understand what is going on in the person's mind. Theory of mind also enables us to predict what other people will do. It is a very important skill, and our brain has a special area devoted to it.

The brain's representation of faces is essential to the beholder's share. We have learned a great deal about the psychology of face recognition and the biological processes underlying it. Let us first consider the psychological aspects of face recognition and then the biology.

Our brain is specialized to deal with faces. Darwin pointed out that the face and the emotion it conveys are key to all human interactions. We judge whether we trust people or are scared of them in part by the facial expressions they show us when we interact with them. We are attracted to people of the same sex and the opposite sex because of their physical appearance and their facial expressions.

Face recognition is a difficult task, yet we can recognize hundreds of faces effortlessly. We do even better when we see them in cartoon form,

because our brain responds powerfully to exaggeration. Thus, we are likely to recognize a cartoon of the Mona Lisa even more readily than the original image because the cartoon exaggerates her features.

The brain treats faces very differently from other objects. For example, if we turn a bottle of water upside down, we will still recognize it as a bottle of water. But we may not recognize a face when it is upside down. Moreover, if we view two images of the Mona Lisa upside down (fig. 1.25), we may recognize both of them as the Mona Lisa but not realize that they have different expressions. One is the enigmatic Mona Lisa; the other has a smirk on her face that we don't see when the image is upside down (fig. 1.26). With an object other than a face, we would see the difference.

How do we recognize faces? In brief, our brain has four lobes: frontal, parietal, occipital, and temporal. The occipital lobe is where visual information first enters the brain; the temporal lobe is where facial representation occurs. Visual information comes in through our eyes. At the back of the eye is the retina, a sheet of light-sensitive nerve cells whose long axons form the optic nerve. The optic nerve ends in an area of the brain

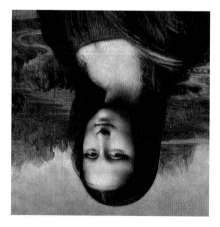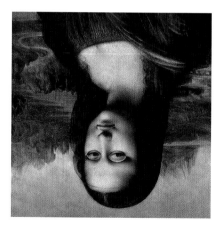

1.25 Inverted images of da Vinci's *Mona Lisa*

Adapted from P. Thomas, "Margaret Thatcher: A New Illusion," *Perception* 9 (1980): 483, fig. 1

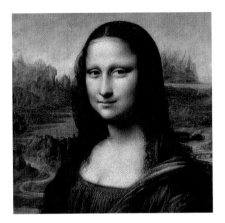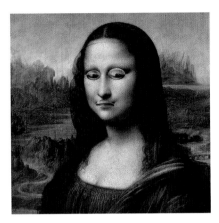

1.26 Upright images of da Vinci's *Mona Lisa*

Adapted from P. Thomas, "Margaret Thatcher: A New Illusion," *Perception* 9 (1980): 483, fig. 2

called the lateral geniculate nucleus, which then relays the information to the visual cortex. The information is processed in several stages, V1, V2, and V3. In each stage, the information is treated in a progressively more complex manner.

Our understanding of vision owes much to another interaction of Jews and Christians. Stephen Kuffler, a Viennese scientist of Jewish origin, studied at the Vienna School of Medicine but left Vienna in 1938. He moved first to Australia and then to the United States, where he did his great work on the physiology of the visual system. Two of his students, David Hubel and Torsten Wiesel, both non-Jews, continued in his tradition.

Kuffler began to record electrical signals produced by cells in the retina. He found that when he shone a diffuse light on the retina, those cells did not respond. But when he shone small spots of light on the retina, some of the cells did respond. Kuffler realized that each cell responds only to one particular, small point on the retina known as its receptive field. Moreover, each cell responds only to contrasts in its receptive field. Some cells respond to a spot of light surrounded by darkness; Kuffler called these "on-center"

cells. Other cells respond to a spot of darkness surrounded by light; these he called "off-center" cells.

When Kuffler shone a light in the center of an on-center cell, its electrical firing increased. When he shone a light on the periphery, its firing slowed. When he shone a diffuse light, the cell did not respond at all. Off-center cells respond in the opposite way, but both types of cells are responding to contrast.

In addition, if two circles of light, both of the same intensity, are shone on the retina, one may appear brighter than the other because the contrast is greater. So a bit of what we see is the contrast between surfaces, not absolute intensity of light.

When all this information about circular forms reaches the cortex, it is turned into lines. Thus, cells in the cortex respond not to small spots of light but to linear stimuli. Some cells respond to vertical stimuli, some to oblique stimuli, and some to horizontal stimuli. (These are the cells that respond to the Kanizsa square, the optical illusion in which the brain creates a square because most objects that look like it are in fact squares.) In this way our brain begins to put contours together and to re-create faces.

REPRESENTATION OF FACES IN THE BRAIN

Scientists learned an enormous amount about the representation of faces in the brain from people who have face blindness, or prosopagnosia, a condition first described in 1947 by Joachim Bodamer (fig. 1.27). It results from damage to the inferior temporal cortex, whether acquired or congenital. About 10 percent of people have a modest degree of face blindness. People with damage in the front of the inferior temporal cortex can recognize a face as a face but cannot tell whose face it is. People with damage to the back of the inferior temporal cortex cannot see a face at all. In Oliver Sacks's famous story "The Man Who Mistook His Wife for a Hat," a man with face blindness tried to pick up his wife's head and put it on his head because he thought her head was his hat.

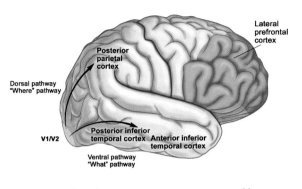

1.27 Bodamer's prosopagnosia—representation of faces

Adapted from Eric R. Kandel, *The Age of Insight: The Quest to Understand the Unconscious in Art, Mind, and Brain from Vienna 1900 to the Present* (New York: Random House, 2012), 282, fig. 17.1

Charles Gross, Margaret Livingstone, Doris Tsao, and Winrich Freiwald have made several advances in analyzing faces. They homed in on a particular region of the brain, the inferior temporal cortex, in macaque monkeys (fig. 1.28), using a combination of brain imaging and recording from

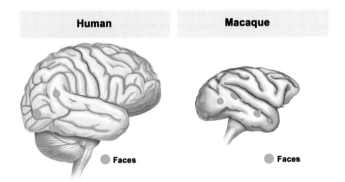

1.28 Face patches in the human and macaque brain

Adapted from A. Freiwald and D. Tsao, "Functional Compartmentalization and Viewpoint Generalization within the Macaque Face-Processing System," *Science* 330 (2010): 846, fig. 1

individual cells. They found six small structures, which they called face patches, in the temporal lobe that lit up when they showed the animals a face. They also found a similar, although smaller, set of face patches in the human brain. When they recorded electrical signals from cells in the monkeys' face patches, they found that different patches respond to different aspects of the face: head-on view, side view, and so on.

Studies by Tsao and a colleague found that monkeys' face patches contain a high proportion of cells that respond only to faces. These cells are sensitive to changes in position, size, and direction of the gaze of the face, as well as to the shape of various parts of the face. Figure 1.29 shows a cell in a monkey's face patch responding to various images.

Not surprisingly, the cell fires very nicely when the monkey is shown a picture of another monkey (a). The cell fires even more dramatically in response to a cartoon face (b); monkeys, like people, respond more powerfully to cartoons than to real objects because the features in a cartoon are exaggerated. But a face has to be complete in order to elicit a response. Thus, when the monkey is shown two eyes in a circle (c), there is no response. A mouth and no eyes also elicits no response (d). Two eyes and a mouth—a nose is not necessary—inside a square again produces no response (e). The same is true if the monkeys are shown only an empty circle (f). The cell responds only to two eyes and a mouth inside a circle (g). If the circles and the mouth are only outlined, there is no longer a response (h). In addition, if the monkey is shown an inverted face, it does not respond. But if the eyes or the mouth are distorted, the cells respond powerfully.

THE BEHOLDER'S SHARE OF BRAIN, BODY, MOVEMENT, EMPATHY, AND THEORY OF MIND

The brain creates representations not only of faces but also of bodies, and these are part of the beholder's share as well. Behind the visual cortex is an area called the extrastriate cortex that responds to bodily parts: arms, hands, legs. Behind that is an area concerned not just with the body but

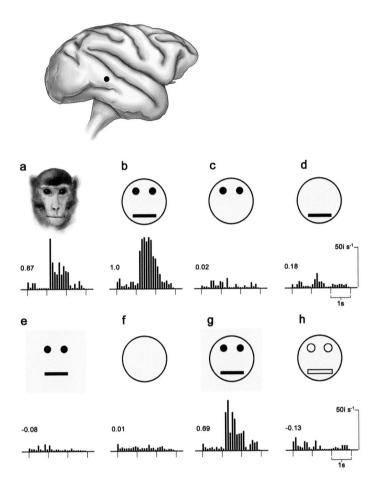

1.29 Using a visual stimulus to excite a single cell in a macaque face patch

Adapted from E. Kobatake and K. Tanaka, "Neuronal Selectivities to Complex Object Features in the Ventral Visual Pathway of the Macaque Cerebral Cortex," *Journal of Neurophysiology* 71, no. 3 (1994): 859, fig. 4

also with the processing of motion—all kinds of motion, artificial as well as biological. Another area analyzes just biological motion, such as an arm reaching forward or legs moving.

Two additional areas in the brain are called the mirror neuron system. Studies of monkeys have shown that mirror neurons respond when one

monkey watches another monkey move, for example when the monkey picks up a glass of water and drinks it. But these cells also respond when a monkey observes a person pick up a glass of water and drink it. They even respond when a person simply picks up a glass. The cells in the monkey's brain mirror movement. They respond to actions that another monkey or a person carries out without prompting any movement on the part of the observer.

This shows us that simply by observing things we are training our motor systems to carry out those acts. Babies do this; we now think that they acquire some aspects of language by actually reading their parents' lips and quietly simulating their mouth movements, in addition to listening to them.

THE EMERGENCE OF A JEWISH CONTRIBUTION TO PAINTING IN VIENNA 1900

The second commandment of the Bible forbids the making of any "graven image." This commandment has been interpreted by Jewish people (and even more strictly by the Islamic people) as not just images for the purpose of worship, but any representation, irrespective of its purpose. This prohibition held, with rare exceptions, until the beginning of the twentieth century.

It is generally thought that the first outburst of Jewish painting was the Paris School of the 1920s, consisting of Marc Chagall, Chaïm Soutine, Jules Pascin, Amedeo Modigliani, and Michel Kikoine. None of the well-known Austrian modernist artists—Klimt, Kokoschka, and Schiele—was Jewish, yet the same cultural forces that inspired these three painters loosened the constraints that had historically inhibited Jews from making images. As a result, turn-of-the-century Vienna saw the rise of a group of Jewish painters—two men and three women—whose work proved both interesting and important. Moreover, this burst of creativity, although not generally appreciated, emerged even earlier than that which emerged

among the Jewish painters in Paris: Chagall, Soutine, Pascin, Modigliani, and Kikoine.

One of the most gifted Viennese painters was Richard Gerstl (1883–1909), the first Austrian Expressionist. Even before Kokoschka, Gerstl captured the intensity of emotion and color that Van Gogh and Munch had introduced into modern painting (fig. 1.30).

Gerstl also preceded Schiele in depicting himself nude, as we see in his extraordinary *Self-Portrait as an Act* (fig. 1.31). Although he had a very brief career—he committed suicide at age twenty-five—Gerstl was nevertheless a major force in Expressionism, his work being on the same level as that of Kokoschka and Schiele.

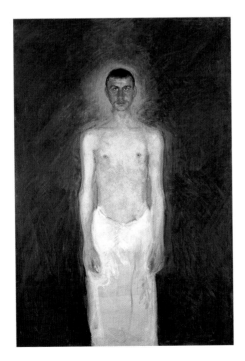

1.30 Richard Gerstl, *Self-Portrait (Nude on a Blue Ground)* (1904–5). Oil on canvas.

Art Resource, artres.com

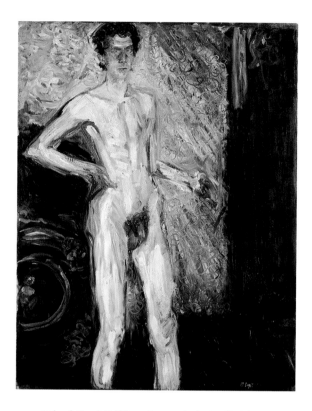

1.31 Richard Gerstl, *Self-Portrait as an Act* (c. 1908). Oil on canvas.

Public domain, Wikimedia Commons

During the last two years of his life, Gerstl spent the summers in the resort of Traunsee with another, ever more influential Jewish artist of the period, Arnold Schoenberg, whom Gerstl instructed in painting. Schoenberg is perhaps best known as a composer and leader of the Second Vienna School of Music. In 1908, he introduced a conception of harmony that has no central key, only changes in timbre and tone. This revolutionary form of composition, referred to as "atonality," also led to a new conceptualization of art. After hearing a concert of Schoenberg's music in 1911, Wassily

Kandinsky, the Russian painter and art theorist, created the first truly abstract work of art, thus beginning the most radical artistic movement of the twentieth century.

But Schoenberg also proved to be a talented and original painter. Between 1908 and 1912, he carried Gerstl's emotional intensity and subjective impressions a step further in his paintings, both in his conventional portraits (fig. 1.32) and in his later "visions" (figs. 1.33 and 1.34). Schoenberg's "visions" moved beyond Expressionism to symbolic and abstract representation (fig. 1.35).

In addition to these two men, there were three particularly talented Jewish women painters who knew and interacted with Klimt, Kokoschka, and Schiele. Their art did not receive the same recognition as the men's art, and only now are critics beginning to remedy that. Tina Blau painted

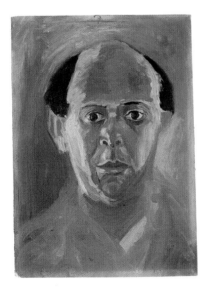

1.32 Arnold Schoenberg, *Self Portrait* (c. 1910). Oil on cardboard.

The Schoenberg family

1.33 Arnold Schoenberg, *Vision Rouge* (1910). Oil on cardboard.

The Schoenberg family

1.34 Arnold Schoenberg, *Self-Portrait* (1910). Oil on cardboard.

The Schoenberg family

1.35 Arnold Schoenberg, *Vision* (1910). Oil on cardboard.

The Schoenberg family

beautiful Impressionist landscapes (fig. 1.36). Her 1882 *Prater Spring*, a major work that depicts Vienna's great public park, was bought by the city. Broncia Koller-Pinell, a personal friend of Klimt and Schiele, painted interiors and focused on domestic subjects, including female nudes, a rarity for female artists at that time (fig. 1.37). Perhaps the most recognized by the public and the art critics was Teresa Reis (fig. 1.38), a major sculptor and painter whose work caught the interest of Theodore Herzl, Stefan Zwers, and Mark Twain.

1.36 Tina Blau, *In the Green Forest, Spring in the Prater* (1884). Oil on wood.

Vienna Museum

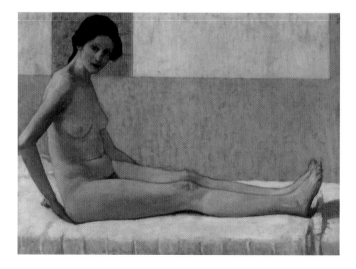

1.37 Broncia Koller-Pinell, *Seated Nude* (1907). Oil on canvas.

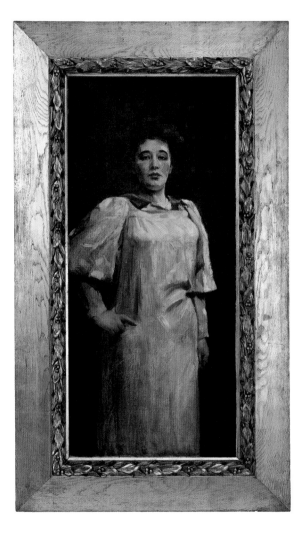

1.38 Teresa Reis, *Self-Portrait*

Vienna Museum

GALLERISTS, PATRONS, AND THE PLEASURES
OF OWNERSHIP

Most of the patrons of modernist artists were Jewish, as were the gallery owners who promoted and supported them, notably Otto Kallir. There is a bit of psychology involved in why this is so. The Jews wanted a new sense of identity; they wanted to become assimilated into Viennese culture. Modernism was a new, interesting movement, and they wanted to be part of it. One way of doing so was by buying modernist art. But Jewish patrons also supported modernist art because they loved it. One important Jewish patron was Ferdinand Bloch, who commissioned Klimt to paint his wife, Adele (fig. 1.39).

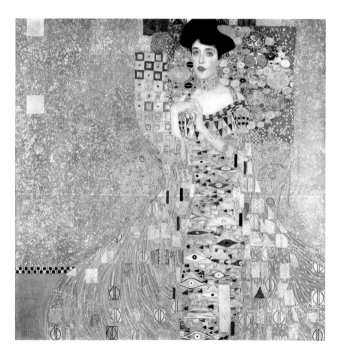

1.39 Gustav Klimt, *Adele Bloch-Bauer I* (1907). Oil and silver and gold leaf on canvas.

Neue Galerie New York

Another Jewish patron who loved modernist art came onto the scene much later: Ronald Lauder, an American. In 1958, when he was fourteen years old, Lauder visited Vienna for the first time and fell in love with Klimt's painting of Adele Bloch-Bauer, which was hanging in the Upper Belvedere Museum. Forty-eight years later, Lauder bought the painting for $135 million, the highest price ever paid for a painting up to that time. What accounts for the fact that Ronald Lauder loved the portrait of Adele so much that he was willing to pay $135 million for it?

When Lauder first looked at the painting, at age fourteen, his brain's dopamine system, which is associated with pleasure, responded forcefully. This response not only increased the production of dopamine but also recruited very powerful neurons in the orbitofrontal cortex that are associated with romantic love (fig. 1.40). The dopamine system is like a sprinkler

1.40 Romantic love lights up cells in the brain's dopamine system.

Reproduced from A. Aron, et al., "Reward, Motivation, and Emotion Systems Associated with Early Stage Intense Romantic Love," *Journal of Neurophysiology* 94 (2005): 332, fig. 4

system: it affects every aspect of the beholder's share. It is also recruited in response to food, drink, sex, and addictive substances such as opium, cocaine, smoking, and drinking. Lauder wanted to own the painting, but of course he couldn't. He came back summer after summer to the Upper Belvedere and thought, *Wouldn't it be nice to own this?*

When the painting finally came on the market, Lauder's dopamine system had been in high gear for years. He desperately wanted the painting. Ultimately, he bought it because he got so much pleasure from it, and from what it represented to him, that he had become addicted to it.

JEWS, CHRISTIANS, AND THE EMERGENCE OF MODERNISM IN PERSPECTIVE

Although Vienna 1900 was a remarkable city at a remarkable time, Vienna had already been at the center of Western musical culture for over a century. The city had been home to Haydn, Mozart, Beethoven, Schubert, Brahms, and Mahler, followed by Schoenberg, Berg, and Webern. This great musical tradition was supported both by the court and by the middle class. Not until 1870 and subsequent years did Vienna begin to excel, for the first time, in medicine, psychology, philosophy, economics, and art. The Jewish writer Stefan Zweig described Vienna before World War I in the following terms:

> There is hardly a city in Europe where the drive towards cultural ideals was as passionate as it was in Vienna. Precisely because the monarchy, because Austria itself, for centuries had been neither politically ambitious nor particularly successful in military actions, the native pride had turned more strongly towards a desire for artistic supremacy. . . . Here rode the Nibelungs, here the immortal Pleiades of music shone out over the world, Gluck, Haydn, Mozart, Beethoven, Schubert, Brahms, and Johann Strauss, here all the streams of European culture converged. . . . Hospitable and endowed with a particular talent for receptivity, the city drew the most diverse forces to it, loosened, propitiated, and pacified

them. It was sweet to live here, in this atmosphere of spiritual concilia-
tion, and subconsciously every citizen became supernational, cosmopoli-
tan, a citizen of the world. (1943)

The Jews who came to Vienna in the years after Franz Josef's reforms
were hungry for culture and scholarship, and they found in the city a new
Jerusalem. Throughout its long history, Judaism's interest in scholarship
has been characterized by three features. The first is historical storytelling.
From their origins in about 1900 B.C., Jews have emphasized the historical
sweep of their religion in the five books of Moses, the Prophets, and the
Talmud. The second feature is universal literacy. Following the destruction
of the Second Temple in Jerusalem by the Romans in 70 A.D., the Jews
could no longer communicate with God through their priests; they had to
communicate with God directly. To do this, each Jew had to learn to read
the Bible, the Talmud, and the commentaries. At a time when the Greeks
and Romans were only educating their elite, every Jew, irrespective of social
class, had to become literate. The Jews thus became the People of the Book,
and study became, for them, the highest form of worship. The third feature
is learning to think critically about different perspectives on the same issue.
This ability derives from the study of the various commentaries on the holy
texts, commentaries that argue about the meaning of specific statements.
This was, in a sense, the Jews' first encounter with the beholder's share,
which would later encourage Jewish art historians to study ambiguity in art.

The destruction of the Second Temple also caused the dispersion of
the Jewish people, known as the Diaspora. As Jews left the Holy Land and
spread through the Middle East and Europe, they interacted with Mus-
lim and Christian inhabitants. From the eighth to the twelfth century
they found nirvana in Muslim Spain. The Muslims encouraged the Jews
to live an independent life, and this led to a creative interaction between
Jews and Muslims, scholars and scientists. The Jews translated Arabic texts
into Hebrew and Hebrew texts into Arabic, encouraging communication
between themselves and other peoples. They began to make important con-
tributions to botany, medicine, and mathematics.

The closest thing to that wonderful burst of creativity and its contribution to a communal culture in Muslim Spain was Vienna 1900. As we have seen, dozens of Jews—among them Theodor Herzl, Josef Breuer, Sigmund Freud, Arthur Schnitzler, Berta and Emil Zuckerkandl, Hugo von Hofmannsthal, Ludwig Wittgenstein, Karl Kraus, Gustav Mahler, and Arnold Schoenberg—owed their considerable creativity in part to their interactions with non-Jewish Austrians. Hans Tietze, the great Viennese Jewish art historian, wrote that "without the Jews, Vienna would not be what it is, and the Jews without Vienna would lose the brightest era of their existence during recent centuries" (1933).

"DER LANGE SCHATTEN" IN PERSPECTIVE

Anti-Semitism is universal, but it is often countered by people who speak out in opposition to it. Thus, while France had the Dreyfus Affair, it also had Emile Zola and many other people who supported Dreyfus. Similarly, during the liberal era that characterized Franz Josef's reign, Austria had the emperor and Rokitansky. In later years, however—during the Chancellor Dollfuss (1932–34), Chancellor Schuschnigg (1934–38), and Hitler periods—few eminent Austrians spoke up for the Jews. In fact, following Hitler's annexation of Austria, a particularly virulent form of anti-Semitism erupted in Austria. According to the historical record, nearly half the crimes committed during the Holocaust were committed by Austrians, even though the Austrian population made up only 8 percent of Hitler's Greater Germany.

After the war, Austria devoted enormous energies to hiding its crimes. While Germany proved admirably transparent about its past, Austria was not. Thomas Bernhard and a few writers and artists did speak out immediately after the war, but very few others did. As a result, anti-Semitism continued in Austria after World War II and is still present today, although thankfully in attenuated form. Only in 1991, a full forty-six years after the end of World War II, did Chancellor Franz Vranitzky make the first explicit statement acknowledging that Austria participated in the Holocaust.

Even Bruno Kreisky, the only chancellor of Jewish origin that Austria has ever had, did not address anti-Semitism. I found this difficult to understand until Andreas Stadler, the head of the Austrian Cultural Forum in New York, defined Kreisky for me in terms of Robert Musil's central character, Ulrich, in his classic novel *A Man Without Quality*. Kreisky, Stadler argued, was the opposite of Ulrich: he was a man of qualities. He had many good qualities.

Largely because of Kreisky, who served as foreign minister from 1959 to 1966, before his tenure as chancellor from 1970 to 1983, Austria began to regain confidence in itself as an independent nation. Kreisky was the first socialist chancellor in the history of Austria. He stabilized the country's economy and moved it in the direction of prosperity. He established a distinctive, independent, and strong foreign policy. Thanks to Kreisky, Austria was, for the first time since 1914, economically secure, politically stable, and influential in the affairs of central Europe. Also for the first time since 1914, Austria had gained the eyes and ears of the world. Kreisky created a powerful social democratic state with a solid base of health care and other benefits for its population. In recognition of Austria's growing importance on the international scene, the United Nations in 1979 established a third headquarters, in Vienna.

By the time Kreisky left office, Austria was a modern state: open to the world, socially concerned, economically well off, and pluralistic. It was a different country by far than it was in 1970, when he took on the chancellorship. This was and is an extraordinary accomplishment, and Kreisky has justifiably been recognized as Austria's most important chancellor in the postwar era.

In this sense, Kreisky is an extraordinary example of a productive interaction between a Jew and his largely Christian countrymen. But Kreisky also had less exemplary qualities, and occasionally his attitude toward his own Judaism was an example.

As a young leader of the Socialist Party of Austria, Kreisky was convicted of high treason and imprisoned for fifteen months by Engelbert Dollfuss's Austrofascist government, which had outlawed all other political parties. In

September 1938, shortly after Hitler annexed Austria, Kreisky escaped to Sweden, where he spent World War II safe from the anti-Semitic onslaught raging in Austria. He undoubtedly suffered in prison as a socialist; however, to declare, as Kreisky did after the war in a dispute with Simon Wiesenthal, that he found it more difficult to be a socialist in Austria than to be a Jew is simply astounding. The open fact is that six million people were killed, with Austrian help, in the Holocaust—the vast majority not because they were socialists, but because they were Jews.

We are fortunate that Kreisky had in his cabinet Heinz Fischer, our present-day Zola and Rokitansky. To my mind, Austria's *Bundespräsident*, who has consistently fought against the neo-Nazis since the 1960s, has contributed as much to Austria's acceptance of minorities and repudiation of anti-Semitism as Kreisky contributed to its national identity. Moreover, Fischer's leadership and openness created an atmosphere that encouraged other people to speak out. Perhaps foremost among them is Ernst Kirschweges, who demonstrated against the neo-Nazis with Fischer in 1965, took a strong stand against anti-Semitic comments made by one of the neo-Nazis, and was subsequently killed by them. Kirschweges is a true hero, as are the three thousand people who demonstrated in January 2013 against the neo-Nazi ball at the Hofburg.

Many other people in Austria today do not countenance intolerance. Among the people whom I have had the privilege to know, I have been inspired by Barbara Prammer, the leader of Parliament; Werner Faymann, the chancellor of Austria; Michael Häupl, the mayor of Vienna; Anton Zeilinger, Austria's leading physicist; Erwin Razinger, a physician and member of parliament; and my friends Andreas Stadler, director of the Austrian Cultural Forum in New York, and Peter Brozowski, the Austrian consul general in New York.

I am delighted not only that Austria has finally achieved the status of a great liberal democratic country but also that, inspired by Fischer, Häupl, Prammer, and Faymann, it is rectifying what for me has been a painful and entrenched shortcoming: its inability to recognize the enormous

contribution that Jewish citizens have made to its economy, to its academic life, and to its creativity. George Berkley, the historian of Jewish life in Vienna, wrote that "the fierce attachment of so many Jews to a city that throughout the years demonstrated its deep-rooted hate for them remains one of the greatest ironies of them all."

I have a dream that one of these days young Jews will again flock to Vienna because life there is so pleasant and so welcoming of all people. Perhaps they would create a new age in Vienna that recapitulates Vienna 1900, in which Jews and non-Jews together bring science and culture to still another great creative flowering.

The recent renaming of the Ringstraße, from Karl Lueger Ring to University Ring, is a turning point in Der Lange Schatten des Antisemitismus at the University of Vienna. It is certainly a key point in my personal history and my gradual reconciliation with Austria. I am therefore particularly grateful to Andreas Mailath-Pokorny, to Andreas Stadler, to Anton Zeilinger, and to the many other young people who have worked to produce this change—a change that Austria will continue, I hope!

ACKNOWLEDGMENTS

This essay originally appeared as "The Productive Interactions of Christians and Jews That Led to the Creation of Modernism in Vienna 1900," in Oliver Rathkolb, *Der Lange Schatten des Antisemitismus*, ed. Oliver Rathkolb (Leiden: V&R Unipress, 2013). I presented the essay at the symposium "The Long Shadow of Anti-Semitism at the University of Vienna Dating Back to 1870," held at the University of Vienna.

I am gratefully indebted to Blair Potter, whose superb editing guided my writing of *The Age of Insight* and who brought her wonderful insights to bear on this essay. I have also benefited from the excellent and extensive comments of Felicitas Seebacher. Finally, I owe a great debt to my colleague Chris Willcox who helped me put the art program for this essay together.

NOTES AND SOURCES

The discussion of art and science that makes up the majority of this essay derives from and is based on my book *The Age of Insight: The Quest to Understand the Unconscious in Art, Mind, and Brain, From Vienna 1900 to the Present* (New York: Random House, 2012), particularly chapters 2, 3, 6, 7, 8, 11, 12, 13, 15, 25, and the references therein.

My discussion of Jews in Muslim Spain is based on:

Menocal, Maria Rosa. 2002. *The Ornament of the World: How Muslims, Jews and Christians Created a Culture of Tolerance in Medieval Spain.* New York: Little, Brown.

My discussion of Jews in Vienna, including Jewish painters, is based on:

Beller, Steven. 1995. *Vienna and the Jews 1867–1938: A Cultural History.* New York: Cambridge University Press.
Breincha, Otto. 1993. *Gerstl und Schönberg: Eine Beziehung.* Salzberg: Galerie Welz.
Howarth, Herbert. 1950. "Jewish Art and the Fear of the Image: The Escape from an Age-Old Inhibition." *Commentary.*
Johnson, Julie M. 2012. *The Memory Factory: The Forgotten Women Artist of Vienna 1900.* West Lafayette, IN: Purdue University Press.
McCagg Jr., William O. 1992. *A History of Habsburg Jews 1670–1918.* Bloomington: Indiana University Press.
Meyers, Christian, and Therese Muzender, eds. 2005. *Arnold Schönberg: Catalogue Raisonné.* London: Thames and Hudson.
Zweig, Stefan. 1943. *The World of Yesterday: An Autobiography by Stefan Zweig.* Lincoln: University of Nebraska Press.

My discussion of Rokitansky and Billroth is based on detailed comments from Felicitas Seebacher, the major scholar in this area, as well as from her book:

Seebacher, Felicitas. 2011. *Das Fremde im 'deutschen' Tempel der Wissenschaft Verlag der 'Österreichische Akademie der Wissenschaften.'* Vienna: Veröffentlichungen der Kommission für Geschichte der Naturwissenschaften, Mathematik und Medizin.

Additional sources are as follows:

Billroth, Theodor. 1875. *Über des Lehren Und Lernen De Medicinischen Wissenschaften an Den Universitäten Der Deutschen Nation Nebst Allgemeinen Bemerkungen Über Universitäten: Eine Culturhistorische Studie.* Vienna: Druck und Verlag von Carl Gerold's Sohn.

Freud, Sigmund. 1989 [1905]. "Fragment of an Analysis of a Case of Hysteria." *The Standard Edition of the Complete Psychological Works of Sigmund Freud, Volume VII (1901–1905): A Case of Hysteria, Three Essays on Sexuality and Other Works,* 1–122. New York: Norton.

Goldman, Alvin I. 2012. "Theory of Mind." In *Oxford Handbook of Philosophy and Cognitive Science,* ed. Eric Margolis, Richard Samuels, and Stephen Stich, 402–24. Oxford: Oxford University Press.

Gombrich, Ernst. 1960. *Art and Illusion: A Study of the Psychology of Pictorial Representation.* London: Phaidon.

Gregory, Richard L. 2009. *Seeing through Illusions.* New York: Oxford University Press.

Rokitansky, Carl von. 1862. "Freiheit der Naturforschung." Speech presented at Feierliche Eröffnung des pathologisch-anatomischen Instituts im k. k. allg. Krankenhaus, Vienna, May 24.

Rumpler, Helmut, Helmut Puzzle, and Christine Ottner, eds. 2005. *Carl Freiherr von Rokitansky (1804–1878): Pathologe—Politiker—Philosoph; Gründer der Wiener Medizinischen Schule des 19. Jahrhunderts; Gedenkschrift zum 200. Geburtstag.* Vienna, Cologne, and Weimar: Bohlau.

Saxe, R., and N. Kanwisher. 2003. "People Thinking about Thinking People: The Role of the Temporo-Parietal Junction in 'Theory of mind.'" *NeuroImage* 19, no. 4: 1835–42.

Schnitzler, Arthur. 1924. *Fräulein Else. Novelle.* Vienna and Leipzig: Paul Zsolnay.

Tietze, Hans. 1933. *Die Juden Wiens: Geschichte – Wirtschaft – Kultur.* Vienna and Leipzig: E. P. Tal & Co. Verlag.

The Kreisky years are described in:

Fischer, Heinz. 1994. *Die Kreisky Jahre, 1967–1983 (Sozialistische Bibliothek).* Vienna: Löcker Verlag.

CHAPTER 2

EMPATHY AND THE UNCERTAINTIES
OF BEING IN THE PAINTINGS
OF CHAIM SOUTINE

—

A Beholder's Perspective

To fully appreciate a body of work by a particular artist, it is useful to know something about the artist, the culture from which he derived, the other artists he learned from and those he interacted with, the variety of art he produced, and how beholders respond to that art. Understanding the social context from which Soutine emerged not only enriches further our understanding and enjoyment of his art, it helps inform our reactions to his paintings.

THE JEWISH ATTITUDE TOWARD THE MAKING OF IMAGES
AND THE PALE OF SETTLEMENT

Historically, the Jewish people were discouraged from creating visual images by the second commandment: "Thou shalt not make unto thee any graven image, or any likeness of any thing that is in heaven above, or that is in the earth beneath, or that is in the water under the earth." This prohibition, designed to prevent the worship of idols, was generally interpreted liberally, for Jews have created images throughout their history.[1] Nevertheless, Jewish art seems not to have become prevalent until after the Second Exodus from the Holy Land, in A.D. 70, when the Romans, under Titus, destroyed the

Second Temple and decimated the city of Jerusalem—almost five hundred years to the day after the Babylonians had destroyed the First Temple—and the Jews dispersed to other lands.[2] Although there continued to be a Jewish presence in the ancient land of Israel, historians believe that the main reason the Jews survived annihilation is that they scattered into areas of the Roman and Persian empires and later into parts of Europe, settling in a network of communities known since as the Diaspora, or dispersion.

Early examples of Jewish art in the Diaspora appear on sarcophagi in Roman catacombs of the second century A.D., some of which are decorated with a menorah or even an image of the deceased. The most impressive examples of Jewish art in the Diaspora are twenty-eight frescoes depicting fifty-eight biblical scenes in a third-century-A.D. synagogue in Dura-Europos, Syria, on the eastern border of the Roman Empire. Later, in the Middle Ages, Jews produced illuminated manuscripts, especially Haggadahs, with human and animal images.[3]

Some of the Jews who left the Holy Land settled in northeastern Europe and became a distinct cultural group, the Ashkenazim. They initially lived along the Rhine River in what is now Germany, but during the first century A.D. the Ashkenazi people and their culture spread from the banks of the Rhine to France, and from there east to Poland, Lithuania, and Russia.

Czarist Russia treated its Jewish population with utter contempt. Subject to arbitrary laws that deprived them not only of their right to own property but their own identity as well, Jews were restricted to certain areas on the fringes of the country. One of these was the Pale of Settlement, a ghetto that contained about five million Ashkenazi Jews—almost half the total population of Ashkenazim—located in a region that included parts of present-day Lithuania, Poland, and Ukraine. Although living conditions in the Pale were often brutal and oppressive, there nevertheless grew up among the residents a common culture with a common language, Yiddish. The Jews of the Pale took their common culture and language with them to other parts of the world.

Many Jews of the Pale were influenced by the Hasidic ("pious") movement, which was led in the eighteenth century by the influential Ukrainian

Rabbi Israel ben Eliezer, also known as the Ba'al Shem Tov, or Master of the Good Name. The Ba'al Shem Tov was a Kabbalist, and his mystical teachings stressed the presence of miracles, divine intervention, and the belief that God is in everything and that it is God who created delight and joy.[4] Hasidic folktales emphasized the mystical and historical tendencies in Jewish thought, and their intuitive approach to life was often accompanied by a suspicion of "book learning." During the eighteenth century an opposition group, the Misnagdim (opponents), arose in reaction to the Hasidic movement. Headed by Rabbi Elijah ben Solomon, the Ga'on of Vilna, the Misnagdim emphasized scholarship and opposed the mysticism of the Hasidic Jews.[5] Nonetheless, according to Jonathan Wilson, the Hasidic community continued to tell tales into the 1950s of objects thought to be miraculous, such as amulets, magic candlesticks, and levitating rabbis.[6]

JEWISH PAINTERS IN THE NINETEENTH CENTURY AND THE ÉCOLE DE PARIS

Despite the trickle of images created throughout the Diaspora, no major Jewish painter emerged until the nineteenth century, when some European countries that had oppressed and exploited Jews began to relax certain restrictions, such as bans on travel. With their newfound mobility, Jews could work in different fields, including those that had formerly been closed to them, leading to the emergence of a significant number of Jewish painters, some of whom began to achieve recognition by the century's end. The German painter Moritz Oppenheim (1800–1882) is generally considered to be the first modern Jewish painter. He was followed by the Dutch artist Jozef Israëls (1824–1911), the French Impressionist–Post-Impressionist Jacob Abraham Camille Pissarro (1830–1903), and the German painter Max Liebermann (1847–1935), all of whom worked independently of one another.

It was not until the beginning of the twentieth century, however, between about 1910 and 1920, that a "school" of Jewish painters emerged, for the most part located in Paris, and many of them Ashkenazi Jews from the Pale

of Settlement. All told some two hundred painters emerged from the Pale—among them Marc Chagall (1887–1985), Chaim Soutine (1893–1943), Michel Kikoine (1892–1968), and Jules Pascin (1885–1930)—and many of them settled in Paris. They were joined there by others, such as Amedeo Modigliani (1884–1920), who came from Italy. On arriving in Paris many of these Jewish painters settled in Montmartre and Montparnasse, where they interacted with and influenced one another. There soon emerged the École de Paris, a major school made up of Jewish artists who lived and worked in Paris but were not French and thus either could not or preferred not to be included in the broader category of the École Française.

Several defining characteristics evolved in the École de Paris. Most important was a focus on figurative art, particularly on the face, and a tendency toward a sympathetic and empathic figuration, leading art critic Waldemar-George (Jerzy Waldemar Jarocinski), who lived in Paris at the time, to refer to their art as the New Humanism. This art had much in common with Expressionism, which was indigenous to Austria and Germany but not to France.

The focus on figurative portraiture within the École de Paris derived from another shared characteristic of the group: although they were influenced by the advances in painting that emerged between 1905 and 1912, they did not embrace them. They did not become Fauvists, for example, who emphasized bold color, or Cubists, who investigated multiple perspective. That is not to say, however, that the humanist qualities of the École de Paris led to a uniformity among the artists, whose works often took very different forms, perhaps best seen in the radically different oeuvres of Chagall and Soutine.

CHAGALL AND SOUTINE: CONTRASTING VISIONS IN HUMANISTIC EXPRESSIONISM

Of all of the painters to emerge from the École de Paris, Chagall was arguably the most typically Jewish,[7] capturing in his works the joyous, populist,

and magical spirit of Hasidic Judaism and Hasidic folklore. Much of Chagall's creative output has been described as one long reverie on the romantic and mystical life in his native village of Vitebsk, in present-day Belarus (fig. 2.1).

Among the miraculous events described in Hasidic folktales are flying animals, which appear frequently in Chagall's paintings,[8] as do images of the artist himself taking flight (fig. 2.2). Indeed, a word often used to describe Chagall is *Luftmensch*, meaning a man who walks on air or whose mind is devoted to otherworldly pursuits.

Soutine, in contrast, addressed the existential anxiety of everyday life, a view more characteristic of the rationalist approach of the Misnagdim than the Hasidim. Born in the small village (or shtetl) of Smilovitchi, now part of Belarus, Soutine, like Chagall, was from a Hasidic family, and they

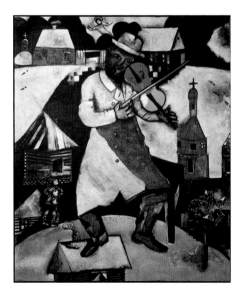

2.1 Marc Chagall, *The Violinist (Fiddler)* (1912–13).
Oil on linen, 74 × 62 inches / 188 × 158 cm.

Stedelijk Museum, Amsterdam. Art Resource, NY © ARS, NY

2.2 Marc Chagall, *Over the Town* (1914–18).
Oil on canvas, 60 1/4 × 82 1/4 inches / 153 cm × 209 cm.

From the collection of the Tretyakov Gallery, Moscow, Russia. HIP / Art Resource, NY © ARS, NY

both lived in a part of the world deeply influenced by the teachings of the Ba'al Shem Tov. The villagers of Smilovitchi had quite different beliefs, however, from those of the people of Vitebsk, where Chagall was raised, including different teachings from the Kabbalah. In his memoir *Journey to a Nineteenth-Century Shtetl*, Yekhezkel Kotik (1847–1921), who lived in Kamenets, a village next to Smilovitchi, describes some of those beliefs.[9] For example, when the body of someone who has recently died is lowered into the grave, the Angel Dumah, the caretaker of souls (also called the Angel of Silence), appears and asks the soul as it leaves the dead body, "What is your [Hebrew] name?" The shock of death causes amnesia in the soul, and the person remembering one's name facilitates the withdrawal of the soul from the body. Once the separation is complete, the soul continues to exist. If, however, the dead person cannot remember his or her name, the Angel Dumah takes this as evidence that the deceased person was wicked and that the soul has lost its identity. Dumah proceeds to cut

open the dead person's body, pull out the intestines, and fling them in the dead person's face. He then hits the corpse with a hot iron rod and tears it to pieces.

"In a town like ours," Kotik writes, "it was a sacred duty to accompany a deceased person to his grave; the entire population turned out for the funeral. . . . I still remember vividly the bone-piercing terror. Everyone was scared to death of the evil spirits hovering about the corpse. Everyone thought of the terrible predicament the deceased person was in, and everyone knew that his own end would not be any different."[10] Soutine apparently was immersed in these death rituals, and by some accounts even participated in mock funerals with other children in the village, although we cannot be certain of this because Soutine never wrote about himself. What little we know about Soutine's early years has been gleaned from a series of anecdotes passed along by his friends and colleagues. In Chagall's case, the details of his life are well known from his own extensive writings and those of his children and grandchildren.

Soutine was the tenth of eleven children of a poor mender of clothes, a professional notch below that of a tailor. He later recalled his delight as a child at seeing the various colors resulting from the sunlight on the wall of his bedroom. Soutine started to draw early, but his parents discouraged him and his brothers reprimanded him, at times physically, telling him that a Jew should not draw. Undeterred, Soutine continued his artistic activities and, according to an often-repeated story, even drew a portrait of the rabbi of Smilovitchi.[11] The rabbi's son, who according to one story was a butcher, beat Soutine for violating the second commandment and according to some reports stabbed him in the thigh.[12] Soutine's injuries required two weeks of recuperation, prompting his furious mother, an otherwise modest woman, to threaten to bring the rabbi's son to trial. She settled instead for compensation of twenty-five rubles, money that Soutine used to leave Smilovitchi, at the age of sixteen, to study art.

Soutine went first to Minsk and then to Vilna, where he enrolled in the School of Fine Arts before moving on to Paris in 1913. He trained at the École des Beaux-Arts with Fernand Cormon (1845–1924), in whose

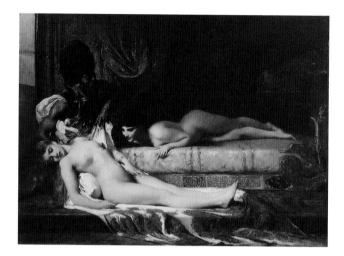

2.3 Fernand Cormon, *Murder in the Serail* (1874).
Oil on canvas, 63 × 86 5/8 inches / 160 × 220 cm.

Musée des Beaux-Arts de Besançon

atelier Van Gogh had studied and who specialized in scenes of the macabre (fig. 2.3). In 1916, Soutine settled in Montparnasse and began to produce some of the most agitated Expressionist canvases of the twentieth century: portraits of figures tormented by nervous agitation, anthropomorphic still lifes, and cataclysmic landscapes. The paintings from this period in Soutine's development appear decidedly unplanned, as if they just "happened." As Andrew Forge writes, "Once in Paris, the interesting thing is that [Soutine] does not appear to have hesitated for a moment. . . . The most characteristic feature of his vision had already declared itself. The lively, almost anthropomorphic, drawing of the fork in his still lifes seems to endow it with an energetic and slightly sinister personality of its own" (fig. 2.4).[13] "This is striking," Forge continues, "when one considers the multiplicity of directions in which painting was thrusting—the very painters with whom he was mixing—and the inevitable difficulties and anxieties that must have crowded in on him at the time. But he doesn't seem to have experimented

2.4 Chaim Soutine, *Still Life with Lemons* (c. 1916).
Oil on Canvas, 25 3/4 × 21 1/4 inches / 63 × 54 cm.

or to have faltered in his stance."[14] Soutine instead emerged as one of the most distinctive and original painters of his era, one whose extreme pictures pushed the subjectivity of painting to an unprecedented point.

From the beginning Soutine distorted reality to an unusual degree, expressing uncertainty in his landscapes and torment in his portraits. In his foundational *History of Art*, H. W. Janson writes, "For his power to transmute sheer anguish into visual form Soutine has no equal among twentieth-century artists."[15] Unlike Chagall, Soutine made few overt references to Jewish life in his paintings. Moreover, he depicted none of the mysticism and magic of Jewish thought, as Chagall did. Instead, Soutine approached his art from the opposite end of the Jewish ideological spectrum, concerning himself with the underlying uncertainty and existential anxiety that characterized Jewish existence in Europe and that were

particularly evident at the beginning of the twentieth century. Thus, in contrast to Chagall's romantic fantasies of life, love, and marriage in the shtetl, Soutine dwelled on the tragic, lonely, and melancholy anxiety of the Jewish experience in the Diaspora.[16]

The nature of this anxiety-laden existence is captured in Yiddish, the language of the Ashkenazi Jews. A polyglot tongue of the Diaspora with roots in Hebrew and medieval German, Yiddish developed during a time of great deprivation. Abraham Joshua Heschel, a leading twentieth-century Jewish theologian, wrote of Yiddish in the following terms:

> The East European Jews created their own language, Yiddish, which was born out of a will to make intelligible, to explain and simplify the tremendous complexities of the sacred literature. Thus there arose, as though spontaneously, a mother tongue, a direct expression of feeling, a mode of speech without ceremony or artifice, a language that speaks itself without taking devious paths, a tongue that has a maternal intimacy and warmth. In this language, you say "beauty" and mean "spirituality"; you say "kindness" and mean "holiness." Few languages can be spoken so simply and so directly; there are but few languages which lend themselves with such difficulty to falseness. No wonder that Rabbi Nahman of Bratslav would sometimes choose Yiddish to pour out his heart and present his yearnings to God. The Jews have spoken many languages since they went into exile; this was the only one they called "Jewish."

But because Yiddish developed among a people constantly struggling to survive, often under perilous conditions, it is also a language that accommodates the free and full expression of complaint, or kvetch. As Heschel says, speaking of the Ashkenazi Jews' response to deprivations, "Sorrow was their second soul and the vocabulary of their heart consisted of one sound—Oy!" A mixture of joy, sadness, and enthusiasm, it is a cry that emanates from all of Soutine's paintings, a flow of passion that calls to mind the outpouring of feelings characteristic of much Yiddish literature.[17]

SOUTINE'S CARCASS PAINTINGS

In the early part of his career, Soutine painted haunting studies of melting flesh and rotting animal carcasses. These paintings express both personal anguish and Jewish cultural anxiety and, by extension, the meaninglessness of human existence. Why Soutine focused on dead animals is difficult to know with any degree of certainty, but we have an abundance of clues. To begin with, the villagers in Soutine's hometown of Smilovitchi were obsessed with death and dying. Then there was Soutine's experience of being beaten up and perhaps stabbed by the rabbi's son, who may have been a butcher. Soutine's mentor, Fernand Cormon, was fascinated with the macabre. Soutine himself, often malnourished, suffered from chronic gastrointestinal problems all his life and ultimately died from them.

In addition to the hints from Soutine's biography, we also have art-historical evidence. Soutine, for example, is known to have admired Rembrandt's paintings of carcasses, and he was not alone among the artists of the École de Paris. Chagall, Modigliani, and Kikoine, in their studies of portraiture, likewise admired Rembrandt, not only as a great portraitist—courageous enough to paint a series of unflinching self-portraits from youth well into old age—but also an artist who portrayed Jewish sitters and found inspiration in Jewish subjects. Rembrandt and other seventeenth-century Dutch painters, in fact, depicted a basically sympathetic interaction with Jewish culture. Indeed, Dutch society in general appreciated the Jews, and rather than demonize them, as the Spanish did, the Dutch viewed them as interesting and worthwhile outsiders.[18]

Soutine, however, had a greater personal affinity for Rembrandt than did the other members of the École de Paris. His *Flayed Beef*, for example, was clearly painted as a tribute to Rembrandt's *The Slaughtered Ox* (fig. 2.5), which Soutine would have seen in the Louvre. In Rembrandt's canvas the animal's head and hide have been removed and its chest braced open to allow air into the cavity to cure the meat. The carcass is carefully splayed out and hung up, as if being crucified.[19] In *Flayed Beef* (fig. 2.6), Soutine goes beyond Rembrandt, depicting an even more turbulent

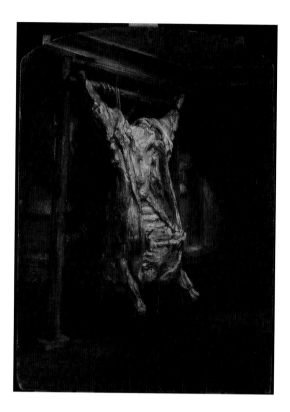

2.5 Rembrandt Van Rijn, *The Slaughtered Ox* (1655).
Oil on wood, 37 × 17 1/8 inches / 94 × 69 cm.

Musée du Louvre, Paris

martyrdom. Whereas in Rembrandt's painting we see the ox's body from the side, in *Flayed Beef* we confront the splayed carcass straight on and, unlike Rembrandt's ox, Soutine's is bloody. To make the painting, Soutine actually installed an immense carcass in his studio and kept the colors and texture fresh looking by periodically pouring blood over it. Thus, in contrast to Rembrandt's *The Slaughtered Ox*, which looks static—more like steak at the butcher's shop—Soutine's carcass is undergoing a dolorous death in front of our eyes.

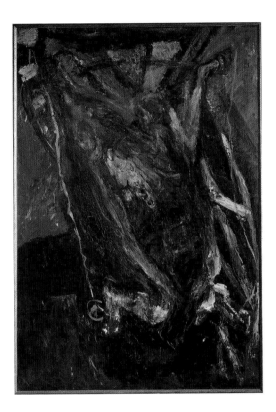

2.6 Chaim Soutine, *Flayed Beef* (c. 1924).
Oil on canvas, 50 3/4 × 29 3/8 inches / 128.9 × 74.6 cm.

Private collection. © Artists Rights Society (ARS), New York / ADAGP, Paris

All of Soutine's paintings were based on close observation of nature, but they were nonetheless painted in an unstudied manner. Without drawing anything first, Soutine squirted paint from the tube directly onto the canvas and then worked the paint into an explosion of red and gold color, thus trapping, as Michael Rogan has described it, "the teeming matter of fleeting life." This technique confronts us with the terror of the ox being utterly exposed, on the one hand, and the mystery of life and death, on the other. The painting is all the more powerful because Soutine's thick

paint appears to be mixed with blood and mud.[20] Whereas Rembrandt made only two paintings of sides of beef; Soutine produced an entire series of flayed oxen between 1920 and 1925. In addition, he explored a variety of other animal carcasses: a hanging rabbit that also looks like a crucified human being (fig. 2.7), a skate with dangling entrails, and birds suspended in the air.

If Soutine's focus on death and dying seems almost overdetermined in a psychoanalytic sense, there were many converging reasons behind it. The French art historian Élie Faure, a friend of Soutine's, has argued that the artist's preoccupation with depicting decaying animal flesh conveys a tragic sense of martyrdom, a melancholy vision of life and of the

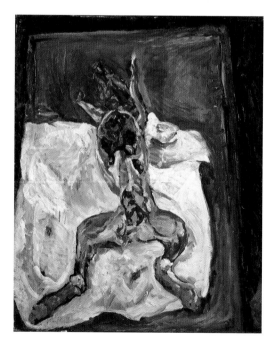

2.7 Chaim Soutine, *Flayed Rabbit* (c. 1921).
Oil on canvas, 29 3/4 × 23 5/8 inches / 75.6 × 60 cm.

The Barnes Foundation. © Artists Rights Society (ARS), New York / ADAGP, Paris

inexorable process of death and decay. Or as Janson points out in discussing the painting *Dead Fowl*, the bird becomes a terrifying symbol of death.[21] In looking at its plucked, creamy white body, we suddenly realize with horror how closely it resembles the human shape, just as we realized with horror that Soutine's and Rembrandt's flayed oxen and Soutine's rabbit resemble Christ on the cross.

When confronted with so many bloody carcasses, one cannot help but contemplate the influence on Soutine of the turbulent times in which he lived. During the First World War he saw members of his generation fight and die in what proved to be the greatest loss of human life in history, with some 37.5 million casualties. And as early as the 1920s and 1930s, he may already have had premonitions of how life in general, but Jewish life in particular, would be threatened with the loss of all meaning amid a totalitarian world in which dictators such as Mussolini, Hitler, Stalin, and Franco were beginning to assume center stage. Forced to flee Paris in 1940 when the Nazis invaded, Soutine lived for several years in French villages. During this time his ulcers became aggravated, and in 1943 he returned to Paris for an emergency operation. He died there that year, of a perforated ulcer, at age fifty.

Interestingly, Chagall, whose temperament, as noted above, could not have been more different from Soutine's, drew somewhat closer to Soutine's perspective in response to the Holocaust. In 1908, Chagall, at an early point in his career—before Soutine was on the scene—had made an ink drawing of the crucifixion. He returned to this subject twice in 1912: once in *Calvary*, where he depicts Christ's image in prism-like facets, reminiscent of his Cubist contemporaries, and again in *Golgotha* (both now at the Museum of Modern Art, New York). These images reflect Chagall's interest in Catholic iconography, which dated to his school days in Vitebsk (his mother sent him to a public high school, where he had Catholic classmates and was exposed to the Catholic religion). In response to Kristallnacht—the evening of November 9, 1938, when coordinated Nazi attacks on Jews began—Chagall painted *White Crucifixion* (fig. 2.8). As in his earlier paintings on the subject, Chagall portrayed Jesus as a Jew, with his loins covered

2.8 Marc Chagall, *White Crucifixion* (1938).
Oil on canvas, 60 7/8 × 55 1/16 inches / 154.6 × 140 cm.

Gift of Alfred S. Alschuler, The Art Institute of Chicago. © Artists Rights Society (ARS),
New York / ADAGP, Paris

by a *tallit*, or Jewish prayer shawl. He also surrounded him with symbols of the persecution of the Jews throughout history, so as to recognize and honor not only Jews but also all peoples who suffered under the Nazis. According to Susan Tumarkin Goodman, Chagall "believed that no other image was powerful enough to convey his profound distress at the annihilation of European Jewry."[22] Chagall intended his crucifixion to touch Christians, Goodman adds, by equating the plight of the Jewish people with the martyrdom of Jesus. Chagall painted several crucifixions between 1938 and 1947, and he also painted *The Flayed Ox* (fig. 2.9), a canvas clearly influenced not only by Rembrandt but also by Soutine.

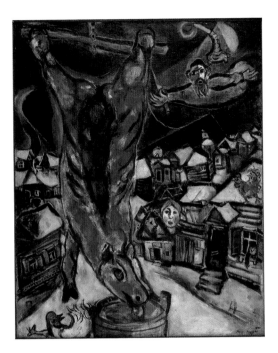

2.9 MARC CHAGALL, *The Flayed Ox* (1947).
Oil on canvas, 39 3/8 × 31 7/8 inches / 100 × 81 cm.

SOUTINE'S PORTRAITS

Like other Expressionists, Soutine used distortion to convey insights into his subjects' psyche, albeit to a more disturbing degree. His portraits recruit not only our visual brain but also, as we shall see, our emotional brain, particularly the amygdala, an area deep in the brain that orchestrates our emotions, including fear and anxiety. A case in point is Soutine's 1928 portrait of Madeleine Castaing (fig. 2.10). Madeleine and her husband, Marcellin, were two of Soutine's greatest patrons, and she in particular provided critical intellectual support of Soutine's art and that of the whole École de Paris.

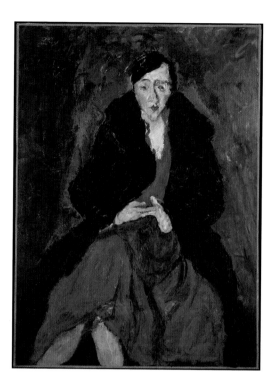

2.10 Chaim Soutine, *Madeleine Castaing* (1929).
Oil on canvas, 39 3/8 × 28 7/8 inches / 100 × 73.3 cm.

Metropolitan Museum of Art, New York, Bequest of Miss Adelaide Milton de Groot (1876–1967), 1967.
© Artists Rights Society (ARS), New York / ADAGP, Paris

Soutine captured Madeleine's wealth, sophistication, and elegance, most notably in her headdress and dark fur coat, but he also laid bare her vulnerability, through her distorted face, and her nervousness, evident in her hand movements. Indeed, part of the undeniable beauty of this mysterious portrait lies in this distortion, which conveys at once the limberness of her hands and the nimbleness of her mind.

Here we see a characteristic feature of Soutine's portraits, namely, a consistently asymmetrical depiction of the human face. This is particularly

interesting in light of psychologist David Perrett's research, which has shown that both women and men across cultures actually prefer symmetrical faces. Perrett suggests that symmetry reflects, for many people, a healthy genetic contribution and good reproductive capabilities.[23] Soutine tried to tap into such primitive emotions in order to evoke a desired response from the viewer. He seems to have understood implicitly that many forms of art are successful because they involve deliberate overstatement, exaggeration, and distortion designed to pique our curiosity and produce a satisfying emotional response in our brains.

To be effective, however, such deviations from realistic depiction cannot be arbitrary. They must succeed in capturing the innate brain mechanisms for emotional release, once again reminding us of the discovery by behavioral psychologists and ethologists of the importance of exaggeration. That discovery became the basis for the exploration of a simple sign stimulus that is capable of releasing a full-blown behavior and whose exaggeration produces an even stronger behavior. Cognitive psychologist Vilayanur Ramachandran refers to these exaggerated sign stimuli as the "peak shift principle."[24] According to this idea, the artist tries not only to capture the essence of a person but also to amplify it by appropriate exaggeration, and thus to activate more powerfully the same neural mechanisms that would have been triggered by the person in real life. Ramachandran emphasizes that the artist's ability to abstract the essential features of an image and to discard redundant or insignificant information is similar to what the visual system, and particularly the various areas of the visual pathway concerned with images, has evolved to do. Thus, the artist unconsciously provides an exaggerated sign stimulus by taking the average of all faces, subtracting this average from the face of the sitter, and then amplifying the difference.

The peak shift principle applies to depth and color as well as to form. We certainly see the exaggeration of depth in the lack of perspective in Soutine's paintings and the amplified color in the faces he portrays. Moreover, following the lead of Van Gogh, Soutine revealed his intuitive knowledge of this principle in his overemphasis on the textural attributes

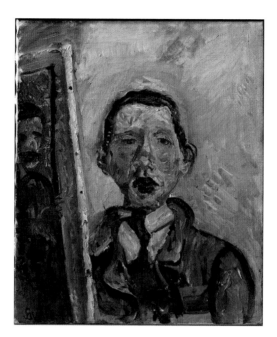

2.11 Chaim Soutine, *Self-Portrait* (c. 1918).
Oil on canvas, 21 1/2 × 18 inches / 54.6 × 45.7 cm.

The Henry and Rose Pearlman Foundation, on long-term loan to the Princeton University Art Museum. ©
Artists Rights Society (ARS), New York / ADAGP, Paris

of the faces he painted.[25] We even see distortions in Soutine's self-portrait
(fig. 2.11), where the colors of parts of his forehead match the background
and he confronts us as if he does not know what to make of the encounter.
This is not a confident artist in the tradition of the Velázquez of *Las Meninas*,
one announcing his central role as a creator of art. This is an insecure man
confronting an uncertain world.

Even greater distortion is evident in Soutine's 1922 *Portrait of a Man*,
a picture of his friend the painter Emile Lejeune (fig. 2.12). Soutine used
these distortions to convey aspects of Lejeune's complex character, as
evident in the differences in his eyebrows, eyes, and nostrils. He is, Soutine

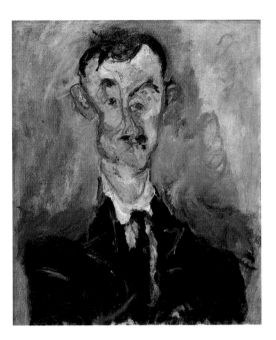

2.12 Chaim Soutine, *Portrait of a Man (Emile Lejeune)* (c. 1922–23).
Oil on canvas, 21 5/8 × 18 5/8 inches / 54.9 × 46.5 cm.

Musée de l'Orangerie, Paris, La Collection Jean Walter et Paul Guillaume.
© Artists Rights Society (ARS), New York / ADAGP, Paris

suggests, a man of many parts. The same is true of *The Pastry Chef (Baker Boy)*, painted in 1919 (fig. 2.13), which was described by Paul Guillaume, Soutine's dealer, as the depiction of "an amazing, fascinating, real truculent pastry cook, afflicted with an ear so huge and superb, and so unexpected and right: a masterpiece. I bought it." The distortions in *The Pastry Chef* convey movement, tension, and animism, an indication of things that have happened and might yet happen. And as Guillaume recorded, *The Pastry Chef* was also the first portrait to bring Soutine recognition: "Dr. [Albert C.] Barnes saw it at my place: 'But it's a peach,' he cried." The spontaneous pleasure that Barnes, one of the most renowned art collectors of the twentieth century,

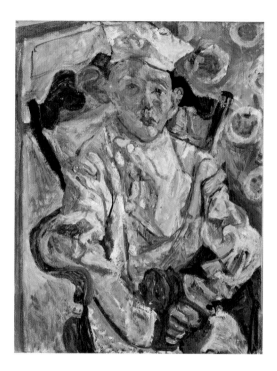

2.13 Chaim Soutine, *The Pastry Chef (Baker Boy)* (c. 1919).
Oil on canvas, 25 7/8 × 19 7/8 inches / 65.7 × 50.5 cm.

The Barnes Foundation. © Artists Rights Society (ARS), New York / ADAGP, Paris

experienced at seeing *The Pastry Chef* forever changed the artist's fortunes. Barnes went on to buy sixty works by Soutine, "turning him overnight into a well known painter, sought after by art lovers."[26]

THE PSYCHOLOGICAL ANALYSIS
OF FACIAL EXPRESSION

Why did Soutine and the other Jewish painters of the École de Paris focus so extensively on portraiture? On faces? Because they, like earlier

artists, realized implicitly that faces are essential for our social interaction. As Charles Darwin pointed out, not only do we recognize each other through our faces, facial expressions are our primary social signaling system, from forming a friendship to finding a partner to making a business arrangement. As social animals, we communicate our ideas and plans, as well as our emotions, to one another in large part through facial expressions. Thus, you can attract another person by smiling seductively or you can repel that person by looking foreboding.

Our brain treats faces differently from all other objects. Computers that can solve complex mathematical and logical problems have great difficulty with face recognition, yet the human brain is extraordinarily good at it. Moreover, we can readily recognize a line drawing of a face; in fact, a slight exaggeration of facial features makes it easier for us to recognize a person. One reason for this is that the human brain processes faces in unusual ways, as we shall see.

In the early 1930s, the Viennese art historian Ernst Kris became interested in the scientific analysis of facial expression. This interest formed the basis of his pioneering attempts to combine art history with psychoanalytic insights. Kris began to study exaggerated facial expressions. He was soon joined by Ernst Gombrich, and together they wrote a book on the psychology and history of caricature, which they saw as a series of experiments in the reading of facial expression.

Artists through the ages have understood the salience of human faces. Kris and Gombrich argued that the artists of the sixteenth century discovered that a caricature of a face—for example, in an exaggerated line drawing—is often easier to recognize than a real face, an insight exploited by the Mannerists, including Michelangelo. In the course of their work, Kris and Gombrich began to view Expressionist painting as a reaction against conventional means of depicting faces and bodies. The new Expressionist style, they argued, derived from the fusion of two traditions: high art, as descended from the Mannerists, and caricature, introduced at the end of the sixteenth century by Agostino Carracci, who used distortion and exaggeration to emphasize a person's identifying features.

In thinking about the history of caricature, Gombrich and Kris, struck by how late it arose, concluded that its appearance coincided with a dramatic change in the artist's role and position in society. By the end of the sixteenth century artists no longer had to be concerned with mastering the techniques required to represent reality. They were no longer technicians; they had become creators, comparable to poets, who could form a reality of their own. This shift culminated in the attempt of Expressionists to make art mirror not simply the object or person being depicted but also the artist's conscious and unconscious mind.

HOW DOES OUR BRAIN PROCESS FACES?

To fully understand this phenomenon, we need to know a little about the structure of the brain. In brief, our brain has four lobes: frontal, parietal, occipital, and temporal (fig. 2.14). The occipital lobe is where visual information first comes into the brain, and the temporal lobe is where facial

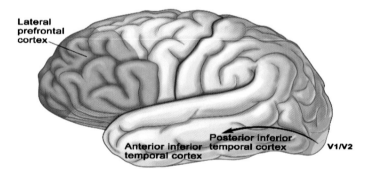

2.14 The left hemisphere of the brain, depicting the areas involved in the representation of faces

Adapted from Eric R. Kandel, *The Age of Insight: The Quest to Understand the Unconscious in Art, Mind, and Brain from Vienna 1900 to the Present* (New York: Random House, 2012), 282, fig. 17.1

representation occurs. Visual information enters through our eyes. At the back of each eye is the retina, a layer of light-sensitive cells, the long axons of whose nerve cells form the optic nerve. The optic nerve ends in an area of the brain called the lateral geniculate nucleus, which then relays the information to the visual cortex at the back of the brain. The information is processed in several stages, each of which treats it in a progressively more complex manner.

Scientists have learned a great deal about the representation of faces in the brain from people who have face blindness. The condition was first described by Jean-Martin Charcot in 1883 and given its current name, prosopagnosia, and modern characterization in 1947 by Joachim Bodamer. The disorder results from damage to the inferior temporal cortex (fig. 2.14), whether present at birth or acquired through head injury or disease. About 10 percent of people have a modest degree of congenital face blindness.

People with damage in the front of the inferior temporal cortex can recognize a face as a face but cannot tell whose face it is. People with damage to the back of the inferior temporal cortex cannot see a face at all. In Oliver Sacks's famous story "The Man Who Mistook His Wife for a Hat," a man with face blindness tries to pick up his wife's head and put it on his own because he mistakes her head for his hat.

Paradoxically, people with prosopagnosia can recognize inverted faces more easily than people without face blindness, suggesting that our brain contains an area specialized for recognition of upright faces. Charles Gross at Princeton, and later Margaret Livingstone, Doris Tsao, and Winrich Freiwald at Harvard, have made several important discoveries about this area in macaque monkeys. Using a combination of brain imaging and electrical recording of signals from individual cells, they found six small structures, which they called face patches, in the temporal lobe of monkeys that light up in response to a face. When the scientists recorded electrical signals from cells in the face patches, they found that different patches respond to different aspects of the face: head-on view, side view, and so on. They found a similar, although smaller, set of face patches in the human brain. Studies by Tsao and a colleague[27] have shown a cell in a monkey's face patch responding strongly to a picture of another monkey

and even more strongly to an exaggerated, cartoon face (chapter 1, fig. 1.29). The cell responds to a complete face—two eyes and a mouth inside a circle—but will not respond if one or more of these features is missing.

Computer models of vision suggest that some facial features are defined by contrast.[28] One example is the area of the eyes and forehead: eyes tend to be darker than the forehead, regardless of lighting conditions. Computer models suggest that such contrast-defined features signal the brain that a face is present. To test these ideas, Ohayon, Freiwald, and Tsao presented monkeys with a series of artificial faces, each of whose features was assigned a unique luminous value ranging from dark to bright.[29] They then recorded the activity of individual cells in the monkeys' middle face patches in response to the artificial faces and found that the cells do respond to contrasts between facial features. Moreover, most of the cells are tuned to contrasts between specific pairs of features, the most common being those in which the nose is brighter than one of the eyes.

These preferences agree with those predicted by the computer model of vision. But since the results in both the macaque and computer studies are based on artificial faces, the obvious question is whether they extend to real faces. Ohayon and his colleagues studied the response of the cells to images of a large variety of real faces. They found that responses increased with the number of contrast-defined features. Specifically, the cells did not respond optimally to real faces containing only four contrast-defined features, although they did recognize them as faces, but they responded well to faces containing eight or more contrast-defined features.

Tsao, Freiwald, and their colleagues had found earlier that cells in the face patches respond selectively to the shape of some facial features, such as noses and eyes.[30] Ohayon's findings now showed that the preference for a particular facial feature depends on its luminance relative to other parts of the face. Importantly, most of the cells in the middle face patches respond both to contrast and to shape. This fact leads us to an important conclusion: contrast is useful for face detection, and shape is useful for face recognition, two of the many characteristics that Soutine used extensively.

These studies have shed new light on the nature of the templates that the brain uses to detect faces. Behavioral studies suggest further that there is a powerful link between the face-detection machinery and the areas that control attention, which may account for why faces and portraiture draw our attention so strongly.

MULTISENSORY PERCEPTION IN SOUTINE'S PAINTINGS

Although I have focused on Soutine's carcass paintings and portraits, his landscapes, writhing and tortuous, are generally considered his most remarkable works, the full flowering of his Expressionist form. The buildings in the landscapes seem anthropomorphic; rather than assume a static architectural form, they gyrate. At times they are also almost abstract, with formless swirls and odd blotches of color, and the figures in them seem even more stretched than usual (fig. 2.15).

2.15 Chaim Soutine, *Houses* (c. 1920–1921).
Oil on canvas, 22 7/8 × 36 1/4 inches / 58.1 × 92.1 cm.

Musée de l'Orangerie, Paris, La Collection Jean Walter et Paul Guillaume.
© Artists Rights Society (ARS), New York / ADAGP, Paris

Soutine's paintings are distinguished not only by visual distortion but also by the richness of the paint, with one layer superimposed on another, creating a tactile sensation. The artist tended to reuse old canvases because he liked to apply fresh paint to an already richly textured surface. He implicitly appreciated that texture creates visual illusions that lend a tactile (haptic) quality to the surface of a painting. Soutine achieved this through impasto, the application of thick paint with a brush or paint knife. When this technique is used successfully, the viewer can actually feel the texture of the paint. Because Soutine's colors are so rich and his brushwork so agitated, his thick impasto over textured surfaces enabled him to create what could almost be considered agitated sculpture.

To develop this sculptural quality further, he shaped mounds of thick pigment into bas-reliefs designed to express feelings, a technique introduced by Van Gogh and Munch, the first Expressionists, and carried forward later by the Viennese Expressionists Oskar Kokoschka and Egon Schiele. Soutine went further, however. He stabbed the canvas with a palette knife and ground in color with his bare hands. He scrubbed, scraped, and slapped the pigment on the canvas with such force that he sometimes tore holes in it. As we have seen, Soutine's world teetered on the edge of disintegration. As a result, he could infuse an image with an extraordinary tactile sense, and this emphasis on tactile perception became even more explicit with time.

TACTILE, VISUAL, AND EMOTIONAL INTERACTIONS IN THE NEURAL PROCESSING OF THE BEHOLDER'S SHARE

The use of strong tactile elements in a painting adds an important dimension to the beholder's response. One of the first art historians to emphasize this was Bernard Berenson. In *The Florentine Painters of the Renaissance* he argued that "the essential in the art of painting . . . was . . . to stimulate our consciousness of tactile values" and thus to appeal to our tactile

imagination just as much as the actual objects do. Berenson goes on to say that form—volume, bulk, and texture—is a principal element of our aesthetic enjoyment. In viewing a Giotto, for example, our visual sensations are translated into sensations of touch, pressure, and grasp. Such visual perception is a unified experience of mind and body, both physiological and psychological unity.[31]

Perception involves a number of senses, not just vision. In evaluating the beholder's response to art, historians have often underestimated the brain's ability to coordinate the interaction of our senses, particularly the visual and the haptic but also, when appropriate, the sense of taste or smell. In recent years the classical idea that the brain processes the various senses separately has been replaced by a new conceptual view of a "metamodal" brain whose organization facilitates the carrying out of multisensory tasks.[32]

Modern brain science has revealed that several regions of the cortex thought to be specialized for processing visual information are also activated by touch. One particularly important region is the lateral occipital complex, a region of the cortex that responds to both the sight and the touch of an object.[33] The textures of objects also activate neurons in a neighboring area, the medial occipital cortex, whether those objects are perceived by the eye or the hand.[34] This is why we can easily identify and distinguish between different materials—skin, cloth, wood, or metal—and can do so at a glance.[35]

Brain-imaging studies have revealed that the way visual information about materials is coded changes gradually. In the early stages, visual processing of a painting or any other object is completely and solely visual. Further processing results in a multisensory representation of the object in our brain (specifically, in the fusiform gyrus and collateral sulcus) that enables us to categorize different materials.[36] In these higher regions of the brain, perception of texture, which is so central to Soutine's paintings, is intimately tied to visual discrimination, because this part of the brain's visual system has a robust and efficient set of mechanisms for processing textured images.[37] Indeed, cross-modal association is key to the brain's experience of art.

In addition to visual and tactile interactions, powerful emotions—sometimes pleasure, but often fear, anxiety, and uncertainty—are also recruited in our brain by Soutine's torturous, asymmetrical, and existential images. In 1900 the great Viennese art historian Alois Riegl was the first to try to bridge art history and science by focusing on the psychology of perception. Riegl argued that no work of art is complete without the response of the beholder, the beholder's share. Today we can begin to outline in a preliminary way a set of neural circuits for the beholder's share that goes considerably further than Berenson's important beginning. Figure 2.16 shows that in addition to visual perception of an image, including the translation of the visual experience into tactile sensations, the brain contains a representation of the face, particularly the emotion conveyed by the face, which is mediated through the amygdala, the executive structure for emotion. The beholder's share also includes perception of the body, the body in motion, emotion, simulation, empathy, and theory of mind.

I focus here only on a few, more recently delineated components of the neural circuit of the beholder's share. Moreover, although I schematically illustrate the various components that contribute to the beholder's share as interacting in a linear manner, in fact they do not. They also have important additional connections, including feedback connections with one another. Higher-order cognitive areas involved in the theory of mind that have

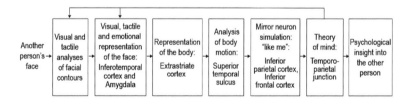

2.16 Flow diagram of the neural circuit involved in the beholder's share

Chris Wilcox

received information from earlier areas involved in visual and tactile processing can feed back to and modify the processing of earlier sensory areas involved in face recognition.

One interesting finding is the mirror neuron system, which is involved in imitation and was discovered in monkeys by Giacomo Rizzolatti, an Italian brain scientist. Rizzolatti realized that some cells in the motor system of the monkey brain respond not only to movements that monkeys make but also to movements that others, including people, make. This mirror neuron system, it has been suggested, may also be responsible for our empathic response to images and to works of art.

In addition to the mirror neuron system, art recruits other components of the neural circuits of the beholder's share, including brain systems concerned with empathy and theory of mind, processes that are concerned with another person's feelings, goals, and aspirations. Thus, the beholder not only projects his own feelings onto a person or persons in a painting but also tries to understand the goals and aspirations of the subjects. As we have seen, this also holds true for the tactile sense. The sculptural quality of Soutine's painting actually gives us an experience of touch, and this interacts with our visual sensibility. When we "feel the texture of the paint" with our eyes, we are really re-creating the actions of the artist as he created the image. Much as mirror neurons may be used to interpret the meaning of observed behaviors, we can almost see the actions of the artist's hand in the traces on the canvas. The notion of using thick paint to convey agitation is important; we see it also in the repetitious short, parallel brushstrokes in Van Gogh's late work, where texture and brushstrokes represent emotions rather than people or things.

The various functions of the beholder's share are located in distinct regions of the brain (fig. 2.17). Thus, the striate cortex (1), which is the first visual processing relay in the cerebral cortex, projects to the posterior and anterior temporal cortex (2), where faces are represented. Behind the striate cortex lies an extrastriate body area (3), which processes images of the body. Behind the extrastriate body area is an area that processes motion (4),

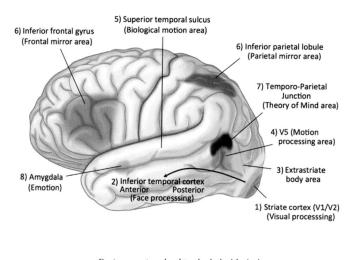

2.17 Brain areas involved in the beholder's share

Illustration by Therese Winslow, for Eric Kandel

whether generated by an automobile or a person. By contrast, in the upper part (superior) of the temporal cortex is an area (5) that processes only biological motion, such as what occurs when a person is moving or reaching a hand out to greet you. Children with autism can respond perfectly well to the movement of a car, but have difficulty with the socially significant biological movements of a person.

In the parietal cortex and the frontal supplementary motor cortex (6) are two areas containing mirror neurons, which are involved in imitation, as noted above. In the temporal parietal junction (7) is an area concerned with theory of mind, part of a brain system concerned with empathy, as described above. Here, for example, the beholder tries to understand empathetically what is going on in the mind of Madeleine Castaing as depicted by Soutine (fig. 2.10). Finally, many of these areas are connected reciprocally with the amygdala (8), the orchestrator of our emotions.

How these higher-order processes interact to create the totality of the beholder's share of a Soutine painting is one of the great challenges confronting brain science in the twenty-first century.

ACKNOWLEDGMENTS

This essay originally appeared as "Empathies and the Uncertainties of Being in the Paintings of Chaim Soutine: A Beholder's Perspective," in *Life in Death: Still Lifes and Select Masterworks of Chaim Soutine*, ed. Esti Dunow and Maurice Tuchman (New York: Paul Kasmin Gallery, 2014), 11–25.

I am grateful to Blair Potter, Jillian Davidson, Tom Albright, Charles Gilbert, and Virginia Barry for their insightful comments on this essay.

COMPETING INFLUENCES THAT GAVE RISE TO THE MODERN REPRESENTATION OF WOMEN

M odernist thought—the thought that led to the world we live in today—emerged in good part in Vienna 1900, a time and place in which Freud, Schnitzler, Mahler, Schoenberg, Klimt, Kokoschka, Schiele, and many other notable artists and intellectuals lived and worked. It originated in part as a reaction to the restrictions and hypocrisies of everyday life in the mid-nineteenth century, but even more as a response to the Enlightenment of the eighteenth century, with its excessive emphasis on the rationality of human behavior.

Modernism represented a search for a new worldview, and it found one in the work of Charles Darwin (1809–1882). Darwin argued that we are not uniquely created individuals, but rather biological creatures that have evolved from simpler animal ancestors. Biological evolution, Darwin continued, is driven by sexual selection. Thus, from an evolutionary perspective, the primary function of a biological organism is to reproduce itself. Moreover, since sexual attraction and mate selection are central to all animal behavior, they must be central to human behavior as well. Key to sexual attraction and mate selection, which leads to all social interaction, are facial and bodily expression and the emotions they reveal.

Darwin's ideas greatly influenced Sigmund Freud (1856–1939), who pioneered the study of the unconscious mind. Freud argued that human beings

are not rational creatures—we are driven by irrational, unconscious mental processes. Moreover, adult characteristics, including adult sexuality and aggression, originate in the mind of the child. Finally, Freud thought that there is no noise in the machine; that is, no mental event occurs by chance. Mental events adhere to scientific laws and follow the principles of psychic determinism. These ideas gave rise to our modern propensity for seeking meaning beneath the surface of behavior.

One of the defining characteristics of Viennese life in 1900 was the free and easy interaction of artists, writers, and scientists. Through these interactions, the ideas of Darwin and of Freud came to the attention of the three great Viennese modernist artists—Gustav Klimt, Oskar Kokoschka, and Egon Schiele—whose depictions of women are the focus of this exhibition. All three artists were very much taken with Darwin's emphasis on the role of facial expression and bodily movements in conveying emotion, and with Freud's view of the mind and its unconscious processes.

OSKAR KOKOSCHKA

The artist who appears to have been most aware of his unconscious mental processes and most profoundly influenced by them is Kokoschka. In fact, Kokoschka claimed to have discovered the existence of unconscious mental processes on his own, independently of Freud. Like Freud, Kokoschka believed that the study of the unconscious of others must begin with a study of one's self, and he developed an abiding interest in exploring his own emotional life as well as that of his subjects. Also like Freud, Kokoschka was fascinated with child and adolescent sexuality.

Whereas Klimt never painted himself, his disciple Kokoschka created numerous self-portraits. In keeping with his own zeitgeist and that of Vienna 1900, Kokoschka presented an unflinchingly honest, even merciless, analysis of his psyche (fig. 3.1). Consequently, his self-portraits are more penetrating and psychologically revealing than even those painted by great earlier artists when they were the same age, including Rembrandt (fig. 3.2) and Dürer.

3.1 Oskar Kokoschka, *Self-Portrait, One Hand Touching the Face* (1918–19)

Bayerische Staatsgemäldesammlungen – Alte Pinakothek, Munich

3.2 Rembrandt Harmensz. Van Rijn, *Self-Portrait* (1629)

Bayerische Staatsgemäldesammlungen—Alte Pinakothek, Munich

Perhaps the most interesting self-portraits were those done during his love affair with Alma Mahler, one of the most beautiful women in Vienna and the widow of composer Gustav Mahler. At age thirty-three Alma Mahler was much more mature and experienced than Kokoschka, who was only twenty-six years old. In April 1912, soon after they met, Kokoschka proposed to Alma in a passionate letter. The letter initiated a stormy erotic relationship in which Kokoschka never felt secure.

Throughout their affair, Kokoschka created several double portraits (fig. 3.3). In these portraits Alma is typically calm, whereas Kokoschka

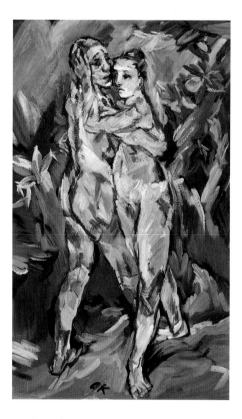

3.3 Oskar Kokoschka, *Two Nudes (Lovers)* (1913) (detail)

Museum of Fine Arts, Boston

looks either passive or very anxious, almost terrified—on the verge of a nervous breakdown (fig. 3.4). In the most important of these, *The Tempest* (fig. 3.5), Kokoschka and Alma lie shipwrecked in a small boat in the midst of a raging storm, buffeted by the waves of their tempestuous relationship. She is sleeping calmly, while Kokoschka, as usual, is anxious, lying rigidly beside her, his emotional state heightened by the background colors.

In these double portraits Kokoschka conveys a view of Woman as being at once seductive and unobtainable. Although his affair with Alma lasted only three years, it dominated the artist's life for years afterward. The affair ended with Alma (who had earlier aborted their unborn child) leaving Kokoschka for the architect Walter Gropius. Kokoschka expressed

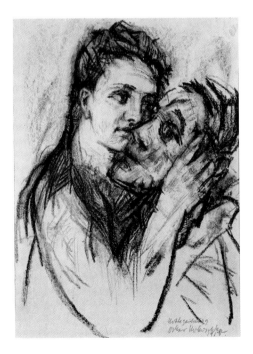

3.4 Oskar Kokoschka, *Self-Portrait with Lover (Alma Mahler)* (1913)

Leopold Museum, Vienna

3.5 Oskar Kokoschka, *The Tempest* (1914)

Kunstmuseum, Basel

his depression in a series of self-portraits (fig. 3.1) and by commissioning a life-sized doll made in Alma's image, which he painted and drew repeatedly until he had exorcised her spirit.

Like Freud, the young Kokoschka was interested in the sexuality of children and adolescents, and in his early years he did many drawings of prepubescent youths. This is evident in his 1907 drawing *Studies for the Nude, Lilith Lang* (fig. 3.6). Kokoschka was attracted to Lilith, but their relationship was never consummated. Dürer had painted himself in the nude as an adolescent, but Kokoschka is one of the first artists to have drawn nude adolescent girls.

3.6 Oskar Kokoschka, *Studies for the Nude, Lilith Lang* (1907)

Private collection

Kokoschka appreciated that even early in their teens, children can have feelings driven by sexuality and aggression. In 1909 he painted five-year-old Lotte and eight-year-old Walter, the children of Richard Stein, playing (fig. 3.7). Kokoschka suggests through their body language that their interaction is not completely innocent, that they struggle with their attraction to each other.

3.7 Oskar Kokoschka, *Children Playing* (1909)

Lehmbruck Museum, Duisburg

The art critic Ernst Gombrich, who considered Kokoschka the best portrait painter of his time, describes the painting of the Stein children in the following terms:

> In the past, a child in a painting had to look pretty and contented. Grown-ups did not want to know about the sorrows and agonies of childhood, and they resented it if this aspect of it was brought home to them. But Kokoschka would not fall in with these demands of convention. We feel that he has looked at these children with a deep sympathy and compassion. He has caught their wistfulness and dreaminess, the awkwardness of their movements and the disharmonies of their growing bodies. . . . His work is all the more true to life for what it lacks in conventional accuracy.[1]

Thus, very much like Freud, Kokoschka grasped the importance of eroticism in children and adolescents as well as in adults.

EGON SCHIELE

Schiele, the Kafka of Viennese art, infused everything, including sexuality, with the existential anxiety of modern life. Since the women he depicted were complete equals with him in their sexual relationship, they share his anxiety, unlike Alma Mahler, who remained emotionally aloof from Kokoschka's suffering. We see an expression of Schiele's eroticism and anxiety in the 1915 watercolors *Lovemaking* (fig. 3.8) and *Seated Couple* (fig. 3.9), where he fuses sexuality, eroticism, world-weariness, exhaustion, and fear.

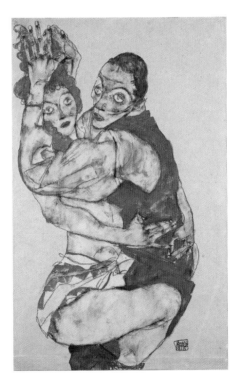

3.8 Egon Schiele, *Lovemaking* (1915)

Leopold Museum, Vienna

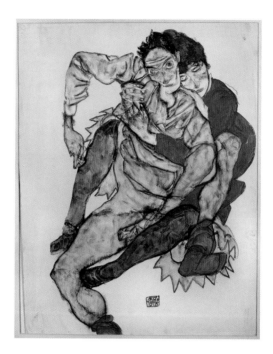

3.9 Egon Schiele, *Seated Couple* (1915)

Albertina, Vienna

In 1911 Schiele met Valerïe Neuzil, a seventeen-year-old redhead who called herself Wally. Schiele himself was twenty-one at the time. A former model and perhaps a mistress of Klimt's, Wally became Schiele's model and his lover. Thanks to Wally, Schiele developed a sense of the range of female eroticism. Like Kokoschka, he was fascinated by adolescent sexuality, and he posed the pubescent girls who modeled for him in sexually explicit positions. But Schiele went beyond Kokoschka: he depicted disturbing explorations of sexuality. Some of his images focus explicitly on genitalia, while others focus on sexual acts.

In *Crouching Female Nude with Bent Head* of 1918 (fig. 3.10), Schiele conveys a girl's feelings by depicting her with her head deeply bowed and

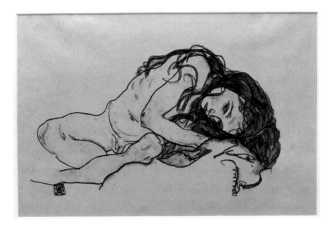

3.10 Egon Schiele, *Crouching Female Nude with Bent Head* (1918)

Leopold Museum, Vienna

an expression of wistful melancholy on her face. Long, loose strands of hair frame her face, as if she were searching for protection and security.

In 1915 Schiele abandoned Wally to marry Edith Harms, a socially acceptable, middle-class young woman. In response to Edith's ultimatum that he break up with Wally, Schiele painted the double portrait *Death and the Maiden* (fig. 3.11). The painting, a view from above, shows Schiele and Wally lying on a mattress covered with a white sheet. Wally embraces Schiele with her head resting on his chest. Although the two lie in a position suggesting they had just made love, they are now staring past each other, as if they are thinking about something or someone else.

Death and the Maiden is often compared to Kokoschka's *The Tempest* (Fig. 3.5), but here the situation is reversed: whereas Alma rejected Kokoschka, Schiele has rejected Wally. Wally is experiencing a sense of isolation and desperation at the death of their relationship that is comparable to Schiele's own deep anxiety. In Schiele's world, no one is safe.

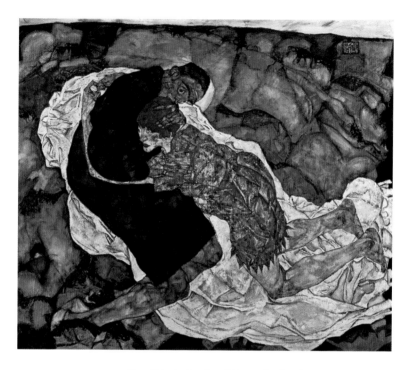

3.11 Egon Schiele, *Death and the Maiden* (1915)

Belvedere, Vienna

THE BRAIN'S RESPONSE TO EXAGGERATED
FACIAL EXPRESSIONS

One characteristic of the Expressionist portraits of both Kokoschka and Schiele is their dramatic and exaggerated presentation of facial expressions. We are now beginning to understand how our brain processes faces and how it responds to exaggeration.

Charles Gross at Princeton and, later, Margaret Livingstone, Doris Tsao, and Winrich Freiwald at Harvard have made several important discoveries. Using a combination of brain imaging and electrical recordings of signals from individual nerve cells, they found six small structures in the

temporal lobe of macaque monkeys that light up in response to a face. Each of these structures, or face patches, responds to a different aspect of the face: head-on view, side view, and so on. They found a similar, although smaller, set of face patches in the human brain.

Studies by Tsao and colleagues[2] have shown that the monkey's face patches contain a high proportion of cells that respond only to faces. These cells are sensitive to changes in position, size, and direction of the gaze of the face, as well as to the shape of its various features.

A cell in a monkey's face patch responds strongly to a picture of another monkey and even more dramatically to a cartoon face. Monkeys, like people, respond more powerfully to cartoons than to real objects because the features in a cartoon are exaggerated. If the eyes are pushed farther apart or closer together, the cells fire more rapidly. But the cell in the monkey's face patch follows Gestalt principles: a face has to be complete in order to elicit a response. The cell responds only to two eyes and a mouth inside a circle (see chapter 2, fig. 2.29). In addition, if the monkey is shown an inverted face, it does not respond.

These studies have shed new light on the nature of the templates our brain uses to detect faces. Behavioral studies suggest further that there is a powerful link between the brain's face detection machinery and the areas that control attention, which may explain why faces and portraits grab our attention so powerfully.

GUSTAV KLIMT

Gustav Klimt was in many ways a role model for Kokoschka and Schiele. Although he never moved toward Expressionism, as they did, he had great insight into the psychology of his subjects, almost all of whom were women. Despite Freud's many insights into the human psyche, he failed to understand certain aspects of human nature, particularly female sexuality. In his early thinking, Freud simply extended his view of male sexuality to women, seeing them as men without a penis. Because women don't have a penis, he

pronounced, they experience penis envy. This, he argued, is the jealousy little girls feel toward boys and the resentment they feel toward their mothers, whom they blame for having deprived them of a penis. Freud also thought that women do not enjoy sex; they engage in it only passively and primarily to have children, preferably boys.

Freud spells out these ideas in a 1925 paper entitled "Some Psychical Consequences of the Anatomical Distinction between the Sexes": "Women oppose change, receive passively and add nothing of their own."[3]

Klimt, in contrast, had considerable insight into female sexuality. In a sense, he achieved a post-Darwinian breakthrough in depicting it. Influenced by Rodin, Klimt had his models move about the studio until they assumed a pose that pleased him. This atmosphere of freedom encouraged these naked or seminaked women to explore themselves and others sexually: to masturbate or couple with one another or with male models. Moreover, since Klimt had extensive sexual experience himself, he knew that women have a rich, independent sexual life that in every way parallels the sexual life of men.

One can readily see the difference between Klimt's view of female sexuality (fig. 3.12) and the conventional nude in Western art, as depicted by Giorgione (fig. 3.13), Titian (fig. 3.14), and Manet (fig. 3.15). In the three latter paintings, the woman is a mythological character (Venus, or Olympia), who looks out at the presumably male beholder as if her only pleasure were to satisfy his erotic curiosity. Finally, each woman's left hand is covering her pubic area, either because of modesty or because she is masturbating—her intentions are ambiguous. In Klimt's drawing, the woman is focused solely on herself and her own erotic pleasure, and there is no ambiguity about her intentions.

What is particularly amazing about Klimt—and what separates him further from Freud—is that Klimt appreciated not only that women have erotic instincts equal to those of men but also that they, like men, can fuse eroticism with aggression. Klimt depicts this in his 1901 painting *Judith* (fig. 3.16).

Judith was a heroine of the Jewish people. In 500 B.C., the Assyrian general Holofernes led his troops in a siege of Bethulia, a small town near

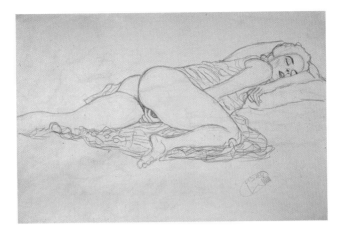

3.12 Gustav Klimt, *Reclining Nude Facing Right* (1913)

Private collection. Courtesy Neue Galerie, New York

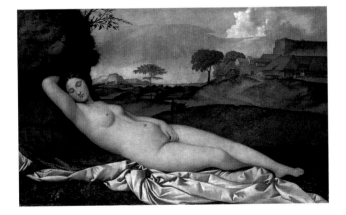

3.13 Giorgione, *Sleeping Venus* (1508–10)

Gemäldegalerie Alte Meister, Dresden

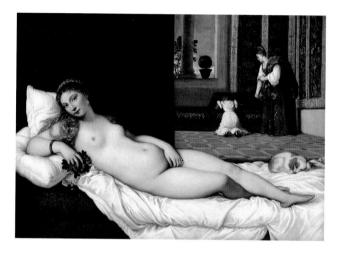

3.14 Titian, *Venus of Urbino* (before 1538). Oil on canvas.

Galleria degli Uffizi, Florence. Art Resource, artres.com

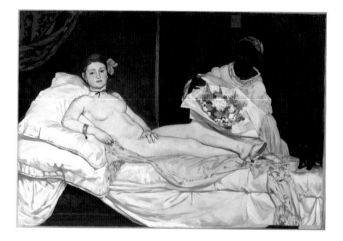

3.15 Edouard Manet, *Olympia* (1863). Oil on canvas.

Musée d'Orsay, Paris. Art Resource, artres.com

3.16 Gustav Klimt, *Judith* (1901)

Belvedere, Vienna

Jerusalem. After a week or two, the siege had become so severe that Judith, a modest young widow of about twenty-four years of age, decided to try to save her people. She managed to sneak past the troops and found Holofernes drinking at a banquet. She encouraged him to drink more, then went with him to his tent, where they made love. After Holofernes feel asleep, satiated with sex and wine, Judith took his sword and cut off his head.

The image of Judith beheading Holofernes has been repeatedly depicted in Western art as the chaste widow sacrificing herself for her people. But in

Klimt's painting Judith is no poor widow sacrificing herself. She is a femme fatale in a postcoital trance, wearing elegantly patterned clothing that leaves her left breast exposed and absent-mindedly fondling Holofernes's severed head.

THE INTERACTION OF EROTICISM
AND AGGRESSION IN THE BRAIN

Today, brain scientists are examining the fusion of aggression and sex that Freud observed in men and that Klimt depicted in *Judith*. In his studies of the neurobiology of emotional behavior, David Anderson at the California Institute of Technology has found some of the biological underpinnings of this fusion of eroticism with aggression (fig. 3.17).[4]

3.17 Heywood Hardy, *Three Lions Fighting* (1873)

Private collection

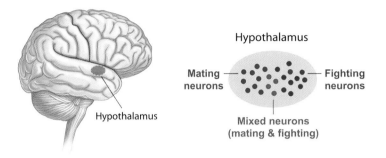

3.18 The hypothalamus has two groups of neurons, one that regulates fighting and one that regulates mating. Some neurons are activated by either behavior.

Chris Wilcox

We have known for some time that the region of our brain known as the amygdala orchestrates emotion and that it communicates with the hypothalamus, the region that houses the brain cells, or neurons, that control instinctive behavior such as parenting, feeding, mating, fear, and fighting (fig. 3.18). Anderson has found a nucleus, or cluster of neurons, within the hypothalamus that contains two distinct populations of neurons: one that regulates aggression and one that regulates mating. About 20 percent of the neurons located on the border between the two populations can be active during either mating or aggression. This suggests that the brain circuits regulating these two behaviors are intimately linked.

How can two mutually exclusive behaviors—mating and fighting—be mediated by the same population of neurons? Anderson found that the difference hinges on the intensity of the stimulus applied to the neurons. Weak sensory stimulation, such as foreplay, activates mating, whereas stronger stimulation, such as danger, activates fighting (fig. 3.19).

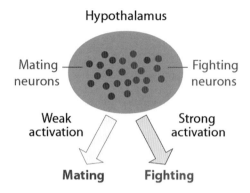

3.19 The intensity of a stimulus determines which neurons are activated.

Chris Wilcox

AN EXPANDED VIEW OF HUMAN SEXUALITY:
A SEARCH FOR SELF-KNOWLEDGE
THROUGH EROTIC LOVE

We see in the women of Kokoschka, Schiele, and Klimt a view of the liberated woman who enjoys her sexuality as much as a man and who suffers as much as a man when rejected in love. Moreover, we see in Klimt's *Judith* the fusion of eroticism with aggression and in Schiele's women the fusion of eroticism with anxiety. The view that emerges from these three artists is that women are men's equals. As a result, sexuality is not one-sided, it is a dialogue—a metapsychological search for new experiences and new knowledge, especially new knowledge about oneself.

The power of women celebrated in these artists' portraits hearkens back to the ideal of "the eternal feminine," an ideal deeply rooted in German culture. Goethe invokes the eternal feminine to save Faust's soul from eternal damnation. Thus Mephistopheles is disarmed by the redemptive

power of love. This concept is expressed in the well-known concluding lines of *Faust, Part II*:

Das Ewig-Weibliche
Zieht uns hinan.
(The eternal feminine draws us upward)[5]

But the concept of the eternal feminine goes beyond redemption. It also celebrates Faust's unremitting pursuit of knowledge and improvement. The angels carrying his soul to safety intone: "Wer immer strebend sich bemüht, den können wir erlösen" (Whoever exerts himself in constant striving, him we can save).[6]

The idea of the eternal feminine as inspiring the search for knowledge can be traced to Plato. In the *Republic*, Plato has Socrates say that falling in love involves not only physical desire but also a striving for wisdom, the most significant of the urges. This theme, which was known to almost every literate Viennese, was emphasized anew in Vienna 1900 by Gustav Mahler (Alma Mahler's late husband), whose Eighth Symphony, composed in 1906, concludes with the last scene of *Faust II*.

According to Goethe—and, I would argue, Kokoschka, Schiele, and Klimt—one inspiration for this striving is the presence of the eternal feminine in men's lives and the knowledge men gain about themselves in the context of love. We can see this in the artists' depictions of women. In Kokoschka's depictions, we sense that his striving for Alma Mahler derives from his belief that he depends on her love for his creativity. He did his best early work in the context of that love relationship. In turn, Schiele's affair with Wally heightened his anxiety and allowed him to produce the angst-riddled art that defines his greatness. Schiele's marriage to Edith reduced the tormenting anxiety and allowed him to push his creativity in a different, more bourgeois, direction. Klimt's drawings and paintings of women are suffused with a remarkable sensitivity to the full range of women's sexuality, an understanding that stems from his own experience.

Thus, the modernist thought that emerged in Vienna 1900 not only emphasizes the equality of women and men striving for self-knowledge in the context of expressing their sexual urges but also implies that a higher wisdom can emerge from the redemptive power of love and the striving for self-knowledge. These hallmarks of modernist thought are evident in Klimt's, Kokoschka's, and Schiele's depictions of women.

ACKNOWLEDGMENTS

This essay was written for "The Women of Klimt, Schiele and Kokoschka," an exhibition held at the Lower Belvedere Museum in Vienna, Austria, October 22, 2015–February 28, 2016. It was published in the exhibition catalogue, *The Women of Klimt, Schiele and Kokoschka*, ed. Agnes Husslein-Arco, Jane Kallir, Alfred Weidinger, Eric R. Kandel, and Mateusz Mayer (Munich: Prestel Publishing, 2015).

CHAPTER 4

PORTRAITURE AND THE
BEHOLDER'S SHARE

▬

A Brain Science Perspective

The central challenge of science in the twenty-first century is to understand the human mind in biological terms. The possibility of meeting that challenge opened up in the late twentieth century, when cognitive psychology, the science of mind, merged with neuroscience, the science of the brain. The result was a new biological science of mind that has allowed us to address a range of questions about ourselves: How do we perceive, learn, and remember? What is the nature of emotion, empathy, and consciousness?

This new biological science of mind is important not only because it provides a deeper understanding of what makes us who we are but also because it makes possible a meaningful series of dialogues between brain science and other areas of knowledge. In a larger sense, these dialogues could help make science part of our common cultural experience.

I would like to take up this scientific challenge by focusing on how the new biological science of mind has begun to engage with figurative art. In my life as a scientist, I have often benefited from taking a reductionist approach. I try to explore a large problem that interests me—the problem of memory storage—by initially focusing on its simplest example and trying to explore it deeply. Thus, in engaging with art I again take a reductionist approach, limiting my discussion to one particular art form—portraiture.

I focus on portraiture because it is a highly suitable art form for scientific exploration. We now have the beginnings of an intellectually satisfying understanding of how our brain responds to the facial expressions and bodily postures of others. Portraiture is perhaps the most fascinating topic in art from the perspective of brain science. There is magic in portraiture because of all the objects in the world, faces are the most special.

WHY ARE FACES SO SPECIAL?

This question was first addressed by Charles Darwin, who pointed out in his book *The Expression of the Emotions in Man and Animals* (1872) that faces are essential for social interaction. We recognize each other and even ourselves through our faces. Moreover, being social animals, we need to communicate not only our ideas and plans but also our emotions to one another. Facial expressions are our primary social signaling system. They are central to all social communication, from forming a friendship to making a business arrangement to finding a partner.

Darwin proposed that we convey our emotions in large part through a limited number of facial expressions—about seven of them (fig. 4.1). Since all faces have the same number of features—one nose, two eyes, and one mouth—the sensory and motor aspects of emotional signals communicated

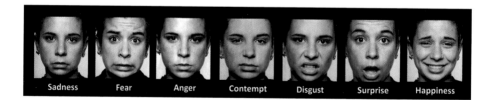

Sadness Fear Anger Contempt Disgust Surprise Happiness

4.1 The valence of facial expressions of emotion, from happiness (inviting approach) to fear (inviting avoidance)

"Portraiture and the Beholder's Share: A Brain Science Perspective," TEDxMet Talk, Metropolitan Museum of Art, 2013; image: Chris Wilcox

by the face must be universal, regardless of culture. Darwin argued that both the ability to form facial expressions and the ability to read the facial expressions of others are innate, not learned. Years later, experiments in cognitive psychology showed that face recognition does indeed begin in infancy.

Our brain is extraordinarily good at recognizing faces. Moreover, we can readily recognize a line drawing of a face. In fact, a slight exaggeration of facial features makes it even easier for us to recognize a person. One reason for this is that our brain treats faces differently than all other objects.

THIRTY CENTURIES OF PORTRAITURE

Prehistoric art contains very few examples of human portraiture. Some of the first representational art is thought to be the 17,300-year-old paintings on the walls of Lascaux, a network of caves and grottos in southwestern France. Human beings appear in them very rarely and are never the central feature—horses, bulls, bison, and other animals are.

Even earlier than the Lascaux paintings is the Venus of Willendorf, a sculpture of a pregnant woman—perhaps a fertility goddess—that is thought to date to about 22,000 B.C. The sculpture was discovered in Austria and is thought to be from a Paleolithic tribe that worshiped images of fertile women to encourage pregnancy. Although it is human-centered art, the sculpture is quite different from modern portraiture. Leaving behind a visual record of one's own life or that of another person for posterity was not uppermost in the minds of prehistoric people.

Portraiture comes from a different lineage and has played a key role in Western art. For centuries before the advent of photography, affluent and influential families used portraits to convey the power and status of their members, as well as to show posterity what their forebears looked like.

Beginning in about 15,000 B.C., Egyptians used portraiture to depict their godlike rulers, the pharaohs. These images were painted and carved in places of spiritual importance, and they were used to show not only the appearance but also the power and symbolic significance of the sitter.

The Greeks of the early seventh century B.C. also undertook portraiture, mostly in the form of sculpture, but their portraits represented people of power and influence as well as gods—the idea being that art elevates people to the status of gods. This tradition was continued in Rome in the first century B.C. Portraiture declined in the Middle Ages, however, when the only portraits were religious depictions of Jesus, Mary, and Joseph.

In the transition from the Middle Ages to the Renaissance, the portrait began to be used as a stand-in for the living person, representing the sitter when he or she was absent. In this role, portraits converted transience into permanence, conjuring the self that might survive even death. The task of a great artist was to ennoble both himself and his subject by depicting the sitter's permanent significance. This was done most commonly by painting the sitter in profile.

During the Renaissance, portraiture depicted the noble and the affluent, presenting not only their physical and psychological appearance and their personality but also the objects and surroundings that characterized them. Until the sixteenth century, royalty and rulers were the typical subjects, but as the economy shifted wealth to the business class, portraiture also shifted, from depicting its subjects in profile to depicting them head-on. This change is sometimes referred to as the "Renaissance gaze shift." Renaissance artists favored the direct gaze, which allows the beholder to make eye contact with the subject and to perceive enduring character traits.

The method of painting also changed. In the Renaissance, paintings were done with egg tempera, a mixture of egg yolk and powdered pigment that gave rise to colorful works of art containing contrast, which had not been possible in medieval paintings. In Holland, Jan van Eyck used a new medium—oils—that made possible an even greater range of color and greater contrast and depth. Later, in the seventeenth century, the Dutch painters Rembrandt and Franz Hals and the Italian sculptor Bernini all introduced the play of emotion on the human face to a degree that had not been present in earlier works, such as those by Raphael or Titian.

Portraiture was initially successful because viewers could compare the portrait in front of them with their memory of the sitter's face, someone

they knew to be a person of stature and accomplishment. Modern artists changed that. Their subject might be a commoner or an aristocrat. Moreover, their subject was no longer presented as a representative of all members of his or her class, but rather as an individual.

Since Rembrandt and the Dutch School of the seventeenth century, artists have tried to get below the surface appearance of their sitter. As the French sculptor August Rodin said, "If the artist only reproduces superficial features, as photography does, if he copies the lineaments of faces exactly, without reference to character, he deserves no admiration. The resemblance which he ought to obtain is that of the soul." Vincent van Gogh expressed a similar sentiment: "Ah! Portraiture, portraiture with the thought, the soul of the model in it. That is what I think must come." And finally, as the American artist Alice Neel said, "Like Chekov, I am a collector of souls. I think if I hadn't been an artist I could have been a psychiatrist."

Self-portraits play a revolutionary but underappreciated role in the history of art. They are unique in that they merge the artist and the sitter. Thus they provide the artist with an avenue for self-examination and give the viewer a glimpse of the artist's personality (West 2004). But self-portraits have also functioned in a variety of other ways: as a signature, as an advertisement for an artist's skill, and as an experiment in technique or expression.

Self-portraits were rare before the fifteenth century. But with the advent of better, less expensive mirrors, painters and sculptors began to explore self-portraiture and to use it to depict themselves as they changed in appearance and character throughout their life span. Albrecht Dürer and Rembrandt, in particular, created honest series of self-revelations through the different stages of their lives.

THE BEHOLDER'S SHARE: THE BEGINNING OF A SCIENTIFIC APPROACH TO PORTRAITURE AND ART

The idea of relating portraiture to science came from the art historian Alois Riegl. He and two of his students at the Vienna School of Art History, Ernst

Kris and Ernst Gombrich, attained international renown at the end of the nineteenth century for their efforts to establish art history as a scientific discipline by grounding it in psychology and sociology.

Riegl discovered a new, psychological aspect of art: namely, that art is incomplete without the perceptual and emotional involvement of the viewer. The viewer collaborates with the artist in transforming a two-dimensional likeness on a canvas into a three-dimensional depiction of the visual world and interprets what he or she sees on the canvas in personal terms, thereby adding meaning to the picture. Riegl called this phenomenon the "beholder's involvement." (Gombrich later elaborated on this concept and referred to it as the "beholder's share.") Based on ideas derived from Riegl and from contemporaneous schools of psychology and psychoanalysis, Kris and Gombrich devised a new approach to the mysteries of visual perception and incorporated it into art criticism.

Kris studied ambiguity in visual perception, which led him to elaborate on Riegl's insight that the viewer completes a work of art. Kris argued that every powerful image is inherently ambiguous because it arises from the experiences and conflicts of the artist's life. The viewer responds in terms of his or her own experiences and conflicts. The extent of the viewer's contribution depends on the degree of ambiguity in the image.

The idea of ambiguity as Kris used it was introduced by the literary critic William Empson, who held that ambiguity exists when "alternative views [of a work of art] might be taken without sheer misreading." Empson implied that ambiguity allows the viewer to read the aesthetic choice, or conflict, that exists within the artist's mind, whereas Kris held that ambiguity enables the artist to transmit his sense of conflict and complexity to the viewer's brain.

THE INVERSE OPTICS PROBLEM

Gombrich extended Kris's ideas about ambiguity to visual perception per se. In the process, he came to understand a crucial principle of brain function:

our brain is not simply a camera, it is a creativity machine. It takes incomplete information from the outside world and makes it complete.

Any image projected onto the retina of the eye has countless possible interpretations. Therefore, as Gombrich realized (1960), visual perception is only a special case in a larger question that Western philosophy has long debated: How can the real world of physical objects be known through our senses? The Anglo-Irish philosopher George Berkeley, Bishop of Cloyne, had already grasped the central problem of vision as early as 1709, when he wrote that we do not see material objects per se, but the light reflected off them (Berkeley 1709). This light passes through the lens of the eye and onto the retina, the flat layer of light-sensitive tissue lining the inner surface of the eye. The two-dimensional image projected onto our retina can never directly specify all three dimensions of an object. This fact, and the difficulty it creates for understanding our perception of any image, is referred to as the inverse optics problem (Albright 2013; Purves and Lotto 2010).

As Berkeley pointed out, the inverse optics problem arises because any given image projected onto the retina can be generated by objects of different sizes, with different physical orientations, and at different distances from the observer. For example, a souvenir model of the Eiffel Tower held close to the eye may appear identical in shape and size to the actual Eiffel Tower as seen from across the Champ de Mars. As a result, the actual source of any three-dimensional object's image is inherently uncertain. Gombrich fully appreciated this problem and cited Berkeley's observation that "the world as we see it is a construct slowly built up by every one of us in years of experimentation" (1960). Shortly after Berkeley's writings, David Hume and Immanuel Kant generalized this argument from vision to all perception. They argued that the real world is inevitability remote from us and that we can only appreciate it indirectly.

Edward Adelson (1993) and subsequently Dale Purves and R. Beau Lotto (2010), two contemporary students of vision who have revisited the inverse optics problem, asked how we are able to respond so successfully to the real world if our perceptions are illusory constructs. The answer

is that our visual system must have evolved primarily to solve this fundamental problem. Even though there is not enough information in the image that our eyes receive to reconstruct an object accurately, we do it all the time. How?

An answer to this question was set forth by the noted nineteenth-century physician and physicist Hermann von Helmholtz, who argued that we solve the inverse optics problem by including two additional sources of information: *bottom-up* and *top-down information* (Adelson 1993).

Bottom-up information is supplied by computations that are inherent in the circuitry of our brain, in the connections among cells that enable us to extract key elements of images in the physical world, such as contours and junctions. These computations are governed by innate, universal rules built into our brain by evolution. As a result, each of our visual systems extracts the same essential information from the environment. This is why, despite countless ambiguities, even young children can interpret images.

Many of these innate rules we take for granted. For example, the brain realizes that the sun is always above us, no matter where we are. We therefore expect light to come from above. If it does not—as in a visual illusion—our brain can be tricked. Gombrich was fascinated by how the brain responds to such illusions, as we shall see.

Top-down information is supplied by learning from earlier experience, by remembrance, and by the associations we bring to bear on every image we encounter, including a work of art. Thus, perception also incorporates knowledge based on learning, hypothesis testing, and goals—knowledge that is not necessarily built into our brain. Because much of the sensory information that we receive through our eyes can be interpreted in a variety of ways, we must use inference to resolve this ambiguity. When, for example, we see a person growing larger and larger, we typically conclude that he or she is not rapidly expanding but merely walking toward us. Although we tend to draw such conclusions automatically, they require our brain to do some guesswork that is not based on the visual stimulus alone. We must guess, based on experience, what the image in front of us is. Since we are not normally aware of constructing visual hypotheses and drawing conclusions

from them, Helmholtz called this top-down process of hypothesis testing *unconscious inference.*

Helmholtz's remarkable insight is not restricted to perception: top-down processing applies to emotion and empathy as well. The noted cognitive psychologist Chris Frith of the Wellcome Center for Neuroimaging at University College London has summarized this insight: "We do not have direct access to the physical world. It may feel as if we have direct access, but this is an illusion created by our brain."

The influence of top-down processing on the beholder's perception convinced Gombrich that there is no such thing as an "innocent eye": all visual perception is based on classifying concepts and interpreting visual information. We cannot perceive that which we cannot classify, he argued. These insights inspired him to explore the psychology of perception more deeply than any art historian before him. He appreciated that painting is concerned with light and color only as they impinge upon the retina. To reproduce an image correctly, the painter must clear his mind of all he knows about the object in front of him—wipe the slate clean—and let nature write her own story.

Riegl, Kris, and Gombrich realized that each of us brings to a work of art our memories in addition to our bottom-up, built-in visual processes. We remember other works of art that we have seen and scenes and people that have meaning to us. And when we look at a work of art, we relate it to those memories. In this way the artist's modeling of physical and psychic reality parallels the intrinsically creative operations of our brain in everyday life.

These psychological insights into perception served as a solid footing for a bridge between the visual perception of art and biology.

THE BRAIN AS A CREATIVITY MACHINE

As Gombrich's fascination with visual perception deepened, he became intrigued by Kris's ideas about ambiguity in art and began to study the

ambiguous figures and illusions made famous by Gestalt psychologists. (Several examples of ambiguous figures, including the Kanizsa square, and their interpretation were discussed in chapter 1.) Kris's and Gombrich's studies of ambiguity and of the beholder's share led them to conclude that the brain generates internal representations of what we see in the world around us, whether as an artist or as a beholder. Moreover, they held that we are all wired to be "psychologists" because our brain also generates internal representations of other people's minds—their perceptions, motives, drives, and emotions. These ideas contributed greatly to the emergence of a modern cognitive psychology of art.

Kris and Gombrich realized that their ideas were based on sophisticated insights and inferences; they could not be examined directly and therefore could not be analyzed objectively. To examine these internal representations directly—to peer into the brain—cognitive psychology had to join forces with brain biology.

THE BEHOLDER'S SHARE OF FACE RECOGNITION: PSYCHOLOGY AND BIOLOGY

As we look at a portrait, our brain is busy analyzing facial contours, forming a representation of the face, analyzing the body's motion, forming a representation of the body, experiencing empathy, and forming a theory of the person's mind. These are all components of the beholder's share, and modern biology makes it possible for us to begin to explore them. Figure 4.2 shows my initial approximation of the neural circuit involved in the beholder's share. It indicates seven points of analysis along the circuit and the areas of the brain involved in each.

Analysis of facial contours and the brain's representation of a face in a portrait are clearly of central importance to the beholder's share. Fortunately, we have learned a great deal about the psychology of face recognition and the biological processes underlying it. Let us first consider the psychological aspects of face recognition and then its biology.

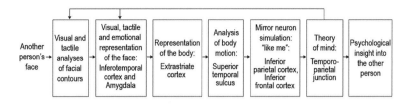

4.2 Flow diagram of the neural circuit involved in the beholder's share

"Portraiture and the Beholder's Share: A Brain Science Perspective," TEDxMet Talk,
Metropolitan Museum of Art, 2013; image: Chris Wilcox

THE PSYCHOLOGICAL ANALYSIS
OF FACE RECOGNITION

Our brain is specialized to deal with faces. Indeed, face perception has evolved to occupy more space in our brain than any other figural representation. As Darwin pointed out, the face and the emotion it conveys are key to all human interactions. We judge whether we trust people or are scared of them in part by the facial expressions they show us when we interact with them. We are attracted to people of the same sex and the opposite sex because of their physical appearance and their facial expressions.

The brain treats faces very differently from other objects (see chapter 2). For one thing, face recognition is uniquely sensitive to inversion. If we were to turn a bottle of water upside down, we would still recognize it as a bottle of water. However, we might not recognize a face when it is upside down. Giuseppe Arcimboldo, a sixteenth-century Milanese artist, illustrates this dramatically by using fruits and vegetables to create faces in his paintings (Kandel 2012). When viewed right side up, the paintings are readily recognizable as faces, but when inverted, they are recognizable only as bowls of fruits and vegetables (fig. 4.3).

To answer the question of how we recognize faces, we need to know a little about the structure of the brain. Our brain has four lobes: frontal, parietal, occipital, and temporal (fig. 4.4). The occipital lobe is where visual information first comes in; the temporal lobe is where facial representation

4.3 Giuseppe Arcimboldo, *The Vegetable Gardener* (1587–90).
14.1 × 9.4 in, oil on panel.

Museo Civico Ala Ponzone, Cremona, Italy

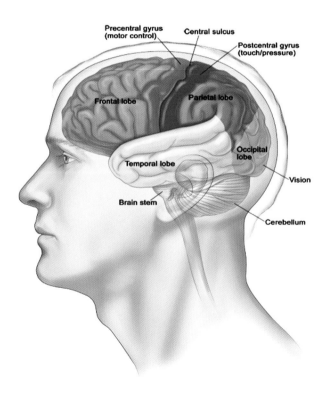

4.4 Left hemisphere of the brain, showing the four lobes:
frontal, parietal, occipital, and temporal

Illustration by Therese Winslow, for Eric Kandel

occurs. Visual information comes in through our eyes. At the back of the eye is the retina, whose long axons form the optic nerve. The optic nerve ends in an area of the brain called the lateral geniculate nucleus, which then relays the information to the visual cortex, located in the occipital lobe. The information is then processed in several stages, each of which treats it in a progressively more complex manner.

THE BIOLOGY OF THE REPRESENTATION
OF FACES IN THE BRAIN

Scientists learned an enormous amount about the representation of faces in the brain from people who have face blindness, or prosopagnosia. First described in 1947 by Joachim Bodamer, the condition results from damage to the inferior temporal cortex, whether acquired or congenital (see chapter 1, fig. 1.27). People with damage in the front of the inferior temporal cortex can recognize a face as a face but cannot tell whose face it is. People with damage to the back of the inferior temporal cortex cannot see a face at all. Paradoxically, people with prosopagnosia can recognize inverted faces more easily than people without face blindness, which suggests that our brain contains an area that is specialized for upright face recognition.

Charles Gross at Princeton, and later Margaret Livingstone, Doris Tsao, and Winrich Freiwald at Harvard, have made several important discoveries about how our brain analyzes faces. Using a combination of brain imaging and electrical recording of signals from individual cells, they found six small structures, which they called face patches, in the temporal lobe of macaque monkeys that light up in response to a face. They also found a similar, although smaller, set of face patches in the human brain. As discussed in detail in chapter 1, such studies have shown that the monkey's face patches contain a high proportion of neurons that respond only to faces. These cells are sensitive to changes in position, size, and direction of the gaze of the face, as well as to the shape of various parts of the face.

Computer models of vision suggest that some facial features are defined by contrast (Sinha 2002). For example, the eyes tend to be darker than the forehead, regardless of lighting conditions. Moreover, computer models suggest that such contrast-defined features signal the brain that a face is present. To test these ideas, Ohayon, Freiwald, and Tsao (2012) presented monkeys with a series of artificial faces, each of whose features was assigned a unique luminous value ranging from dark to bright. They then recorded the activity of individual cells in the monkeys' middle face patches in response to the artificial faces. They found not only that the cells respond to contrasts between facial features but also that most of the cells are tuned to contrasts between specific pairs of features.

These preferences agree with those predicted by the computer model of vision. But since results in both the macaque and computer studies are based on artificial faces, the obvious question is whether they extend to real faces. To examine that question, Ohayon and his colleagues next studied the response of the cells to images of a large variety of real faces and found that the cells' response increased with the number of contrast-defined features (2012).

Tsao, Moeller, and Freiwald (2008) had found earlier that cells in these face patches respond selectively to the shape of some facial features, such as noses and eyes. Ohayon's findings now showed that the preference for a particular facial feature depends on its luminance relative to other parts of the face. Most of the cells in the middle face patches respond both to contrast and to the shape of facial features. This leads us to an important conclusion: contrast is useful for face detection, and shape is useful for face recognition.

These studies have shed new light on the nature of the templates the brain uses to detect faces. Behavioral studies further suggest that there is a powerful link between the brain's face detection machinery and the areas that control attention, which may account for why faces and portraiture draw our attention so strongly.

KNOWING OURSELVES: THE NEW DIALOGUE BETWEEN SCIENCE AND ART

Ever since Socrates and Plato speculated on the nature of the human mind, serious thinkers have sought to understand the self and human behavior. For past generations, that quest was restricted to the intellectual and often nonempirical frameworks of philosophy and psychology. Today, however, brain scientists are attempting to translate abstract philosophical and psychological questions about mind into the empirical language of cognitive psychology and brain biology.

The guiding principle is that mind is a set of operations carried out by the brain, an astonishingly complex computational device that constructs our perception of the external world, fixes our attention, and controls our actions. One of the aspirations of this new biological science of mind is to gain a deeper understanding of ourselves—including how we respond to, and perhaps even create, works of art—by linking the biology of mind to other areas of humanistic knowledge such as art and portraiture.

Establishing a dialogue between science and art is not easy, however, and it requires special circumstances. One such set of circumstances arose in Vienna 1900, which I describe in *The Age of Insight* (Kandel 2012). At the turn of the twentieth century, Vienna was a relatively small city that provided a social context—the university, coffeehouses, and salons—in which scientists and artists could readily exchange ideas. Their dialogue was conducted in a common language derived from scientific medicine, psychology and psychoanalysis, and art history. That dialogue continued to develop in the 1930s, with the contributions of cognitive psychology and the Gestalt psychology of visual perception. This bold and successful advance provided the impetus for applying the insights of cognitive psychology to the biological study of perception, emotion, empathy, and creativity, thus leading to the new dialogue that is under way today.

Important insights into mind have come from writers and poets as well as from artists, psychologists, and scientists. Each kind of creative

endeavor has made and continues to make specific contributions to our full conception of mind. If we disregard one in favor of another, our conception will be incomplete. After all, it took a psychologist like Freud to explain what unconscious processes *are*, but artists like Shakespeare, Beethoven, and the Austrian modernists to show us how some of those unconscious processes *feel*.

Scientific analysis represents a move toward greater objectivity, toward a closer description of the actual nature of things. This is accomplished in the case of visual art by describing the observer's view of an object not in terms of the subjective impressions the object makes on the senses but in terms of the brain's specific responses to the object. Art, such as portraiture, is best understood as a distillation of pure experience. As such, it provides an excellent and desirable complement to and enrichment of the science of mind. Neither approach alone is sufficient to understand fully the dynamics of human experience. What we require is a third way, a set of explanatory bridges across the chasm between art and science.

How, then, do we extend the search for common concepts and meaningful dialogues? One way is to examine successful attempts and see how they were accomplished. How long did they take? How completely were they realized?

We can see how the unification of one field can positively affect others in the interaction of physics with chemistry, and of both with biology. In the 1930s, Linus Pauling demonstrated that the physical principles of quantum mechanics explain how atoms behave in chemical reactions. Stimulated in part by Pauling, chemistry and biology began to converge in 1953 with the discovery of the molecular structure of DNA by James Watson and Francis Crick. Molecular biology unified in a brilliant way the previously separate disciplines of biochemistry, genetics, immunology, development, cell biology, cancer biology, and more recently, molecular neurobiology. This unification has set a precedent for other disciplines. It holds out the hope that in the fullness of time, large-scale theories will include the science of mind.

The evolutionary biologist E. O. Wilson saw the possibility of a unity of knowledge between biology and the humanities that is at once broad and

realistic. He based it on *consilience*, a set of dialogues. Wilson argues that knowledge is gained and science progresses through a process of conflict and resolution. For every parent discipline such as psychology, the study of behavior, there is a more fundamental field, an antidiscipline—in this case, brain science—that challenges the precision of the methods and claims of the parent discipline. Typically, however, the antidiscipline is too narrow to provide the coherent framework or richer paradigm needed to usurp the role of the parent discipline. The parent discipline—whether psychology, ethics, or law—is larger in scope and deeper in content, and it ends up incorporating and benefiting from the antidiscipline.

These are evolving relationships, as we can see with art and science. Art and art history are the parent disciplines, and psychology and brain science are their antidisciplines. We have seen that our perception and enjoyment of art is wholly mediated by the activity of our brain and we have examined a number of ways insights from the antidiscipline of brain science enrich our discussion of art. We have also seen how much brain science can gain from trying to explain the beholder's share.

But the grand vision of unity must be balanced with a strong appreciation of historical reality. Rather than seeing a unified language and a useful set of concepts connecting key ideas in the humanities and the sciences as an inevitable outcome of progress, we should treat the attractive idea of consilience as an attempt to open a dialogue between restricted areas of knowledge. In the case of art, this dialogue might involve a modern equivalent of the famous salons in Europe, in which artists, art historians, psychologists, and brain scientists exchanged ideas with one another—only today, ideas would be exchanged in the context of new interdisciplinary centers at universities. Much as the modern science of mind emerged from discussions between cognitive psychologists and brain scientists, so now modern students of the science of mind can engage in dialogue with artists and art historians.

Dialogues are most likely to be successful when fields of study are naturally allied, as are the biology of mind and the perception of art, and when the goals are limited and benefit all the fields. It is very unlikely that

a complete unification of the biology of mind and aesthetics will occur in the foreseeable future but quite likely that a new dialogue between aspects of art and aspects of the science of perception and emotion will continue to enlighten both fields, and in time may have cumulative effects.

What benefits would this dialogue confer?

The potential benefits for the new science of mind are obvious. One of its goals is to understand how the brain responds to works of art, how we process unconscious and conscious perception, emotion, and empathy. But what is the potential usefulness of this dialogue for artists?

Since the beginning of modern experimental science in the fifteenth and sixteenth centuries, artists from Filippo Brunelleschi and Masaccio, to Albrecht Dürer and Pieter Bruegel, to Richard Serra and Damien Hirst have been interested in science. Much as Leonardo da Vinci used his knowledge of human anatomy to depict the human form in a more compelling and accurate manner, so too contemporary artists may use our understanding of the biology of perception and of emotional and empathic response to create new art forms and other expressions of creativity.

Indeed, some artists who are intrigued by the irrational workings of the mind, such as René Magritte and other Surrealists, have attempted this already, relying on introspection to infer what was happening in their own minds. While introspection is helpful and necessary, it is not capable of providing a detailed understanding of the brain and its workings. Artists today can enhance traditional introspection with the knowledge of how aspects of our mind work.

Today, for the first time, we are in a position to address directly what neuroscientists can learn from the experiments of artists and what artists and beholders can learn from neuroscience about artistic creativity, ambiguity, and the perceptual and emotional response of the viewer. We have seen in this essay specific instances of how the art of portraiture and science can enrich each other. Moreover, we have seen the potential of the new biology of mind as an intellectual force, a font of new knowledge that is likely to bring about a new dialogue between the natural sciences and the humanities. This dialogue could help us understand better the mechanisms

in the brain that make creativity possible, whether in art, the sciences, or the humanities, and open up a new dimension in intellectual history.

ACKNOWLEDGMENTS

This essay was originally a TEDxMet Talk given at the Metropolitan Museum of Art, New York, on October 19, 2013. See https://www.youtube .com/watch?v=Jyc7FIglkHI.

REFERENCES

Adelson, Edward H. 1993. "Perceptual Organization and the Judgment of Brightness." *Science* 262:2042–2043. Oxford: Clarendon Press.

Albright, Thomas. 2013. "On the Perception of Probable Things: Neural Substrate of Associative Memory, Imagery, and Perception." *Neuron* 74, no. 2: 227–45.

Berkeley, George. 1709. "An Essay Towards a New Theory of Vision." In *The Works of George Berkeley, Bishop of Cloyne*, ed. Arthur A. Luce and Thomas E. Jessop, vol. 1, 171–239. London: Nelson, 1948–1957. Originally published in *George Berkeley, An Essay Towards a New Theory of Vision* (Dublin: printed by Aaron Rhames for Jeremy Pepyat.

Darwin, Charles. 1872. *The Expression of the Emotions in Man and Animals*. New York: Appleton-Century-Crofts.

Freiwald, Winrich, and Doris Tsao. 2009. "A Face Feature Space in the Macaque Temporal Lobe." *Nature Neuroscience* 12: 1187–1196.

Frith, Chris. 2007. *Making Up the Mind: How the Brain Creates Our Mental World*. Oxford: Blackwell.

Gombrich, Ernst H. 1960. *Art and Illusion: A Study in the Psychology of Pictorial Representation Summary*. London: Phaidon.

Gregory, Richard L. 2009. *Seeing Through Illusions*. New York: Oxford University Press.

Kandel, Eric R. 2012. *The Age of Insight: The Quest to Understand the Unconscious in Art, Mind, and Brain from Vienna 1900 to the Present*. New York: Random House.

Ohayon Shay, Winrich A. Freiwald, and Doris Y. Tsao. 2012. "What Makes a Cell Face Selective? The Importance of Contrast." *Neuron* 74: 567–81.

Purves, Dale, and R. Beau Lotto. 2010. *Why We See What We Do Redux: A Wholly Empirical Theory of Vision*. Sunderland, MA: Sinauer Associates.

Sinha, P. 2002. "Qualitative Representations for Recognition." *Journal of Vision* 1: 249–62.

Tsao, Doris Y., Sebastian Moeller, and Winrich A. Freiwald. 2008. "Comparing Face Patch Systems in Macaques and Humans." *PNAS* 49: 19514–19.

West, Shearer. 2004. *Oxford History of Art: Portraiture*. Oxford: Oxford University Press.

Zeki, Semir. 1993. *A Vision of the Brain*. Oxford: Blackwell Scientific Publications.

THE CUBIST CHALLENGE
TO THE BEHOLDER'S SHARE

L ike other artists of the time, Braque and Picasso were influenced by the general intellectual ferment of the early twentieth century, which focused on three aspects of modern science. First, following Sigmund Freud's publication of *The Interpretation of Dreams* (1900), the intellectual public had become fascinated by psychology, by the mind's construction of reality. Freud realized that there is no single reality; instead, our mind freely associates ideas, and both conscious and unconscious mental processes influence our experience of the world. Freud argued that unlike conscious mental processes, the unconscious has no sense of time and place (1911). He distinguished between "primary process thinking," the language of the unconscious (the id), and "secondary process thinking," the language of the conscious mind (the ego). Whereas secondary process thinking is logical and purposeful, primary process thinking is marked by a failure to distinguish fantasy from reality and dreams from waking states, and it equates thought and action, time and space.

Ernst Kris and Ernst Gombrich, two disciples of the noted Viennese art historian Alois Riegl (Riegl 1902; Kemp 1999), applied their understanding of Freud's ideas to art. Riegl had argued that no work of art is complete without the beholder's involvement, a principle that Gombrich later called the "beholder's share." Kris and Gombrich elaborated on the idea that the

visible world we experience is constructed in part from what we perceive and in part from our memories of sights, smells, movements, and touch. Thus, the act of viewing is an elaborate and creative mental process that is central to the beholder's response to any work of art (Kris with Kaplan 1952; Gombrich 1982).

Cubism made the beholder's share the essential subject of art. Gombrich suggested that Picasso's intuitive insight into the richness of the unconscious mind encouraged Cubists "to do away with the peep-show convention and even to show the various aspects of one object in the same painting" (Gombrich 1960). Cubist artists understood that visual perception is an elaborate mental process, and they experimented extensively with ways to engage different aspects of the viewer's attention and perception. By exploring the same object from multiple vantage points, they implicitly acknowledged the existence of several perspectives in space and time, perspectives they had uncovered in their own unconscious mental processes (Henderson 1988; Shlain 1991; Miller 2001). Cubism thus called attention to art in psychologically new ways. As the critic Michael Brenson pointed out, "a Cubist painting is constantly revealing itself in new ways. It is continually changing and surprising" (1989).

In addition to their implicit awareness of unconscious mental processes, Picasso, Braque, and other Cubists were surely aware of the two other major developments in the physical sciences that were emerging at the beginning of the twentieth century: Albert Einstein's general theory of relativity and the discovery of X-rays. Einstein's revolutionary theory overthrew the absolute status of space and time and made all frames of reference equal, an idea inherent in Cubist art. Moreover, the argument against Einstein's theory—that it is not consistent with the reality of our visual perception—was overturned by the discovery of X-rays, which demonstrated that our perception is extremely limited. Thus, beyond showing the limitation of the human eye—indeed, as Linda Dalrymple Henderson described it more broadly, "the inadequacy of human sense perception"—X-rays offered a view of a reality beneath the surface of objects (1988).

Like Freud's psychology, these radical ideas from physical science were commonly discussed in intellectual circles and written about in newspapers and magazines. They undoubtedly stimulated Picasso and Braque to liberate themselves from certain artistic traditions that had scarcely changed since the Renaissance (Henderson 1988). We see these new conceptions of mental processes in three *papier collé* works by Picasso in the Leonard A. Lauder collection at the Metropolitan Museum of Art: *Composition with Violin*, *Head of a Man*, and *Head of a Man with a Moustache* (figs. 5.1, 5.6, and 5.7). The technique of *papier collé*, or pasted paper, represents the most extreme Cubist reduction of the picture's surface to a flat plane. We identify the musical instrument in *Composition with a Violin* and a face with a hat in *Head of a Man* amid the intersecting, abstract shapes and lines by free association, which relies heavily on primary process thinking. In *Head of a Man with a Moustache*, Picasso goes even further, testing the limits of our ability to process visual ambiguity.

Cubism allowed artists to demonstrate that art can exist on the canvas or sheet of paper, a two-dimensional surface, in the same way that it exists in the unconscious mind—independent of nature, time, and space. This new view altered forever how artists depict the world before them. It also altered how the viewer apprehends images—by free association in response to clues such as profiles of objects, related objects or words, and titles. As the art critic Carl Einstein emphasized: "'Cubism' goes far beyond painting. . . . Cubism is tenable only if one creates equivalents in the mind" (Einstein 1923, cited in Haxthausen 2011). Consequently, Cubism posed what is probably the most radical challenge to the viewer's perception in the history of art. To appreciate this challenge, it is useful to place Cubism in the context of the biology of visual perception and examine how the modernist understanding of the beholder's share evolved.

Kris argued that each work of art is ambiguous and evokes a somewhat different perceptual and emotional response from the beholder. As a result of these differences in response, Kris held that each beholder's brain recapitulates, in a modest way, the creative process that took place in the artist's

brain (Kris and Gombrich 1938; Kris with Kaplan 1952). This is certainly true of Cubist art, which played with the ambiguous representation of things, forcing an unprecedented examination of the artist's intentions.

Ernst Gombrich went a step further, arguing that the very act of visual perception is creative. In this, he was influenced by the Anglo-Irish philosopher George Berkeley, who in 1709 appreciated that we do not see material objects per se, but the light reflected off them (Berkeley 1709). Thus, the two-dimensional image projected onto the retina of our eye can never accurately specify a three-dimensional object. This fact, and the difficulty it raises for understanding the reality of any image, is referred to as the *inverse optics problem* (for modern discussions see Albright 2012; Purves and Lotto 2010). Berkeley went on to say that the inverse optics problem arises because any given image can be generated by objects of different sizes, with different physical orientations, and at different distances from the observer. Therefore, the actual location in space of any three-dimensional object is inherently uncertain (Gombrich 1982; 1984).

How are we are able to respond so successfully to the real world if we depend on a retinal image that precludes direct knowledge of that world? Our eyes do not receive enough information to reconstruct an object accurately, yet we do it all the time. The answer to this question was outlined, in good part, by Hermann von Helmholtz, a noted nineteenth-century physician, physicist, and physiologist. Helmholtz argued that we solve the inverse optics problem by including two additional, unconscious sources of information: bottom-up information and top-down information (Kandel 2012; see also Adelson 1993).

Bottom-up information is supplied by computations that are inherent in our brain's circuitry and governed by universal rules for extracting sensory information from the physical world. We use these rules to discern objects, people, and faces; to ascertain their placement in space (perspective); and ultimately to construct visual worlds of great subtlety, beauty, and practical value. Edward Adelson (1993) and Dale Purves and R. Beau Lotto (2010) proposed that since our brain can construct images from incomplete information, our visual system must have evolved to compensate for gaps in

information. For example, the brain assumes that the sun is always above us, no matter where we are. We therefore expect light to come from above, as it has reliably for the millennia of human evolution predating the electric light bulb. If it does not—as in a visual illusion—our brain can be tricked.

These universal rules of visual processing were analyzed in depth by the Gestalt psychologists, whose work greatly influenced Kris and Gombrich. The Gestalt movement, which began in Berlin in 1910, introduced two new concepts into the study of visual perception, and therefore into our understanding of the beholder's share. *Gestalt* means configuration, and what interested the pioneering Gestaltists Max Wertheimer, Wolfgang Köhler, and Kurt Koffka about configuration was first, that the whole is more than the sum of its parts and second, that our ability to perceive and respond to the whole instead of its parts is inborn. For example, we see a face not as an image made up of individual components—two eyes, a nose, and a mouth set into an oval structure—but as a total entity. Our ability to respond holistically to sensory images and to assign meaning to them and not to their parts is a function of our built-in bottom-up processing.

One universal rule of this process is that lines that follow the same arc are likely to belong to the same object, even if they are interrupted by a gap or another shape. This is known as the principle of "good continuation." Thus, if a tree occludes a segment of the horizon, we do not assume that the two horizon lines on either side of it belong to different objects, but rather that they connect out of view. Psychologist of art Robert Solso wrote that bottom-up perception is a matter of nativistic perception: "People have certain inborn ways of seeing, in which visual stimuli, including art, are initially organized and perceived. Causally speaking, nativistic perception is 'hard-wired' in the sensory-cognitive system" (Solso 2003). Cubism, as we will see, subverts those innate rules of perception.

Top-down information refers to cognitive influences and higher-order mental functions such as attention, expectations, and learned associations. Information from top-down processing impinges on the information we receive from bottom-up processing. Because much of the sensory information that our brain receives through our eyes can be interpreted in a variety

of ways, it must use top-down information to resolve ambiguity. We must guess, based on experience, the meaning of the image in front of us. Our brain does this by constructing and testing a hypothesis. As Charles Gilbert (2012; 2013) and Tom Albright (2012) have emphasized, top-down information places the image into a personal psychological context, thereby conveying different meanings about it to different individuals. Since we are not normally aware of constructing visual hypotheses and drawing conclusions from them, Helmholtz called this top-down process of hypothesis testing *unconscious inference.*

The great American philosopher and psychologist William James, a contemporary of Helmholtz and a teacher of Gertrude Stein, wrote in 1890: "Whilst part of what we perceive comes through our senses from the objects before us, another part (and it may be the larger part) always comes . . . out of our own head." Perception incorporates the information our brain receives from the external world with knowledge based on learning from earlier experiences and hypothesis testing. We bring this knowledge—which is not necessarily built into the developmental program of our brain—to bear on every image we see.

When we look at a work of art, we relate it to memories of other artworks we have seen, as well as to scenes and people that have meaning to us. In a sense, to see what is represented by the paint on a canvas, we have to know beforehand what sort of image we might expect to see in a painting. Our familiarity with centuries of landscape paintings helps us to discern almost immediately the haystacks among the Post-Impressionist swirls of Van Gogh or a field in the pointillist dots of Georges Seurat. In this way, the artist's modeling of physical and psychic reality parallels the intrinsically creative operations of our brain in everyday life (Miyashita et al. 1998).

Bottom-up and top-down processing do not contribute to the beholder's share to the same degree throughout the history of Western art. When looking at a Renaissance painting, for example, our brain comprehends the image in accordance with unified perspective and the inborn rules of bottom-up processing (Deregowski 1973). Western painters mastered the elements of perspective, foreshortening, modeling, and chiaroscuro—the tools that evolved

to enable our brain to infer the three-dimensional cause of the flat, two-dimensional images on our retina (a skill that is critical to our survival). In fact, one can argue that classical painters' experiments in perspective, illumination, and form—from early Western figurative painting to the Impressionists, the Fauves, and the Expressionists—recapitulate intuitively the developmental brain processes that give rise to bottom-up processing.

Cubism poses such an enormous challenge to the beholder because it dares our visual system to reconstruct an image that is fundamentally different from the kinds of images our brain evolved to reconstruct. By dismantling perspective and showing us several different views of the same object, Cubist art requires the brain to either come up with a new logic of bottom-up processing or to override it altogether by means of top-down processing. It requires the beholder to substitute primary process thinking, which easily forms connections between different objects and ideas and has no need of time or space, for secondary process thinking, which is logical and requires time and space coordinates. As Carl Einstein pointed out, Cubism deformed our normal habits of perception; the visual arts no longer paralleled the operations of the visual brain: "Cubism put an end to the laziness or fatigue of vision. Seeing had again become an active process" (Einstein 1931, cited in Haxthausen 2011).

Picasso and Braque had already thrown bottom-up processing into disarray with Analytic Cubism. With Synthetic Cubism they incorporated large colored or printed pieces of paper—including newspaper clippings, advertisements, and wallpaper—into their compositions to redefine the role of top-down processing in art. These new, ready-made materials convey additional content because they are culturally recognizable artifacts in themselves. Newspaper clippings are an example. By the beginning of the twentieth century, the demand for information had made daily newspapers the first mass medium (Mileaf and Witkovsky 2012), and they had moved to the center of Parisian life (Brodie with Boxer 2012). With their use of pasted newspaper clippings, Picasso and Braque combined their interest in conveying a new experience of art with the Parisian reader's—and beholder's—insatiable desire for new knowledge, which they obtained

from the newspapers and of which they were reminded repeatedly by simply looking at the typed insert and perceiving it as such. This combination would capture the beholder's attention and demand greater top-down processing to understand how the image is presented.

Whereas in Analytic Cubism the artists reassembled small facets of an object to evoke that object from a number of perspectives, in Synthetic Cubism they eliminated, with some exceptions, the last vestiges of three-dimensional space. Picasso created an image using pieces of paper that allude to the object, either by echoing its shape, as in *Composition with Violin* (fig. 5.1), or by using words or graphic elements that relate to the

5.1 Pablo Picasso, *Composition with Violin* (Paris, 1912). Cut-and-pasted newspaper, graphite, charcoal, and ink on white laid paper, 24 × 18 3/8 in. (61 × 46.7 cm)

The Metropolitan Museum of Art. Art Resource, artres.com

object's function or material. He combined elements not as visual reproductions but as parts of or clues to how we conceptualize objects: a collage of a musical instrument becomes a reflection of our brain as much as of our eyes. As we can see in *Composition with Violin*, Picasso held on to the idea of illusionistic representation, even as he challenged the process itself. For example, he used traditional chiaroscuro modeling to cast the right side of the pasted-paper shape into relief. The pasted materials used in papier collé images add novel tactile as well as visual elements. Paradoxically, the introduction of a second aesthetic element—touch—comes close to creating an illusionary effect in these works.

In *Composition with Violin* the profile of the newspaper segment (cut from *Le Journal*) does not follow the profile of the violin, yet it is shaped somewhat like a violin. It seems to represent the violin as seen from another perspective. Moreover, the curved sides of the violin resemble the outlines of a curved face, and the tailpiece resembles a mouth. Indeed, the rectangular violin also resembles a face, its eyes formed by the half circle at the top, cut in two by the instrument's neck (the nose), and a mouth below, formed by the shape of the bridge. The two f-holes even form dimples! The switching between violin and face requires attention and increases the beholder's involvement, reminding us of Gombrich's fascination with the famous duck-rabbit image (fig. 5.2).

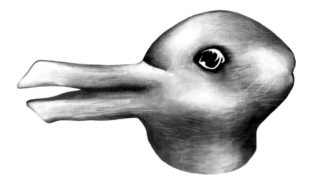

5.2 Joseph Jastrow, *Duck-Rabbit Illusion* (1899)

From Joseph Jastrow, "The Mind's Eye," *Popular Science Monthly* 54 (January 1899): 312

If we focus initially on the left side of the image, we see the beak of a duck with the back of its head on the right. If we focus on the right side, we see the head of a rabbit with its ears on the left. Because conscious attention is limited and top-down perceptual hypothesis generation is automatic, we can see only one image or the other, the rabbit or the duck, but never both at once. In accepting one hypothesis of the image we automatically exclude the other (Gregory and Gombrich 1973). The intriguing thing about this image is that the visual information on the page does not change. What changes is our interpretation of the image, triggered by the focus of our attention. Interpretation is inherent in visual perception, as we have seen, but it is particularly important in the perception of Cubist art, which relies heavily on top-down processing.

Because faces, in various forms, appear frequently in the Cubist art of Picasso and Braque—as, indeed, they do in all Western art—it behooves us to explore why faces are so important, how face recognition relates to bottom-up processing, and how the Cubists transformed the depiction of faces. Of all the objects in the world, faces are the most special from a biological point of view. As Charles Darwin first pointed out, we recognize each other and even ourselves through our faces (1872). Moreover, since we are social animals, we communicate not only our ideas and plans but also our emotions through our faces. The ability to form facial expressions and to read those of others is innate, not learned, and our brains treat faces differently from all other objects. Face recognition is uniquely sensitive to inversion: not only do we have difficulty recognizing a face upside down, we cannot under most circumstances recognize a change in expression on an inverted face.

In this context it is illuminating to trace the evolution of Picasso's depiction of faces as he moved into his Cubist period. In his extraordinary 1905–6 painting of Gertrude Stein (fig. 5.3), Picasso reduced the figure to simple masses, the face having large, distorted, heavy-lidded eyes and an oversized brow, reflecting his recent interest in Iberian sculpture. The exaggeration of Stein's brow and eyelids also announced Picasso's recruitment of caricature and exaggeration, devices he would use repeatedly in

5.3 Pablo Picasso, *Gertrude Stein* (1905–6).
Oil on canvas, 39 3/8 × 32 in. (100 × 81.3 cm)

The Metropolitan Museum of Art, New York, Bequest of Gertrude Stein, 1946 (47.106)

his Cubist phase. As Adam Gopnik has argued (1983), caricature played a critical role in the evolution of Cubism. At the same time, the portrait of Stein clearly displays plausible spatial depth, and we have no difficulty in perceiving that this is a portrait of a person.

Four years later, Picasso painted portraits of two of his dealers, Ambroise Vollard (fig. 5.4B) and Daniel-Henry Kahnweiler (fig. 5.5), in his Analytic Cubist style. Although the portrait of Vollard is made up of small, prism-like facets, we recognize his face as a face because it is presented right side up and has all the components of a face. Further, with a photograph for comparison

5.4A Brassai (Gyula Halasz), *Ambroise Vollard in His Office with His Cat* (1934). Gelatin silver print.

Private collection

5.4B Pablo Picasso, *Ambroise Vollard* (1910). Oil on canvas, 36 5/8 × 26 in. (93 × 66 cm).

Pushkin State Museum of Fine Art, Moscow

(fig. 5.4A), we recognize the individual known as Vollard because the few characteristic features that Picasso painted capture the unique and distinguishing elements of Vollard's face.

Picasso surmised, correctly, that our recognition of the face of a person in a painting reenacts the brain's bottom-up information processing. Our top-down processing, which then comes into play, is based not on a series of cerebral snapshots filed away in memory but on salient, meaningful features that are stored in our brain as abstract representations of that person.

In contrast, Picasso's portrait of Kahnweiler (fig. 5.5) presents the viewer with a more demanding image of rearranged components of a face.

5.5 Pablo Picasso, *Daniel-Henry Kahnweiler* (autumn 1910).
Oil on canvas, 39 1/2 × 29 1/2 in. (100.4 × 72.4 cm)

Art Institute of Chicago, Gift of Mrs. Gilbert W. Chapman in memory of Charles B. Goodspeed (1948.561)

Our top-down processes must search with greater than usual intensity for meaning, in their unconscious as well as their conscious knowledge of the external world. Indeed, without the title, we would be hard put to be certain that this image is a portrait. Only by focusing our attention on the upper third of the canvas can we discern a face. Once we have accepted the hypothesis of a face, we can make out two eyes and a nose and a curve that may function as either a mouth or a mustache.

Picasso's portrait of Kahnweiler provides an excellent example of the critical role that attention plays in visual perception, especially in the perception of Cubist art (Baxandall 1910). As with the duck-rabbit image, when we focus our attention on an image, we not only identify what the image is, we also exclude alternative hypotheses of what it might be. Here we see Helmholtz's top-down process at work: once we form a hypothesis, the image is no longer ambiguous.

In a line drawing, facial features are slightly exaggerated, making recognition easier. Kris and Gombrich have argued that the facial exaggeration used by cartoonists is successful because our brain responds specifically to such exaggeration. Despite the absence of three-dimensional mass and volume in *Head of a Man* (fig. 5.6), we can identify the curves of a face with a centrally located eye, two ears on either side, a tiny mouth below, and a prominent nose pointing to the left. The nose casts a shadow on its right side, giving this otherwise flat image a sense of three dimensions.

Yet here our brain must still explore images that at first glance appear to have little or no relation to each other and convey no sense of time or space: truth is buried beneath the surface. As a result, our bottom-up processes, which follow built-in rules of perspective and Gestalt, cannot help us, and our top-down mental processes must work extra hard to extract meaning. In addition, the two strips of papier collé–the *faux bois* and the newspaper— add a sly commentary on the nature of artifice. Art, this work tells us, is no longer a record of images bombarding the retina with reflected light; it is the result of intelligent, top-down exploration.

In *Head of a Man with a Moustache* (fig. 5.7), Picasso tests the limits of our ability to process visual ambiguity. We see only half of the face, whose

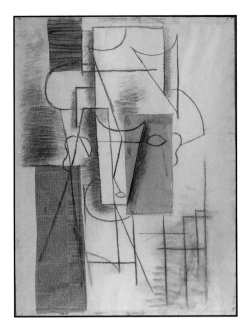

5.6 Pablo Picasso, *Head of a Man* (Paris, 1912). Charcoal, watercolor, cut-and-pasted newspaper, and gray laid paper on white laid paper, 24 5/8 × 18 1/2 in. (62.5 × 47 cm)

The Metropolitan Museum of Art. Art Resource, artres.com

5.7 Pablo Picasso, *Head of a Man with a Moustache* (1913). Ink, charcoal, and graphite on newspaper, 21 7/8 × 14 3/4 in. (55.6 × 37.5 cm)

The Metropolitan Museum of Art. Art Resource, artres.com

curved shape is echoed by its one ear; the moustache lies below the chin rather than on the upper lip, or perhaps the little square beneath it can be seen as a mouth. Such visual contradictions violate our innate rules for facial perception. The drawing also contains several vaguely mechanical lines whose function is uncertain, further disorienting us. The situation is compounded by the brain having to read an image right side up against a background of writing that is upside down. Picasso simultaneously shows us different components of a single face—the side of a head, an ear, a moustache, and a mouth—without any shading or perspective. Our bottom-up processes fail us and our top-down processes face a challenge unprecedented in the history of Western art.

Because Picasso has drawn the man's face on a page from a newspaper, we have visual and verbal clues to how the various elements of the image relate to each other and what they mean. These clues both delight and confuse us. For one, the image is superimposed on an upside-down page of the newspaper *Excelsior* that features an advertisement for Scrubb's Ammonia, a compound touted as "indispensable" for personal grooming. But in a double entendre that is characteristic of Picasso's collages, ammonia, which is toxic and hazardous, would hardly be indispensable for keeping the French moustache properly tended. Picasso playfully creates a dialogue between two very different kinds of objects: a widely recognizable newspaper advertisement and a relevant drawing of a man with a mustache. In fact, Picasso draws several subtle parallels between his contour lines and the information contained in the newspaper: for example, the symmetrically curved two-part ear of the man mirrors the reversed *B*'s in the word "Scrubb's" (Rubin 1989). We see a similar visual play in the contour lines themselves: the head of the man with the moustache is projected against a larger circle that could also be a face and could even share the mustache with the "original" man.

Perhaps the most extreme example of top-down processing in this image can be found in the part of the drawing to the right of and below the primary head. These paired, (mostly) perpendicular lines may be seen as a chair prominently in profile, upon which various elements, perhaps parts

of the head, rest. Or the rectangular form of the chair could appear as an arm or a hand on which the head is resting. While the average beholder most likely sees the chair, scholars and connoisseurs familiar with Picasso's schematic reduction of heads may protest that he did not depict heads on chairs and seek another interpretation. Thus, *Head of a Man with a Moustache* illustrates perfectly how the beholder's share—the knowledge, experience, and memories a viewer brings to a work of art—can create very different conceptions of an ambiguous image and, moreover, how those conceptions may or may not differ from the artist's intended range of possible readings.

In his papier collé works Picasso not only dismantled the building blocks of bottom-up visual processing by eliminating perspective and holistic depiction, he also nullified the very premise on which bottom-up processing is based. We scan a Cubist painting for Gestaltist links between line segments (good continuation), for recognizable contours and objects, but in the most fragmented works our efforts are thwarted. Such works call for new rules of bottom-up processing that often do not exist and have to be supplied by extensive, creative, top-down processing.

Gombrich criticized the nineteenth-century English art critic John Ruskin's idea of the innocent eye, arguing that perception is not an emotion but a learned practice involving what we now call active top-down reconstruction of the world. Yet, in the sense that it disorients the bottom-up processing we are born with, Cubism reinstituted the innocent eye. More broadly, Cubism offers us an opportunity to respond to works of art in new ways that in turn make it easier for us to respond to subsequent artistic experiments. Writing in the first years of the twentieth century, Viennese art historian Riegl put forth the notion of *kunstwollen*, an artistic drive that is determined by the historical period in which an artist lives (Kemp 1999), and developed this principle as a means of analyzing different modes of representation in art history. It is clear from the work of Picasso and Braque that Cubism demands a parallel development in the beholder's response: that is, it demands changes in the beholder's share that are suited to the modern era.

ACKNOWLEDGMENTS

This essay was originally published in *Cubism: The Leonard A. Lauder Collection*, ed Emily Braun and Rebecca Rabinow, 106–15. Copyright © 2014 by The Metropolitan Museum of Art, New York. Reprinted by permission.

I am indebted to Emily Braun for her insightful comments on the manuscript as it progressed, which greatly enhanced its clarity. I am also grateful to Ann Tempkin, Tony Movshon, and Blair Potter for their earlier reviews.

This essay also draws from my book *The Age of Insight: The Quest to Understand the Unconscious in Art, Mind, and Brain From Vienna 1900 to the Present* (New York: Random House, 2012), particularly chapters 11–18 and the references therein. I also draw on material discussed in *Principles of Neural Science*, 4th ed., ed. Eric R. Kandel, James H. Schwartz, and Thomas M. Jessell (New York: McGraw Hill, 2000).

REFERENCES

Adelson, Edward H. 1993. "Perceptual Organization and the Judgment of Brightness." *Science* 262: 2042–44.

Albright, Thomas D. 2012. "Perception and the Beholder's Share," a conversation with Roger Bingham. The Science Network, http://thesciencenetwork.org.

Baxandall, Michael. 1994. "Fixation and Distraction: The Nail in Braque's *Violin and Pitcher* (1910)." In *Sight and Insight: Essays on Arts and Culture in Honour of E.H. Gombrich at Age 85*, ed. John Onians, 399–415. London: Phaidon.

Berkeley, George. 1709. "An Essay Towards a New Theory of Vision." In *The Works of George Berkeley, Bishop of Cloyne*, ed. Arthur A. Luce and Thomas E. Jessop, vol. 1, 171–239. London: Nelson, 1948. Originally published as George Berkeley, *An Essay Towards a New Theory of Vision* (Dublin: Aaron Rhames for Jeremy Pepyat, 1709).

Brenson, Michael. 1989. "Picasso and Braque: Brothers in Cubism." *New York Times*, September 22, C1, C30.

Brodie, Judith with Sarah Boxer et al., eds. 2012. *Shock of the News*. Exhibition catalogue. Washington, DC: National Gallery of Art.

Darwin, Charles. 1872. *The Expression of the Emotions in Man and Animals*. New ed. Ed. Joe Cain and Sharon Messenger. London: Penguin, 2009.

Deregowski, Jan B. 1973. "Illusion and Culture." In *Illusion in Nature and Art*, ed. Richard L. Gregory and Ernst H. Gombrich, 161–91. London: Duckworth.

Freud, Sigmund. 1900. "The Interpretation of Dreams." In *The Standard Edition of the Complete Psychological Works of Sigmund Freud*, ed. and trans. James Strachey. Vols. 4 and 5. London: The Hogarth Press and the Institute of Psycho-Analysis, 1953.

——. 1911. "Formulations on the Two Principles of Mental Functioning." In *The Standard Edition of the Complete Psychological Works of Sigmund Freud*, ed. James Strachey. Vol. 12, 213–26. London: The Hogarth Press and the Institute of Psycho-Analysis, 1958.

Gilbert, Charles D. 2013. "Top-Down Influences on Visual Processing." *Nature Reviews: Neuroscience* 14, no. 5: 350–63.

——. 2012. "Intermediate-Level Visual Processing and Visual Primitives." In *Principles of Neural Science*, 5th ed., ed. Eric R. Kandel, James H. Schwartz, Thomas M. Jessell, Steven A. Siegelbaum, and A. J. Hudspeth, 602–20. New York: McGraw-Hill, pp. 602–20.

Gombrich, Ernst H. 1984. "Reminiscences on Collaboration with Ernst Kris (1900–1957)." In *Tributes: Interpreters of Our Cultural Tradition*. Ithaca, NY: Cornell University Press.

——. 1982. *The Image and the Eye: Further Studies in the Psychology of Pictorial Representation*. London: Phaidon.

——. 1960. *Art and Illusion: A Study in the Psychology of Pictorial Representation*. The A.W. Mellon Lectures in the Fine Arts. Bollingen Series 35, no. 5. New York: Pantheon, 282; see also 203–59, 297.

Gopnik, Adam. 1983. "High and Low: Caricature, Primitivism, and the Cubist Portrait." *Art Journal* 43, no. 4: 371–76.

Gregory, Richard L. and Ernst H. Gombrich, eds. 1973. *Illusion in Nature and Art*. London: Duckworth.

Haxthausen, Charles W. 2011. "Carl Einstein, Daniel-Henry Kahnweiler, Cubism, and the Visual Brain." Nonsite.org no. 2, Evaluating Neuroaesthetics; https://nonsite.org/issues/issue-2-evaluating-neuroaesthetics.

Henderson, Linda Dalrymple. 1988. "X Rays and the Quest for Invisible Reality in the Art of Kupka, Duchamp, and the Cubists." *Art Journal* 47, no. 4: 323–40.

———

James, William. 1890. *The Principles of Psychology*. New ed. in 3 vols. Cambridge, MA: Harvard University Press, 1981, vol. 2, 747.

Kandel, Eric. 2012. *The Age of Insight: The Quest to Understand the Unconscious in Art, Mind, and Brain drom Vienna 1900 to the Present*. New York: Random House, 202–3.

Kemp, Wolfgang. 1999. "Introduction." In *The Group Portraiture of Holland*, trans. Evelyn M. Kain and Daniel Britt. Los Angeles: Getty Research Institute for the History of Art and the Humanities, Texts and Documents Series.

Kris, Ernst and Ernst H. Gombrich. 1938. "The Principles of Caricature." *British Journal of Medical Psychology* 17, nos. 3–4: 319–42.

Kris, Ernst with Abraham Kaplan. 1952. "Aesthetic Ambiguity." In *Psychoanalytic Explorations in Art*, ed. Ernst Kris, 243–64. New York: International Universities Press.

Mileaf, Janine and Matthew Witkovsky. 2012. "News Print and News Time." In *Shock of the News*, ed. Judith Brodie with Sarah Boxer et al. Exhibition catalogue. Washington, DC: National Gallery of Art.

Miller, Arthur I. 2001. *Einstein, Picasso: Space, Time, and the Beauty that Causes Havoc*. New York: Basic Books.

Miyashita, Yasushi, Masashi Kameyam, Isao Hasegawa, and Tetsuya Fukushima. 1998. "Consolidation of Visual Associative Long-Term Memory in the Temporal Cortex of Primates." *Neurobiology of Learning and Memory* 70: 197–211.

Purves, Dale and R. Beau Lotto. 2010. *Why We See What We Do Redux: A Wholly Empirical Theory of Vision*. Sunderland, MA: Sinauer Associates.

Riegl, Alois. 1902. *The Group Portraiture of Holland*, trans. Evelyn M. Kain and Daniel Britt. Los Angeles: Getty Research Institute for the History of Art and the Humanities, Texts and Documents Series, 1999.

Shlain, Leonard. 1991. *Art and Physics: Parallel Visions in Space, Time, and Light*. New York: Morrow.

Solso, R. L. 2003. *The Psychology of Art and the Evolution of the Conscious Brain*. Cambridge, MA: MIT Press, 2.

COMPARISON OF SCULPTURE AND PAINTING

The visual arts—painting and sculpture—allow us to enrich our perceptual experiences and thereby our lives by exposing us to objects in the world we might otherwise never encounter. They not only inform and enlighten us but also enchant us with their magic.

This essay focuses primarily on the enchantment of sculpture. To place sculpture into a meaningful context, I divide the discussion into three parts. First I provide a brief introduction to the origins and early history of sculpture. Then I discuss why we perceive sculpture and painting so differently. Finally I compare six sculptures exhibited at the Metropolitan Museum of Art to six contemporaneous paintings.

A BRIEF HISTORICAL PERSPECTIVE ON SCULPTURE

Sculpture is the oldest of the fine arts. The earliest known examples date to the Aurignacian culture of the Upper Paleolithic period, which lasted from about 40,000 to 30,000 B.C., some 10,000 years before the first cave paintings. In addition, because they are carved in stone, which is far less perishable than the materials used in paintings, sculptures are the most numerous examples we have of the visual arts of ancient cultures.

Sculptures from the Aurignacian culture were probably made to be used in rituals. This is evident in the oldest surviving example: the Venus of Hohle Fels, an image of a woman thought to be a fertility goddess that was carved in about 35,000 B.C. from mammoth tusk ivory (fig. 6.1). A second early fertility goddess is the Venus of Willendorf (fig. 6.2), a plump woman carved in about 24,000 B.C. from limestone and tinted with red ochre. The Venus figures do not have faces, and they represent rather crude, exaggerated versions of the female body. Their vulva, breasts, and swollen belly are pronounced, suggesting a strong connection to fertility and pregnancy.

Since the discovery and naming of these two statues, in 2008 and 1908 respectively, more than one hundred other fertility figures have been discovered. They are referred to collectively as the Venus figurines, and they represent women in all stages of their lives: pubescent, mature, pregnant, and giving birth.

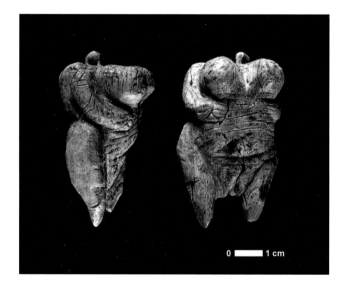

6.1 The first known sculpture, the Venus of Hohle Fels, circa 35,000 B.C.

Public domain, Creative Commons

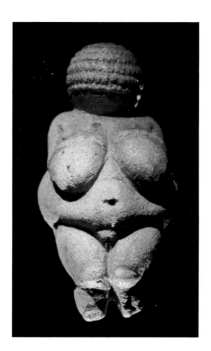

6.2 The Venus of Willendorf, circa 24,000 B.C.

Public domain, Creative Commons

Interestingly, the first known male fertility symbol did not appear until 18,000 B.C., and then not as a sculpture. It was a painting on a cave wall of a sleeping man with an erection (fig. 6.3).

At the dawn of Egyptian civilization, between 4500 and 3000 B.C., the first statues were also fertility symbols. Portrait sculpture came on the scene somewhat later, when the pharaohs began to have their likeness carved, possibly with the hope of making themselves immortal (fig. 6.4). These sculptures were hierarchical: the pharaoh and his queen were always larger than less important people.

At its best, Egyptian sculpture was amazingly lifelike, as we can see in the magnificent image of Queen Nefertiti, carved in 1345 B.C. (fig. 6.5).

6.3 The first male fertility symbol: a sleeping man painted on the walls of the cave of Lascaux in France, circa 18,000 B.C.

Art Resource, artres.com

6.4 Egyptian portrait sculpture of Pharaoh Menkaure and his queen, circa 2500 B.C.

Art Resource, artres.com

6.5 Egyptian portrait sculpture of Queen Nefertiti, circa 1345 B.C.

Art Resource, artres.com

The realistic depiction of human beings was further advanced by the Greeks. The ancient Greeks made statues to honor the gods, as we see in the *Venus de Milo*, which is thought to depict Aphrodite, the goddess of beauty and love (fig. 6.6). Later, in the classical period, Greek sculpture became increasingly naturalistic, emphasizing principles of symmetry, proportion, and poise, and began to depict mortal men and women as well as gods and goddesses.

Roman sculpture was strongly influenced by Greek sculpture, but it did have important original characteristics of its own. The best Roman sculpture consists of extremely realistic portraits. Its depictions of people are unforgiving, unlike most of the more idealized Egyptian and early Greek works. A fine example of a Roman portrait is the image of Constantine the Great, the first Roman emperor to convert to Christianity (fig. 6.7).

6.6 Greek sculpture *Venus de Milo*, circa 130–100 B.C.

Art Resource, artres.com

Greek and Roman sculpture continued to influence most Western sculpture for two thousand years. Early Christians decorated churches with demons and devils to remind churchgoers, many of whom could neither read nor write, of the presence of evil (fig. 6.8).

In his discussion of painting and sculpture, Ernst Gombrich (1967) pointed out that during the Renaissance, the very aim of art shifted. Whereas the major function of art in earlier periods had been narrative, with the artistic means of relating the story taking a subordinate role, the

6.7 Roman portrait sculpture of Emperor Constantine the Great, circa A.D. 325–370

Art Resource, artres.com

6.8 A gargoyle on the Gothic cathedral Notre-Dame of Paris, A.D. 1163–1345

Public domain, Creative Commons

sculptor Giovanni da Bologna (Giambologna) heralded a new era. His primary purpose was to solve a technical problem—how to carve the interaction of several nude figures from a single block of marble. He did this admirably in several very large marble statues, including one (fig. 6.9) that shows "the decline of old age, the strength of youth, and the delicacy of womanhood" (Borghini 1584).

Borghini, who wrote about this sculpture two years after it was completed, stated that the sculptor undertook it "for no other reason than to demonstrate the excellence of his skill and without proposing to himself any particular subject matter other than a group consisting of a proud young man who snatched a most beautiful girl from a weak old man." Only after

6.9 Giovanni da Bologna, *The Rape of the Sabine Women* (1574–82), Florence

finishing the sculpture did Giovanni da Bologna Giambologna name it *The Rape of the Sabine Women*. It is a sculpture, as Gombrich points out, that "every visitor to Florence has seen, which owes its entire existence to the desire of its maker to show that he could solve an artistic problem."

COMPARING SCULPTURE AND PAINTING:
THE BEHOLDER'S PERSPECTIVE

The most obvious difference between sculpture and painting is that sculpture is three-dimensional, whereas painting is flat, or two-dimensional. We can see this in the ancient Egyptian sculpture of Queen Nefertiti discussed above and a painting of Queen Nefertari done approximately a century earlier (fig. 6.10). Another major difference is that painting is additive, allowing for constant correction, whereas sculpture is subtractive: once something has been chiseled away, it can never be replaced.

6.10 Sculpture of the Egyptian Queen Nefertiti, circa 1345 B.C. (left) and painting of Queen Nefertari, thirteenth century B.C. (right)

Sculpture (left): public domain, Creative Commons; painting (right): Art Resources, artres.com

In comparing sculpture to painting, we begin with the common-sense difference in dimensionality, but sculpture is not simply a multisided painting. We actually perceive sculpture differently than we do paintings.

From the time we are born, we are intimately involved with the world of three-dimensional form. As a result, we learn something about the structure and expressive properties of forms, and we develop emotional responses to them. This combination of understanding and sensitive response, often called a *sense of form*, can be cultivated and refined. Sculpture appeals to our sense of form. In addition, because it influences how we perceive the space surrounding it, sculpture possesses an outgoing quality known as *sculptural presence*.

Western painting from Giotto to the Impressionists represents increasingly successful *illusions* of sculptural presence. The success of those paintings derives from the ability of the artist to master the elements of perspective, foreshortening, modeling, and chiaroscuro—elements that enable the beholder to believe that he or she is looking at a three-dimensional image.

Vision is fundamental to the perception of both painting and sculpture, but sculpture calls into play more powerful tactile and kinesthetic sensations than paintings do. Even if we do not actually touch a sculpture, it elicits from us both a desire to touch it and the sensation of touching it. Thus, when we look at a sculpture, our visual sensations are translated into sensations of touch, pressure, and grasp. In fact, some art historians and scientists argue that sculpture should be regarded primarily as an art of touch and that our attraction to it is rooted in the pleasure we experience in fondling things. Johann Gottfried Herder, the great Enlightenment student of the aesthetics of touch, argued that touch is the most faithful and fundamental of the five senses. It is the foundation and guarantor of sight: "in the sense of sight is dream, in the sense of touch, truth" (Herder in Gaiger 2002).

We have recently learned that our visual and tactile sensations are closely related. Modern brain science has revealed that the cerebral cortex, the outer covering of our brain that is concerned with higher mental

functioning, has several regions that are specialized for processing visual information and that are also activated by touch. The texture of an object activates neurons in these regions, whether the object is perceived by the eye or the hand. This is why we can easily identify and distinguish between the different materials of an object—skin, cloth, wood, or metal—and can do so at a glance.

Brain imaging studies have also revealed that the way our brain processes information about materials changes gradually over the course of our perceptual experience. In the early stages of perception, the brain processes solely the visual information about a sculpture or a painting. In later stages, it processes both visual and tactile information, resulting in a multisensory representation of the object in the higher regions of the brain. This multisensory representation is the key to how we experience art.

Because of sculpture's three-dimensional form, we have a more visceral reaction to its qualities—delicate or aggressive, flowing or taut, relaxed or dynamic. By exploiting the expressive qualities of form, sculpture is able to create images in which form and subject matter reinforce each other. Such images go beyond the mere presentation of facts. Thus sculpture, like painting, has been used to express a vast range of subtle and powerful human emotions and feelings, from the most tender and delicate to the most violent and ecstatic. But sculpture can activate a more direct physical and bodily response than painting. Rather than hanging flat against the wall, sculpture intrudes on the surrounding space. It encourages us to interact with it physically, by walking around it rather than just looking at it. We relate to it as a thing, an object, or even a being.

How does sculpture do this? One purpose of art is to allow the beholder to experience aspects of life that he or she would normally not experience. Sculpture achieves this by recruiting several of the brain mechanisms used for social interaction (fig. 6.11). For example, when I extend my hand to you, I engage in a basic social act that is processed by a specific region of the brain, a region concerned with biological motion as distinct from the movement of a car or a clock. People with autism have difficulty responding to

biological motion, but sculpture can bring out this social response in some people on the autism spectrum.

As we have seen, sculpture also invites tactile sensitivity. For this reason, it elicits a more pronounced desire to simulate and empathize with a motion being depicted than drawings or paintings do. Two additional psychological processes are richly represented in the brain: the mirror neuron system, which is concerned with simulation, and the theory of mind system, which is concerned with empathy (fig. 6.11). These systems of the social brain are recruited by paintings, but often even more powerfully by sculpture.

The three-dimensional nature of sculpture can limit its scope, however. Sculpture cannot invest its forms with the same qualities of atmosphere,

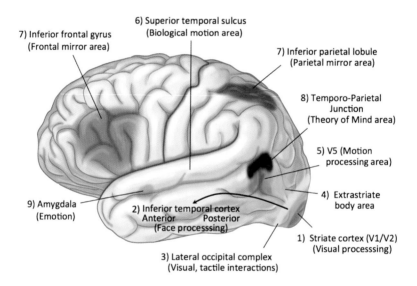

6.11 The beholder's emotional and empathetic responses to sculpture and portraiture are represented in a number of regions of the brain that are involved in emotional, imitative, and social interaction, as well as empathy. Each region has a particular function: area 1 is the first processing area for vision; area 2 is concerned with the processing of faces; area 3 coordinates visual-tactile interactions; area 4 responds to the body; area 5 responds to motion; area 6 responds only to biological motion; both areas 7 imitate (mirror) motion; area 8 is responsible for our theory of mind; and area 9, the amygdala, is concerned with emotion.

Illustration by Therese Winslow, for Eric Kandel

light, and color that a painting can, because canvas enables the artist to display a greater variety of color and a greater subtlety of light than bronze, steel, or stone does. Moreover, since our perception of color in the real world and on canvas is complex and depends on neighboring hues, the painter can play colors off each other in ways that the sculptor cannot. As a result, pointillist painters, such as Monet, could use color to depict nuanced light in shade, and they could achieve a new level of color mixing by using small dots of different colors. Neither of these techniques is available to the sculptor. Sculpture cannot depict a large, complex scene; therefore, painting is the ideal medium for synthesizing the natural world.

Finally, sculpture usually does not depict psychological subtleties in the human face as readily as painting does (Harrison and Wood 2003). Our brain perceives forms like the face in part because of their luminance, their brightness. Therefore, painters use color not simply to depict the natural surfaces of objects but also to convey a wide spectrum of vivid emotion. Nevertheless, sculpture has a vivid physical presence that painting lacks—we do not perceive a sculpture as an illusion, we engage with it as a real object.

Both sculpture and painting call into play the *default mode network* of the brain, discovered by Marcus Raichle in 2000 (Raichle et al. 2001). The network consists of three brain regions: the precuneus, the anterior cingulate cortex, and the inferior prefrontal cortex. It is active when we are resting but suppressed when we are dealing with the world, consistent with the idea that we lose ourselves in our work. More recently this network has been related to the "autobiographical self," "stimulus-independent thought," and "mentalizing."

Surprisingly, this network comes online for the highest aesthetic experiences: it is stimulated when we encounter certain artworks that resonate with our sense of self. Edward Vessel, Nava Rubin, and Gabriella Starr argue that this activation allows our perception of an external sculpture or painting to interact with our neural processes related to the self, possibly affecting them and even being incorporated into them (Vessel and Rubin 2010; Vessel et al. 2012; Starr 2013). This line of thought is consistent with the

idea that an individual's taste in art is linked to his or her sense of identity. Buckner and Carroll (2007) propose that our "default mode" of cognition is characterized by a shift from perceiving the external world to internal modes of cognition that simulate, but are separate from, the world being experienced. Thus, beauty is not only in the eye of the beholder, it is also in the brain of the beholder.

During the sixteenth century, the artists and critics of the Italian Renaissance carried on a debate over the relative merits and fundamental primacy of sculpture versus painting. This discussion took the form of a *paragone*, the Italian word for comparison, and it is crucial for understanding some of the most significant works of art of the high Renaissance (see White 1967). The artists were aware that their culture represented a rebirth of the culture of ancient Greece and Rome, a culture that was passed on largely through sculpture. They saw themselves in competition with the great classical artists, and they tried to surpass the technical virtuosity of the ancients, as we have seen in *The Rape of the Sabine Women* (fig. 6.9).

Renaissance artists not only competed with the ancients, they competed with each other. Moreover, since the guiding principle of Renaissance art was naturalism, the artists also competed with nature.

From this vantage point, painters argued that painting had the advantage over sculpture because a painting could depict an entire visual scene as if viewed through a window and was thus suitable for depicting a narrative. By contrast, Michelangelo—often regarded as the greatest painter in the history of Western art and a great sculptor as well—argued that painting was only great insofar as it imitated the three-dimensional qualities of sculpture (see in particular *Benezit Dictionary of Artists*).

COMPARISONS OF SIX SCULPTURES TO CONTEMPORANEOUS PAINTINGS

To illustrate the differences between sculpture and painting, I compare six sculptures to contemporaneous paintings.

1. The Visitation

First, let us look at the sculpture of the Visitation attributed to Master Heinrich of Constance and the painting of the same subject by Giotto, both done around 1300 (fig. 6.12). Each work depicts the Virgin Mary, who has recently learned of her miraculous conception of Jesus, visiting her kins-woman Elizabeth, who is also expecting a child—John the Baptist.

The figures in the sculpture are carved of walnut, with the original paint and gilding largely intact, and each features a hollowed-out cavity that is covered with crystal. Historians believe that these cavities originally con-tained images of the infants that the viewer could see. The Virgin places her hand tenderly on Elizabeth's shoulder. Elizabeth raises her arm to her breast as if to say: Who am I, that the mother of the Lord should visit me?

The contemporaneous depiction of the Visitation by Giotto, one of the great pioneers in the development of perspective, shows Mary, Elizabeth, and three ladies-in-waiting. The perspective in the painting and the presence of

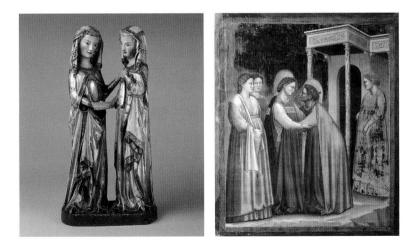

6.12 *The Visitation*, a sculpture attributed to Master Heinrich of Constance (1310–20) (left), and Giotto's painting *The Visitation* (1306) (right)

Art Resource, artres.com

the three additional ladies actually distract a bit from the interaction between Mary and Elizabeth, but Giotto manages to achieve what painting can convey so well—a more psychologically nuanced encounter. Yet the sculpture, while conveying less emotion, conveys a more spiritual attitude by focusing just on the two expectant mothers, who are congratulating each other and interacting as equals. The serenity and simplicity of their faces adds to the effect. Finally, we see their faces very clearly, and since faces are represented prominently in the brain, the sculpture has a great impact on the beholder.

2. *Spinario* and *The Lady with an Ermine*

The second comparison is of Antico's sculpture *Spinario* (Boy Pulling a Thorn from His Foot) and Leonardo da Vinci's painting *The Lady with an Ermine*, both late fifteenth-century works (fig. 6.13).

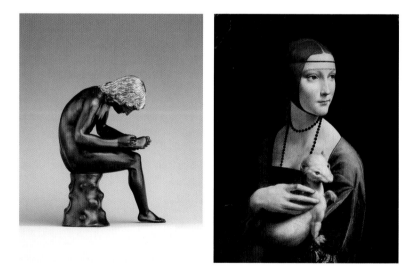

6.13 Antico's sculpture *Spinario* (1496) (left), and Leonardo da Vinci's painting *The Lady with an Ermine* (1489) (right)

Art Resource, artres.com

The sculpture depicts an adolescent boy seated on a tree stump, leaning forward with his left ankle resting on his right thigh. The boy's face is framed by delicate waves of golden hair, and he is focused on the sole of his foot, from which he is removing a thorn, as implied by the position of his right thumb and index finger. The boy's deep concentration as he extracts the thorn from his foot is quite wonderful, as is the position of his body, which is drawn inward, accentuating the graceful curve of his back and the angles of his bent limbs.

The boy is not conscious of the beholder's gaze as he performs his task. Indeed, the small size of the sculpture gives the viewer a feeling of intruding. Although his face—the mouth and eyes inlaid with silver—can best be appreciated from below, his self-contained form is beautiful from any angle, as is the contrast between his smooth skin and the nubbly tree stump he sits on. The three textures—the glossy, striated gold hair; the smooth skin; the knottiness of the tree trunk—almost beg us to reach out and touch the sculpture, creating a powerful example of the brain's ability to process touch and vision together into a multisensory perception.

The original *Spinario*, on which Antico based this work, is one of the few Roman bronze sculptures that has been preserved in excellent shape. An alloy of copper and tin, bronze is a durable material that can take various patinations, such as gilding. Antico's sculpture is unusual in that he adds to the patina of a Roman bronze the blond hair prized in his own day, thereby transforming an ancient masterpiece, descended from an essentially foreign culture, into a contemporary treasure.

Leonardo's *The Lady with an Ermine*, painted in oil on a wooden panel, shows a half-length figure of Cecelia Gallerani, a sixteen-year-old girl. Her body is turned slightly toward her right, and her face is turned to the left. Her gaze is directed not at the beholder but somewhere outside the picture frame. She holds a small white-coated ermine, and her handling of the animal makes an interesting contrast to the boy's handling of his foot.

Cecilia and the boy in the sculpture are about the same age, and each of them is posed in an interesting way. In Leonardo's work, this pose reflects his

lifelong preoccupation with the dynamics of movement. The three-quarter profile was one of his many innovations. The profile might at first suggest that Cecilia is looking at or listening to an unseen person, but on closer examination we may infer that she is lost in thought. The presence of the ermine, whose fur turns white in the winter, adds to the work's richness of meaning and hints at an interesting duality: girl and animal, pure and seductive, perhaps implying that the appearance of purity, even in a person as innocent as Cecelia, simplifies the complexity of feelings that she is capable of having.

Both the painting and the sculpture are rich in detail. Leonardo paints every contour of Cecilia's fingers, each wrinkle around her knuckles, even the flexing of the tendon in her bent finger. Moreover, both the sculpture and the painting capture a moment of movement. Yet although Leonardo is the greater artist and is capable of depicting the psychological depths of his sitters, the sculpture of the boy concentrating on his foot—and our ability to observe him from every angle—is riveting. The sculpture is compelling in a different way than the painting because we identify much more strongly with the bodily presence and intense focus of the boy than with the vague gaze of Leonardo's lady.

3. *A Hypocrite and a Slanderer* and *Self-Portrait as a Warrior*

The third comparison, of Franz Xaver Messerschmidt's sculpture *A Hypocrite and a Slanderer* and Oscar Kokoschka's sculpture *Self-Portrait as a Warrior* (fig. 6.14), departs somewhat from the previous comparisons. It shows the influence of Messerschmidt's sculpture on both a marble bust and a painting by Kokoschka, an Expressionist who worked more than a century later.

Messerschmidt was a gifted portrait sculptor. In 1760, at the age of only twenty-four, he enjoyed considerable success as an artist working in the court of Vienna. As a highly regarded, accomplished assistant professor of sculpture at the Imperial Academy of Vienna, Messerschmidt expected to become the next chair of sculpture when the current chairman died. But Messerschmidt was struck by a mental illness (now thought to be

paranoid schizophrenia) and three years later, when the chair became available, he was passed over. In fact, he lost his teaching position because those making the decisions were concerned that he had not yet recovered from his mental illness.

Deeply offended by this rejection, Messerschmidt left Vienna in 1775 and ultimately settled in Pressburg (now Bratislava) in 1777. There he devoted himself to sculpting over sixty bronze character heads depicting the full range of his mental states. These extraordinary heads feature dramatic, distorted, and at times exalted expressions conveying wildly different emotions. They prefigure Sigmund Freud's focus on mental states and how they are expressed in a person's facial features.

One of the most fascinating aspects of Messerschmidt's portrait sculptures is that he did all of them while actively disturbed by his psychiatric condition. He thus illustrates an important fact that only emerged years later, with the discoveries of modern brain science: a person can be clearly disturbed, yet his creativity may remain intact. In other words, although some parts of the brain are dysfunctional, others can function remarkably well. Some art historians have argued that Messerschmidt's mental illness proved liberating: he began to make art that was true to himself. His demons were now his muses, and he made the creative best of them by portraying them. He did so because they never disappeared from his mirror.

A Hypocrite and a Slanderer (fig. 6.14, above) represents a bald man pressing his chin to his chest, creating concentric wrinkles in his neck and symmetrical jowls and thus increasing the tension evident in his head. This position is an introspective maneuver designed to exclude contact with other people, even with his surroundings. He seems to be attempting to retract his head into his torso as if in shame. Some scholars have referred to this head as depicting a *refusal*, a socially isolated person who averts his gaze and draws into himself, as an autistic or schizophrenic person who lacks communication skills might do.

As mentioned earlier, one purpose of art is to enable us to experience aspects of life we would not normally experience. One way to do that is through empathy, which is strongly represented in the brain. We can look

173

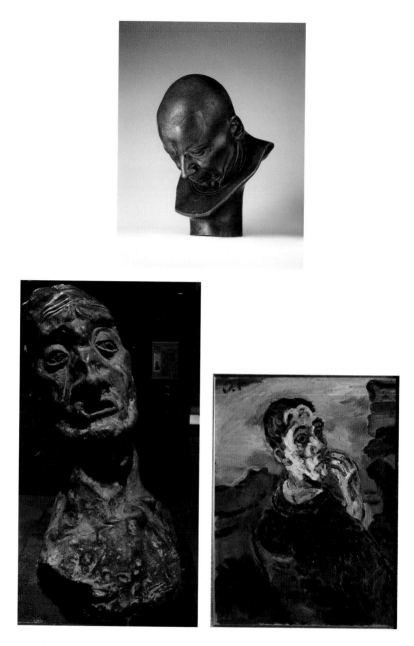

6.14 Franz Xaver Messerschmidt's sculpture *A Hypocrite and a Slanderer* (1771–83) (above) and Oscar Kokoschka's *Self-Portrait as a Warrior* (1909) (below, left) and *Self-Portrait* (1918–19) (below, right)

Sculpture (above), Art Resource, artres.com; sculpture and painting (lower left and right), ResearchGate.

at a Messerschmidt head and sense what he is feeling. The sculpture also recruits the biological motion system and the mirror neuron system of our brain, which are concerned with imitation. So when we look at a Messerschmidt head, we experience internally the emotion that he is portraying; our brain simulates his expression. We may not show it, but we experience it.

Messerschmidt's exaggerated faces and facial expressions are characteristic of Expressionist art, placing him ahead of his time by more than a century. His work was later exhibited in the Lower Belvedere Museum in Vienna and influenced Expressionist painters such as Kokoschka.

We can see Messerschmidt's influence in Kokoschka's first Expressionist work, which was not a painting but a painted clay sculpture of 1909 entitled *Self-Portrait as a Warrior* (fig. 6.14, below, left). In this polychrome bust with its mouth wide open in "an impassioned cry," as Kokoschka wrote in his autobiography, the artist attempts to make his art both more truthful and more jarring by exposing the technique he used to sculpt it. Kokoschka accentuates the physical methods he used to work the clay surface and the techniques he used to suggest the peeling back of his skin and the blood flowing just under the surface. Moreover, to emphasize his individuality as an artist, he leaves his own handprint in the clay and uses unnatural colors—the red above the eyelids and the blue and yellow on the face and hair—to convey extremes of emotion beyond social or painterly decorum.

Here we see Kokoschka forsaking, for the first time, the realistic use of color and texture in favor of their emotional qualities, an approach he would later apply to his painting as well. By freeing color from its representational function, as Van Gogh had begun to do, Kokoschka shifted his art from pictorial accuracy to pure expression. We can see the difference between sculpture and painting by comparing Kokoschka's bust to a painted self-portrait (fig. 6.14, below, right). Kokoschka, in the midst of a tumultuous love affair with the femme fatale Alma Mahler, depicts himself as insecure and anxious—on the verge of a collapse—holding his fingers to his mouth in an infantile fashion. A powerful painting, it nevertheless lacks the sheer sensual power of the sculpture.

4. *Winter* and *Allegory of Winter*

The fourth comparison is of Jean-Antoine Houdon's allegorical sculpture *Winter*, cast in bronze, and the painting *Allegory of Winter*, attributed to Lorenzo Tiepolo, completed within twenty-five years of each other (fig. 6.15).

Houdon's sculpture is a novel depiction of winter. Traditionally, winter is depicted as a hoary old man or an old woman warming herself beside the fire. Houdon opted for the figure of a young girl who is naked except for

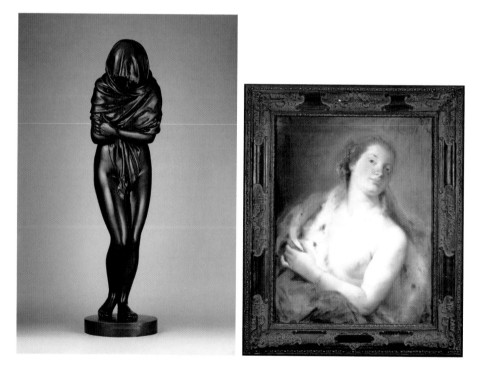

6.15 Jean-Antoine Houdon's sculpture *Winter*, cast in bronze in 1787 (left), and *Allegory of Winter*, a pastel on paper attributed to Lorenzo Tiepolo (1762) (right).

Sculpture (left): Art Resource, artres.com; pastel (right): public domain, Wikimedia Commons

a shawl covering her bowed head and her upper body. Clutching her shawl tightly about her waist and pressing her legs together, she is clearly freezing cold. The naturalistic pose of the shivering girl evokes feelings of empathy in the brain that more traditional versions of winter do not. Her posture and the fact that she is naked are consistent with an allegory of winter, but Houdon clearly intended his sculpture to convey eroticism as well. The girl seems to be avoiding the gaze of the beholder as if she were ashamed of her nakedness.

Houdon's image of winter is shocking, as much to contemporary viewers as to viewers who first saw it in marble in the sculptor's studio. That 1783 marble version was rejected by the Salon in 1785. The eroticism of the half-covered figure struck the jurors as indecent. They proposed that she be displayed with her back in the corner, so viewers would not be disturbed by her shapely posterior. Fortunately, we can view her from all sides at the Metropolitan Museum.

Tiepolo's *Allegory of Winter* also depicts a woman, but again, not the typical woman warming herself by the fire. This woman has slipped her warm coverings off her left shoulder, exposing her breast. Since this is an allegory of winter and she is clearly not cold, she may be inviting the male beholder to slip in beside her and share the warmth of her body. Despite these seductive implications, the painting comes nowhere near depicting the emotion in Houdon's statue, which causes us to shiver.

5. *Nydia, the Blind Flower Girl of Pompeii* and *The Blind Girl*

The fifth comparison is of Randolph Rogers's sculpture *Nydia, the Blind Flower Girl of Pompeii* and John Everett Millais' painting *The Blind Girl*, both created in the mid-1850s (fig. 6.16).

The sculpture of the blind flower seller Nydia was inspired by a popular nineteenth-century British novel, *The Last Days of Pompeii*. In the novel, Nydia and two companions, one of whom is Glaucus, with whom she has fallen in love, attempt to flee the city after the eruption of Mount Vesuvius.

6.16 *Nydia, the Blind Flower Girl of Pompeii* by Randolph Rogers (1853–54) (left) and *The Blind Girl* by John Everett Millais (1856) (right)

Sculpture (left), The Metropolitan Museum of Art, Art Resource, artres.com; painting (right): Wikimedia Commons

The three become separated, however, and the sculpture captures Nydia, alone and isolated, struggling forward through the burning city. The broken Corinthian column at her feet symbolizes the fallen Pompeii, and her clinging garments, entangled in her staff, indicate the chaotic surroundings. Nydia cups her hand to her ear, straining to hear the sound of Glaucus's voice among the sounds of the volcanic eruption. Accustomed to darkness, she uses her acute hearing to find him and to lead the two of them to safety at the seashore, but in the end, despairing at the impossibility of her love, she drowns herself.

Rogers uses a variety of surfaces for the life-sized sculpture. The girl's face, arms, and breast are smoothed with a soulful translucence, while her billowing skirt is carved into thin, dynamic folds. The wind-blown drapery, as it wraps around Nydia's staff and clings to her body, revealing her young figure, gives the sculpture both dynamism and sensuality. The work conveys a sense of emotion that intrudes powerfully into the physical space of the beholder. Her eyes and brows furrowed in concentration add to the depiction of a girl on a mission.

The Blind Girl was painted by John Everett Millais two years later. It depicts an itinerant young musician, who is blind, and her younger, sighted sister sitting on the roadside after a storm. The blind girl cannot see the colorful world around her or the double rainbow in the sky, but she can feel the sun on her upturned face. Like Nydia, the blind girl in Millais' painting has a soulful countenance that evokes pity and appeals to Victorian sensibilities, but unlike Nydia, Millais' blind girl is clothed from head to foot in heavy garments and exudes no sensuality.

Despite Millais' use of vivid color and detail and the blind girl's appeal to the beholder's empathy, the painting cannot match the power and mystery of the sculpture: Millais' blind girl is sitting quietly, while Rogers's Nydia is struggling against the wind. *The Blind Girl* remains essentially a product of the Pre-Raphaelite movement in England, while the sculpture of Nydia transcends time and place.

6. *The Burghers of Calais* and *The Bathers*

Our final comparison is of Auguste Rodin's sculpture *The Burghers of Calais* and Paul Cezanne's *The Bathers*, both late nineteenth-century creations (fig. 6.17).

The Burghers of Calais celebrates a historical event in which Calais, a French port on the English Channel, was under siege by Edward III of England. Starvation eventually forced the residents to negotiate a surrender. Edward offered to spare the people of the city if six of its top leaders would surrender themselves to him, presumably to be executed. He demanded

6.17 *The Burghers of Calais* by Auguste Rodin (1884–85) (above) and *The Bathers* by Paul Cezanne (1894) (below)

Art Resource, artres.com

that each man go forth barefooted, with a noose around his neck, and that they bring him the keys to the city. Eustache de Saint-Pierre was the first to volunteer, and he led the other five men to the city gates. It is this moment, with its poignant mix of defeat, heroic self-sacrifice, and willingness to face imminent death, that Rodin captured in his larger-than-life-sized sculpture. The queen of England later compelled her husband to spare the men's lives, fearing that otherwise, bad luck might befall her unborn child.

Despite their common purpose, each figure in this sculpture faces in a different direction and conveys a distinctly different emotion, ranging from grim determination to terror. In this way, Rodin emphasizes their individuality and isolation. He evokes the heaviness of their psychological burden by making their hands and feet disproportionately large, weighing the figures down. The size and dark color of the figures create a sense of foreboding. But Rodin creates unity in the sculpture by repeating elements: the figures are the same height, they are all wearing plain garments, and two of them have identical facial features. Rodin's arrangement of the figures also unifies their action: he broke from tradition by placing all of them on the same level.

The sculpture exemplifies not only Rodin's extraordinary ability to render the human figure but also his willingness to upend traditional form as he moved toward a more Expressionist style. Almost every aspect of the social brain—emotion, expressive facial gestures, biological movements, simulation, and empathy—is recruited by this powerful sculpture.

Rodin introduced and expanded upon two techniques that would later become characteristic of modern sculpture: fragmentation and repetition. As we see in *The Burghers of Calais*, the repetition of figures and forms creates unity, heightens drama, and introduces a complex psychological dimension. In a larger sense, Rodin exploits fully sculpture's capability for creating depth and sculptural presence, pushing it beyond its traditional limits into modernism.

Rodin's sculpture contrasts dramatically with what was happening in painting at the time. In *The Bathers*, Cezanne depicts six nude men drying and sunning themselves after a swim in a lake surrounded by trees. Whereas

Rodin arranges his six figures to create depth, Cezanne lines his six figures up with the trees to eliminate depth. At the time of this painting, Cezanne was beginning to eliminate perspective in his work, doing away with the illusion of three dimensions and revealing the true, two-dimensional nature of painting.

These two works show us that just as painting was abandoning its historic function of depicting the world in three dimensions by becoming abstract and two-dimensional, sculpture was reasserting its historical role and becoming more Expressionist, occupying even more space. As modern painters were moving toward Cubism and abstraction, modern sculpture, pioneered by Rodin, was emphasizing that its distinctive greatness lies in its three-dimensional form, which invites the viewer to look at it again and again from different vantage points.

These six comparisons illustrate the differences in how our brain responds to sculpture and to painting.

Sculpture's unique features are its three dimensionality, which encourages the beholder to walk around it and interact with it physically and emotionally, and the interaction of its tactile qualities with its visual form, creating a multisensory representation in the brain. The result is that we want to touch and at times to embrace sculpture. Usually we do not act on this impulse, but the areas of the mirror neuron system in the brain that encode simulation, and the theory of mind areas that are concerned with empathy, are likely to be actively recruited.

By contrast, painting is panoramic and can depict large natural scenes, as we see in Cezanne's painting of men drying themselves after a swim. Paintings can also depict subtleties of facial expression and coloration, as well as the play of light and shadow, in ways that are difficult to achieve in sculpture.

Painting and sculpture have evolved along different pathways in response to historical forces. Sculpture was likely the original art form, but painting responded earlier to modern artistic demands for experimentation. In the last century, sculpture has also entered a radical phase of experimentation, one that includes repeated attempts to bring sculpture and painting together into one art form.

ACKNOWLEDGMENTS

This essay originated as a commentary on six sculptures featured as part of the Metropolitan Museum of Art's *Viewpoints* series, September 2014. See https://www.metmuseum.org/search-results?q=eric+kandel

REFERENCES

Benezit Dictionary of Artists. https://www.oxfordartonline.com/benezit.

Buckner, R. L. and D. C. Carroll. 2007. "Self-Projection and the Brain." *Trends in Cognitive Sciences* 11, no. 2: 49–57.

Gombrich, E. H. 1967. The Leaven of Criticism in Renaissance Art." In *Art, Science, and History of the Renaissance*, ed. Charles S. Singleton, 3–42. Baltimore: Johns Hopkins University Press.

Harrison, C., and P. Wood. 2003. *Art in Theory 1900–2000: An Anthology of Changing Ideas*, 652–56. Malden, MA: Blackwell.

Herder, J. G. *Sculpture: Some Observations on Shape and Form from Pygmalion's Creative Dream*. Ed. and trans. Jason Gaiger. Chicago: University of Chicago Press, 2002.

Raichle, M. E., A. M. MacLeod, A. Z. Snyder, W. J. Powers, D. A. Gusnard, and G. L. Shulman. 2001. "A Default Mode of Brain Function." *PNAS* 98: 676–82.

Starr, G. G. 2013. *Feeling Beauty: The Neuroscience of Aesthetic Experience*. Cambridge, MA: MIT Press.

Vessel, E. A. and N. Rubin. 2010. "Beauty and the Beholder: Highly Individual Taste for Abstract, but Not Real-World Images." *Journal of Vision* 10, no. 2: 1–14.

Vessel, E. A., G. G. Starr, and N. Rubin. 2012. "The Brain on Art: Intense Aesthetic Experience Activates the Default Mode Network." *Frontiers in Human Neuroscience* 6, no. 66.

White, J. 1967. "Aspects of the Relationship Between Sculpture and Painting: The Leaven of Criticism in Renaissance Art." In *Art, Science, and History of the Renaissance*, ed. Charles S. Singleton, 43–110. Baltimore: Johns Hopkins University Press.

CHAPTER 7

THE BEHOLDER'S RESPONSE TO ABSTRACT AND FIGURATIVE ART

WITH

C. DURKIN, E. HARNETT, AND D. SHOHANY

Art is incomplete without the perceptual or emotional involvement of the viewer.

—Alois Riegl

When we view a work of art, our brain uses a combination of innate, bottom-up visual processing and top-down cognitive processing to re-create the image. These processes vary, depending on whether the image before us is figurative or abstract. Figurative, or representational, art details naturalistic objects or scenes; abstract art contains no objects or scenes. Cubist art baffles our brain's bottom-up visual system, challenging it to reconstruct abstract images that are fundamentally different from the naturalistic images it evolved to perceive. We also know that our brain is a creativity machine. It uses top-down cognitive processes involving our experiences, attention, expectations, and learned associations to make sense of confusing visual information.

As a result, our subjective experiences of abstract and of figurative art—our perceptual, emotional, cognitive, aesthetic responses—are different. In addition, the more ambiguous a work of art, the more top-down processing we must do to resolve the ambiguities and assign the work meaning, utility, and value. The lack of objects in abstract art requires the viewer to create new personal associations.

Much research has focused on viewers' preferences, which generally favor figurative over abstract art. Schepman and her colleagues have studied the mental processes that may underlie viewer preferences, noting that "taste for representational art is shared across individual observers, while taste for abstract art is more idiosyncratic" (8). Differences in viewer response raise some interesting questions about the differences in the viewer's psychological experience of abstract art: Does abstract art evoke a different state of mind than figurative art does? If so, how can we characterize and quantify the difference empirically?

DIFFERENCES IN PROCESSING ABSTRACT AND REPRESENTATIONAL ART

The beholder's share—the subjective meaning a viewer invests in a work of art—is essential to that work. First formalized as the "beholder's involvement" by the renowned art historian Alois Riegl (1), the viewer's active participation in a work of art became known as the "beholder's share" in the writings of his student, Ernst Gombrich (2). How the viewer projects meaning onto art has fascinated both art historians and psychologists for over a century.

Research in the field of neuroaesthetics has found that the beholder approaches and processes abstract art differently than figurative art. The objects in a figurative painting may help instruct the beholder on how to view and interpret the painting (7), whereas the lack of objects in abstract art forces the viewer to devise new ways of exploring the painting, to go beyond recognition and create new personal associations (5, 6). Abstract art also elicits different cognitive processes than figurative art (9). The viewer's involvement with abstract art may call upon many cognitive processes, ranging from perceptual to mnemonic (3), which vary with the level of abstraction (4–6). Thus, interpretations of a given abstract painting vary widely among viewers.

These differences in cognitive processes begin with how abstract art directs our gaze. When we view figurative art, the patterns of our eye movements are more narrowly distributed and object-focused, whereas when we view abstract art, our viewing patterns are more globally distributed (7, 10, 11). This difference suggests that without the traditional cues of objects and scenes to guide our eye movements, we adopt more wide-ranging, exploratory strategies for seeking visual information.

Differences in gaze are mirrored in brain activity when viewing figurative versus abstract art. Functional magnetic resonance imaging has shown that viewing representational art (portraits, landscapes, and still-lifes) activates specific areas of the brain that are thought to respond to faces, places, or objects, whereas viewing abstract art does not (12), instead activating areas thought to respond to features of intermediate complexity, such as simple shape and color (13, 14). Transcranial Magnetic Stimulation has shown two additional differences between our responses to figurative and abstract art. The lateral occipital area, a brain region that is key to object recognition (15), plays a causal role in our aesthetic appreciation of representational art but not abstract art (16). The V5 visual area, which is thought to process implied motion (17), affects our aesthetic appreciation of abstract art but not representational art (18).

While this research underscores the fact that the brain processes abstract art differently than figurative art, it does not quantify the differences in our subjective experiences.

MEASURING DIFFERENCES IN SUBJECTIVE EXPERIENCE

We know that art affects us in many ways, but we do not know how art recruits the cognitive processes underlying our subjective experience or how that experience differs between abstract and representational art. One way

to quantify these subjective differences is by measuring the mindsets, or cognitive states, evoked by different types of art. A mindset can be defined as specific patterns of cognitive activity or behavior that make certain representations or habits readily available (19). Recently, Celia Durkin, Eileen Hartnett, Daphna Shohamy, and I applied a psychological theory known as Construal-Level Theory to our perception of art.

Construal-Level Theory

"Construal" refers to the subjective interpretation of an event or object. Construal-Level Theory (20) is a cognitive theory of abstraction that characterizes differences in abstract and concrete mindsets and can predict the availability of more abstract or concrete representations. Psychological distance, or distance from oneself, affects the extent to which our thinking about objects or events is abstract or concrete. The theory is based on experimental data showing that psychologically distant events (those occurring farther away in space or time) are represented more abstractly in our brain than events that occur closer to us. Moreover, the theory can predict whether our representation of an object or event will be more abstract or concrete.

Construal-Level Theory is based on the premise that our mental representations of objects or events are flexible: that is, our brain represents (or construes) objects or events more or less abstractly depending on their context. Construal plays a central role when our brain is given unfamiliar or insufficient information. Because abstract art forces viewers to supply information from their own experience, differences in the beholder's share should be reflected in differences in construal. Thus, art representing an object by its concrete, specific, contextual features involves lower, or less abstract, construal, while art representing that object by its essential, decontextualized components involves higher, or more abstract, construal.

My colleagues and I used Construal-Level Theory to study whether abstract and representational art elicit different cognitive states. Data from the study suggest that abstract and representational art do in fact have

different effects on cognition and that Construal-Level Theory is a useful new empirical approach to the analysis of the beholder's share.

Psychological Distance

Psychological distance, or distance from oneself, determines how abstractly our brain represents an object or event: the farther away in time or space an object or event is, the more likely we are to mentally represent it by its abstract components. This relationship between abstraction and distance aids us in decision making. When making decisions about an event occurring far away in space or time, we are more likely to consider higher-level, more abstract components, because those components are more likely to still be relevant in a distant setting. When making a choice about something close by, we are more likely to consider concrete details, because they provide immediate relevance (20–23).

Construal-Level Theory has revealed a bidirectional relationship between psychological distance and abstraction: not only are psychologically distant objects and events represented more abstractly in our brain, but also abstract construals of objects and events are felt to be more psychologically distant (21, 24–26). This relationship indicates that psychological distance can be used to measure empirical differences in a viewer's subjective interpretations of art and that it does so by quantifying the differing levels of representation that art evokes.

Psychological distance is already being used in the context of aesthetics. One study found that temporal distance affects attitudes toward art (27). Participants were asked to imagine their lives tomorrow (near-future priming) or one year from now (far-future priming), and then asked to rate the conventionality of figurative and abstract art. Participants given the far-future priming rated abstract art as more conventional than those given the near-future priming; participants given the near-future priming rated representational art as more conventional than those given the far-future priming. The authors of this study suggest that these discrepancies indicate changes in the viewers' construal levels: viewers with far-future

priming rated abstract (unconventional) art as more conventional because the priming had elevated their construal level. In another study (28), participants were shown abstract and representational art while simultaneously listening to a recording in either their native language or a foreign language. The study found that inducing greater psychological distance by having participants listen to a foreign language increased their appreciation for abstract art.

MEASURING DIFFERENCES IN MINDSET EVOKED BY ABSTRACT AND FIGURATIVE ART

Whereas the studies described above used psychological distance to measure subjective experience of art as more or less distant, our study used it as an empirical measure of the different cognitive states elicited by abstract and figurative art. In seeking to understand the relationship between different levels of abstraction of art and psychological distance, our study addressed the question: Does abstract art evoke a quantifiably different mindset than representational art?

To answer this question, we devised three experiments in which we asked participants to assign abstract or representational paintings by the same artist to a situation that was temporally or spatially near or distant. In each experiment, participants were shown paintings of varying levels of abstraction by the same artist and asked to assign each painting to a hypothetical gallery located temporally or spatially distant or nearby—that is, to a gallery opening tomorrow versus a gallery opening in a year, and to a gallery opening around the corner versus a gallery opening in another state. In addition, a third experiment measured psychological distance in the same individual as a function of that person's liking of individual paintings and overall experience with art (fig. 7.1). Experiments 1 and 2 measured temporal or spatial distance in a large sample of online participants; experiment 3 measured temporal distance in a smaller sample of participants, who were tested in the laboratory.

7.1 Sample tasks used in three experiments to investigate whether study participants construed abstract art to be more distant in time and space than representational art. (A) Task measuring temporal distance evoked by art (Experiment 1). Study participants were given the Temporal Distance Task: each person saw one painting and made a distance-in-time judgment. (B) Task measuring spatial distance evoked by art (Experiment 2). Study participants were given the Spatial Distance Task: each person saw one painting and judged how far away it was. (C) Task measuring temporal distance with respect to 21 paintings (7 representational, 7 indeterminate, and 7 abstract) as a function of liking the painting and experience with art (Experiment 3).

C. Durkin, E. Hartnett, D. Shohamy, and E. R. Kandel, "An Objective Evaluation of the Beholder's Response to Abstract and Figurative Art Based on Construal Level Theory," *Proceedings of the National Academy of Sciences U.S.A.* 117, no. 33 (2020): 19809–15, https://pubmed.ncbi.nlm.nih.gov/32747544/

Given that all works of art can be considered to fall somewhere on the continuum of abstraction, we established three categories based on how recognizable an object is in a painting: representational (concrete), indeterminate, and abstract. Representational paintings were defined as containing easily recognizable objects, indeterminate paintings were defined as containing recognizable but obviously distorted objects, and abstract paintings were defined as not containing any recognizable objects. We excluded abstract paintings that were solely geometric, because geometric shapes are often interpreted as objects.

We hypothesized that abstract and representational art would elicit different psychological distances: specifically, that viewers of abstract art

would be more likely to place the art in a more distant time or place than representational art.

Experiment 1: Abstract Art and Temporal Distance

To test the hypothesis that abstract art evokes more temporal distance than representational art, we chose paintings by four artists: Mark Rothko, Piet Mondrian, Chuck Close, and Clyfford Still. Each of these artists had developed a progressively more abstract style over his career, transitioning from representation to complete elimination of objects (29, 30). For each artist, study participants were shown a set of three paintings, one in each category of abstraction. Paintings by Clyfford Still, for example, included a realistic self-portrait in the representational category; a painting that hints at a body, which can still be recognized through its distortion, in the indeterminate category; and finally, a painting with no recognizable objects, but rather jagged blocks of color and line, in the abstract category. We compiled seven sets of three paintings. Participants included 840 subjects drawn from Amazon's Mechanical Turk.

To gauge the level of abstraction of the paintings, we asked forty independent participants from Amazon's Mechanical Turk to rate each painting from 1 to 7 according to how abstract they thought it was, with 1 being least abstract and 7 being most abstract.

To measure temporal distance, each participant was asked to imagine being an art consultant and was then shown one painting and asked whether or not the painting should hang in a gallery opening "tomorrow" or "in a year." We found a statistically significant relationship between the level of abstraction of a painting and temporal distance: abstract art was more likely than representational art to be placed in a gallery opening in a year (fig. 7.2).

We realized, however, that while abstract art elicited more abstract representations from the viewers, they might also associate abstract art with the future, given its later development in the history of art. Our second experiment addressed this issue by testing spatial distance.

7.2 Results of Experiment 1. Abstract art elicits more temporal distance than indeterminate and representational (concrete) art. A. Effect of category of art on temporal distance judgments. B. Effect of category of art on distance response, broken down by painting. Each set of art represents one representational (concrete) painting, one indeterminate painting, and one abstract painting, all by the same artist. Error bars represent standard error.

C. Durkin, E. Hartnett, D. Shohamy, and E. R. Kandel, "An Objective Evaluation of the Beholder's Response to Abstract and Figurative Art Based on Construal Level Theory," *Proceedings of the National Academy of Sciences U.S.A.* 117, no. 33 (2020): 19809–15, https://pubmed.ncbi.nlm.nih.gov/32747544/

Experiment 2: Abstract Art and Spatial Distance

We designed Experiment 2 to replicate the first experiment, using spatial rather than temporal distance. The viewers in Experiment 2, drawn from Mechanical Turk, were different from those in Experiment 1. To measure spatial distance, each person was shown one painting, asked to imagine that he or she was an art consultant, and asked to assign the painting to a gallery opening "around the corner" or "in another state."

We found a statistically significant relationship between the level of abstraction of a painting and spatial distance: viewers were more likely to place abstract art in a gallery in another state. These results indicate that abstract art, when compared to representational art, elicits more abstract mental representations. Moreover, the results were not solely due to the viewers' confounding temporal distance and the later historical develop-ment of abstract art.

We then wondered whether the viewers' distance judgments in the first two experiments were influenced by their liking of art or their experience with art. To find out, we conducted a third experiment.

Experiment 3: Distance, Liking, and Experience with Art

Experiment 3 examined the role that liking and experience may play in judgments of temporal distance. Unlike the first two experiments, Experiment 3 took place in a laboratory environment, where each participant was shown all twenty-one paintings and then asked to judge temporal distance, rate their liking of the paintings, and answer questions about their experience with art. Fifty-one volunteers in and around Columbia University were recruited through an advertisement for the study. They had little to no experience with art, as determined by their answers to two questions: How would you characterize your experience with art? and How many hours a week do you look at art?

Each participant was shown the paintings, one at a time, in random order on a 27" iMac monitor. The artworks were displayed at the same size and texture resolution. Participants were asked whether the painting should hang in a gallery opening "tomorrow" or "in a year." After initially viewing all the paintings, participants were shown the paintings again and asked to rate how much they liked each one on a 7-point Likert scale. They were then asked to rate how abstract the painting was on a scale of 1 to 7, with 1 being least abstract and 7 being most abstract. Finally, participants were asked to categorize themselves according to their experience with art, as a novice, enthusiast, artist, or art historian, and to report how many hours they spent per week looking at art. The final sample of forty-seven participants included twenty-four who characterized themselves as novices and twenty-three who characterized themselves as enthusiasts.

The results showed that the category of abstraction of a painting was a significant predictor of temporal distance, as it was in the first two experiments. Both indeterminate and abstract art were significantly more likely

than representational art to be placed in a gallery opening "in a year." To make sure that participants' decisions about temporal distance were not due to subjectively defined categorizations of art, we also looked at the effect on decisions of the participants' earlier ratings of abstraction. We found that a participant's rating of abstraction was a significant predictor of temporal distance: paintings with a higher average abstraction rating were more likely to have been placed further away.

Liking also had a significant effect on temporal distance. Study participants were less likely to place a painting they liked in a gallery opening in a year. There was no significant interaction between liking and abstraction. We therefore concluded that the effects of liking and abstraction rating are additive and that, when controlling for liking, the effect of abstraction on temporal distance persists.

The finding that liking has a significant effect on temporal distance raised the question of whether expertise or exposure to art, or both, affects the temporal distance induced by abstract art. The data indicated that neither of the study's measures of experience with art—the participant's relationship with art nor how many hours per week the participant viewed art—had a significant effect on temporal distance. Novices and enthusiasts did not differ in distance response; nor did subjects who spent more hours per week with art.

As in the first two experiments, abstract art was more likely than representational art to be placed in a distant condition. Although liking was a predictor of a participant's choice, we found that when controlling for liking, the effect of abstraction on distance remained. This suggests that abstract art elicits more psychological distance than representational art and thus evokes a more abstract cognitive state in the beholder.

Conclusion

Art is designed to engineer a state of mind in the beholder (31), but how does the state of mind differ when elicited by abstract versus representational

art? My colleagues and I used psychological distance as a theoretically and empirically based indicator of construal level (20–23). In each of the three experiments we conducted, we found that participants were more likely to assign abstract art to the more distant temporal or spatial situation. This pattern of distance assignments suggests that abstract art is construed more highly than representational art.

WHERE ABSTRACT ARTISTS AND CONSTRUAL-LEVEL THEORISTS MEET

Construal-Level Theory has shown that abstract construal of a psychologically distant object involves representing that object by its essential features, which do not change with changes in context (21, 32–34). But distance entails the potential for changes in context. Thus, ancillary features of distant objects or events, which may change with a changing environment, become irrelevant. In this sense, abstract mental construal serves as an adaptive tool to help us predict and plan for distant mental events whose context is uncertain.

The assignment of abstract art to a more distant context by the participants in our study suggests that abstract art depicts representations that do not vary with the passage of time or space. Abstract art transcends the idiosyncrasy of the here-and-now and remains relevant across more varied contexts.

Piet Mondrian, whose works we used in our experiments, Wassily Kandinsky, and Henri Matisse are three artists who articulated theories of abstraction that are deeply grounded in the notion of context (29, 35, 36). They viewed abstraction as a process of revealing unchanging laws of reality, which can only be achieved by divorcing representation from all context. Mondrian emphasized that by removing any reference to the natural world, abstract art was able to reveal "laws [that are] hidden in the reality that surrounds us and do not change" (35). By reducing "natural forms to the constant elements of form and natural colours to the elementary colours" (35),

he attempted to isolate essential truths about color and form. Similarly, Kandinsky (29) and Matisse (36) describe abstract art as isolating properties of reality that will remain the same over time, independent of changes in context. These artists spent years crafting context-invariant representations. The findings in our study suggest that these context-invariant representations are indeed realized in the beholder.

While context-dependent representations include more external, sensory information, context-invariant representations relate to what we carry with us in memory (37–39). Although past research in neuroaesthetics has shown that passive viewing of abstract art activates regions of the brain that process simple sensory information (12, 13), our findings suggest that *actively construing* abstract art transcends direct sensory experience and evokes higher-level representations in the beholder, potentially activating regions of the brain involved in memory (41). If so, this should result in different patterns of neural activity in sensory regions of the brain when we view different forms of art, as well as different experiences of construal.

This prediction remains to be tested. One way might be to use functional magnetic resonance imaging to compare connections between visual areas and higher-level cognitive areas while viewers are deciding the psychological distance of works of abstract and representational art. A finding that such decisions activate a more mnemonic processing mode in the brain would support the conception of the beholder's share as an active process in which we project our expectations and memories onto a work of art in order to endow it with meaning (3). Such a process is necessary in viewing all art, but especially in viewing abstract art.

Overall, our study suggests that abstract art is represented as context-invariant, thus enabling the beholder to traverse mental time and space and resulting in a more distant temporal and spatial placement in the world. By contrast, representational art is more limited and narrower in its temporal and spatial reach.

This finding in the domain of art may extend to other dimensions of psychological distance, such as social distance (41–43) and

hypotheticality (44–46). Abstract art may traverse social distance by connecting and affording aesthetic experience to socially remote and diverse beholders. Similarly, abstract art may remain invariant across hypothetical outcomes and connect to imagined and even unlikely beholders and settings. Finally, as context-independent representations are thought to recruit memory, abstract art may call upon a unique relationship between sensory and mnemonic processing in the beholder. Abstract art also raises questions for future studies about the role of memory as a common mechanism by which we project ourselves both into a work of art and into a psychologically distant situation.

REFERENCES

1. A. Riegl, *The Group Portraiture of Holland* (Los Angeles: Getty Publications, 2000).

2. E. H. Gombrich, *Art and Illusion: A Study in the Psychology of Pictorial Representation* (Princeton, NJ: Princeton University Press, 1969).

3. A. Seth, "From Unconscious Inference to the Beholder's Share: Predictive Perception and Human Experience," *PsyArXiv* (August 7, 2017), https://doi.org/10.31234/osf.io/zvbkp.

4. W. Worringer, *Abstraction and Empathy: A Contribution to the Psychology of Style*, 1st Elephant pbk. ed. (Chicago: Ivan R. Dee, 1997).

5. E. Kris, *Psychoanalytic Explorations in Art* (Madison, CT: International Universities Press, 2000).

6. E. Kandel, *Reductionism in Art and Brain Science: Bridging the Two Cultures* (New York: Columbia University Press, 2016).

7. U. Leonards et al., "Mediaeval Artists: Masters in Directing the Observers' Gaze," *Current Biology* 17 (2007): R8–R9.

8. A. Schepman, P. Rodway, S. J. Pullen, and J. Kirkham, "Shared Liking and Association Valence for Representational Art but Not Abstract Art." *Journal of Vision* 15, no. 5 (2015): 11, http://www.journalofvision.org/content/15/5/11.

9. V. Aviv, "What Does the Brain Tell Us About Abstract Art?" *Frontiers in Human Neuroscience* 8 (2014).

10. N. Koide, T. Kubo, S. Nishida, T. Shibata, and K. Ikeda, "Art Expertise Reduces Influence of Visual Salience on Fixation in Viewing Abstract Paintings," *PLOS ONE* 10 (2015): e0117696.

11. W. H. Zangemeister, K. Sherman, and L. Stark, "Evidence for a Global Scanpath Strategy in Viewing Abstract Compared with Realistic Images," *Neuropsychologia* 33 (1995): 1009–25.

12. H. Kawabata and S. Zeki, "Neural Correlates of Beauty," *Journal of Neurophysiology* 91 (2004): 1699–1705.

13. E. Yago and A. Ishai, "Recognition Memory Is Modulated by Visual Similarity," *NeuroImage* 31 (2006): 807–17.

14. R. Epstein and N. Kanwisher, "A Cortical Representation of the Local Visual Environment," *Nature* 392 (1998): 598–601.

15. K. Grill-Spector, Z. Kourtzi, and N. Kanwisher, "The Lateral Occipital Complex and Its Role in Object Recognition," *Vision Research* 41 (2001): 1409–22.

16. Z. Cattaneo et al. "The Role of the Lateral Occipital Cortex in Aesthetic Appreciation of Representational and Abstract Paintings: A TMS Study," *Brain Cognition* 95 (2015): 44–53.

17. S. Zeki, "Area V5—a Microcosm of the Visual Brain," *Frontiers in Integrative Neuroscience* 9 (2015).

18. Z. Cattaneo et al., "The Role of Prefrontal and Parietal Cortices in Esthetic Appreciation of Representational and Abstract Art: A TMS Study," *NeuroImage* 99 (2014): 443–50.

19. J. Savary, T. Kleiman, R. R. Hassin, and R. Dhar, "Positive Consequences of Conflict on Decision Making: When a Conflict Mindset Facilitates Choice," *Journal of Experimental Psychology General* 144 (2015): 1–6.

20. Y. Trope and N. Liberman, "Construal-Level Theory of Psychological Distance," *Psychological Review* 117 (2010): 440–63.

21. Y. Trope, N. Liberman, and C. Wakslak, "Construal Levels and Psychological Distance: Effects on Representation, Prediction, Evaluation, and Behavior," *Journal of Consumer Psychology* 17 (2007): 83–95.

22. K. Fujita, M. D. Henderson, J. Eng, Y. Trope, and N. Liberman, "Spatial Distance and Mental Construal of Social Events," *Psychological Science* 17 (2006): 278–82.

23. E. Amit, D. Algom, and Y. Trope, "Distance-Dependent Processing of Pictures and Words," *Journal of Experimental Psychology General* 138 (2009): 400–15.

24. G. Oettingen, A. T. Sevincer, and P. M. Gollwitzer, *The Psychology of Thinking about the Future* (New York: Guilford Press, 2018).
25. N. Liberman, Y. Trope, S. McCrea, and S. Sherman, "The Effect of Level of Construal on the Temporal Distance of Activity Enactment," *Journal of Experimental Social Psychology* 43 (2007): 143–49.
26. N. Liberman and J. Förster, "Distancing from Experienced Self: How Global-Versus-Local Perception Affects Estimation of Psychological Distance," *Journal of Personality and Social Psychology* 97 (2009): 203–16.
27. K. Schimmel and J. Förster, "How Temporal Distance Changes Novices' Attitudes Towards Unconventional Arts." *Psychology of Aesthetics, Creativity and the Arts* 2 (2008): 53–60.
28. E. Stephan, M. Faust, and K. Borodkin, "The Role of Psychological Distancing in Appreciation of Art: Can Native Versus Foreign Language Context Affect Responses to Abstract and Representational Paintings?" *Acta Psychologica (Amst.)* 186 (2018): 71–80.
29. W. Kandinsky, K. C. Lindsay, and P. Vergo, *Kandinsky: Complete Writings on Art* (New York: Perseus, 1994).
30. R. Zimmer, "Abstraction in Art with Implications for Perception," *Philosophical Transactions of the Royal Society of London B. Biological Sciences.* 358 (2003): 1285–91.
31. M. Turner, *The Artful Mind* (Oxford: Oxford University Press, 2006), https://doi.org/10.1093/acprof:oso/9780195306361.001.0001.
32. A. Ledgerwood, Y. Trope, and S. Chaiken, "Flexibility Now, Consistency Later: Psychological Distance and Construal Shape Evaluative Responding," *Journal of Personality and Social Psychology* 99 (2010): 32–51.
33. S. J. Maglio and Y. Trope, "Disembodiment: Abstract Construal Attenuates the Influence of Contextual Bodily State in Judgment," *Journal of Experimental Psychology General* 141 (2012): 211–16.
34. N. Liberman and Y. Trope, "The Psychology of Transcending the Here and Now," *Science* 322 (2008): 1201–05.
35. P. Mondrian, "Plastic Art and Pure Plastic Art 1937 and Other Essays, 1941–1943," *Journal of Aesthetics and Art Criticism* 4 (1945): 120–21.
36. H. Matisse, "Notes d'un peinture," in *Matisse on Art*, ed. J. T. Flam (Oxford: Oxford University Press, 1978).
37. I. Brinck, "Procedures and Strategies: Context-Dependence in Creativity," *Philosophica* 64 (1999): 33–47.

38. D. S. Margulies et al., "Situating the Default-Mode Network Along a Principal Gradient of Macroscale Cortical Organization," *Proceedings of the National Academy of Sciences* 113 (2016): 12574–79.

39. D. A. Kalkstein, A. D. Hubbard, and Y. Trope, "Beyond Direct Reference: Comparing the Present to the Past Promotes Abstract Processing," *Journal of Experimental Psychology General* 147 (2018): 933–38.

40. D. Yan, J. Sengupta, and J. Hong, "Why Does Psychological Distance Influence Construal Level? The Role of Processing Mode: Table 1," *Journal of Consumer Research* 43 (2016): 598–613.

41. X. Nan, "Social Distance, Framing, and Judgment: A Construal Level Perspective," *Human Communication Research* 33 (2007): 489–514.

42. S. Rim, J. S. Uleman, and Y. Trope, "Spontaneous Trait Inference and Construal Level Theory: Psychological Distance Increases Nonconscious Trait Thinking," *Journal of Experimental Social Psychology* 45 (2009): 1088–97.

43. C. Wakslak and P. Joshi, "Expansive and Contractive Communication Scope: A Construal Level Perspective on the Relationship Between Interpersonal Distance and Communicative Abstraction," *Social and Personality Psychology Compass* 14, no. 5 (2020): e12528.

44. Y. Bar-Anan, N. Liberman, and Y. Trope, "The Association Between Psychological Distance and Construal Level: Evidence from an Implicit Association Test," *Journal of Experimental Psychology General* 135 (2006): 609–22.

45. M. D. Sagristano, Y. Trope, and N. Liberman, "Time-Dependent Gambling: Odds Now, Money Later," *Journal of Experimental Psychology General* 131 (2002): 364–76.

46. C. Wakslak and Y. Trope, "The Effect of Construal Level on Subjective Probability Estimates," *Psychological Science* 20 (2009): 52–58.

This essay is based extensively on C. Durkin, E. Hartnett, D. Shohamy, and E. R. Kandel, "An Objective Evaluation of the Beholder's Response to Abstract and Figurative Art Based on Construal Level Theory," *Proceedings of the National Academy of Sciences, U.S.A.* 117, no. 33 (2020): 19809–15, https://pubmed.ncbi.nlm.nih.gov/32747544/.

NOTES

2. EMPATHY AND THE UNCERTAINTIES OF BEING IN THE PAINTINGS OF CHAIM SOUTINE: A BEHOLDER'S PERSPECTIVE

1. Eliane Strosberg, *The Human Figure and Jewish Culture* (New York: Abbeville Press, 2010).
2. Oded Irshai in Nicholas De Lange, ed., *The Illustrated History of the Jewish People* (New York: Houghton Mifflin Harcourt, 1997). An even earlier dispersion occurred in about 586 B.C., when the ten tribes of the northern kingdom of Israel went into exile. Their fate remains one of the great mysteries of Jewish history. The history of the Diaspora centers on the tribes of Judah and Benjamin, who lived in southern Israel and whose fate is known.
3. Strosberg, *The Human Figure and Jewish Culture*.
4. A. J. Heschel, *The Earth Is the Lord's: The Inner World of the Jew in East Europe* (New York: Henry Schuman, 1950).
5. De Lange, *Illustrated History of the Jewish People*.
6. Jonathan Wilson, *Marc Chagall*, Jewish Encounters Series (New York: Schocken, 2007).
7. See Wilson, *Marc Chagall*.
8. Jackie Wullschläger, *Chagall: A Biography* (New York: Knopf, 2008).
9. Yekhezkel Kotik, *Journey to a Nineteenth-Century Shtetl: The Memoirs of Yekhezkel Kotik* (1913), ed. and with an introduction by David Assaf (Detroit: Wayne State University Press, 2002), 157. See also Tree Smith,

"Chaim Soutine's Carcass Paintings," accessed March 2014, http://artand perception.com/2009/12/chaim-soutine's-carcass-paintings-part-1.html.

10. *Memoirs of Yekhezkel Kotik*, 157–58.

11. Andrew Forge, *Soutine* (London: Spring Books, 1965); Marie Boyé, Nadine Nieszawer, and Paul Fogel, *Paintres Juifs à Paris 1905–1939, École de Paris* (Paris: Éditions Denoel, 2000).

12. Christopher Benfey, "Wandering Jew," review of the exhibition "*An Expressionist in Paris: The Paintings of Chaim Soutine*" (Jewish Museum, New York, April 26–August 16, 1998), http://www.slate.com/articles/arts /art/1998/05/wandering_jew.html; A. E. Kuznetsova, "Artist of the Week: Chaim Soutine," http://artinvestment.ru/en/invest/ideas/20130530 _Soutine.html.

13. Forge, *Soutine*, 37.

14. Forge, *Soutine*, 12.

15. H. W. Janson, *History of Art* (Englewood Cliffs, NJ: Prentice-Hall, 1969), 522.

16. Smith, "Chaim Soutine's Carcass Paintings."

17. Strosberg, *The Human Figure and Jewish Culture*; A. J. Heschel, "The Eastern European Era in Jewish History," in *Yivo Annual of Jewish Social Science*, vol. 1 (New York: Yiddish Scientific Institute-Yivo, 1946), 86–106.

18. Steven M. Nadler, *Rembrandt's Jews* (Chicago: University of Chicago Press, 2003).

19. Emily Yetzer, "Soutine's Carcass of Beef: Is It Any Good?" http://www. examiner.com/article/soutine-s-carcass-of-beef-is-it-any-good.

20. See Simon Lacey and Krish Sathian, "Representation of Object Form in Vision and Touch," in *The Neutral Bases of Multisensory Processes*, ed. Michah M. Murray and Mark T. Wallace (Boca Raton, FL: CRC Press, 2012), chap. 10.

21. Élie Faure, *Soutine* (Paris: G. Crès, 1929), 522.

22. Susan Tumarkin Goodman, *Chagall: Love, War, and Exile* (New York: Jewish Museum, 2013).

23. David I. Perrett, D. Michael Burt, Ian S. Penton-Voak, Kieran J. Lee, Duncan A. Rowland, and Rachel Edwards, "Symmetry and Human Facial Attractiveness," *Evolution and Human Behavior* 20 (1999): 295–307.

24. V. S. Ramachandran and William Hirstein, "The Science of Art: A Neurological Theory of Aesthetic Experience," *Journal of Consciousness Studies* 6 (1999): 15.

25. For details, see Eric R. Kandel, *The Age of Insight: The Quest to Understand the Unconscious in Art, Mind, and Brain From Vienna 1900 to the Present* (New York: Random House, 2012), chap. 27.

26. As cited in Marie-Madeleine Massé, *Soutine: Le lyrisme de la matière* (Paris: Musée de l'Orangerie, 2012).

27. Doris Y. Tsao, Sebastian Moeller, and Winrich A. Freiwald, "Comparing Face Patch Systems in Macaques and Humans," *Proceedings of the National Academy of Sciences* 49 (2008): 19514–19; Winrich A. Freiwald and Doris Y. Tsao, "A Face Feature Space in the Macaque Temporal Lobe," *Nature Neuroscience* 12 (2009): 1187–96.

28. P. Sinha, "Qualitative Representations for Recognition," in *Biologically Motivated Computer Vision Second International Workshop*, BMCV 2002, Tübingen, Germany, November 22–24, 2002, ed. Heinrich H. Bülthoff, Seong-Whan Lee, Tomaso Poggio, and Christian Wallraven (Berlin: Springer Nature, 2002), 249–62.

29. Shay Ohayon, Winrich A. Freiwald, and Doris Y. Tsao, "What Makes a Cell Face Selective? The Importance of Contrast," *Neuron* 74 (2012): 567–81.

30. Tsao, Miller, and Freiwald, "Comparing Face Patch Systems in Macaques and Humans."

31. See also Lynne J. Walhout Hinojosa, *The Renaissance, English Cultural Nationalism, and Modernism, 1860–1920* (New York: Palgrave Macmillan, 2009).

32. A. Pascual-Leone and R. H. Hamilton, "The Metamodal Organization of the Brain," *Progress in Brain Research* 134 (2001): 427–45.

33. S. Lacey and K. Sathian, "Representation of Object Form in Vision and Touch," in *The Neural Bases of Multisensory Processes*, ed. M. M. Murray and M. T. Wallace (Boca Raton, FL: CRC Press, 2012), chap. 10.

34. K. Sathian, S. Lacey, R. Stilla, G. O. Gibson, G. Deshpande, X. Hu, S. Laconte, and C. Glielmi, "Dual Pathways for Haptic and Visual Perception of Spatial and Texture Information," *NeuroImage* 57, no. 2 (2011): 462–75.

35. C. Hiramatsu, N. Goda, and H. Komatsu, "Transformation from Image-based to Perceptual Representation of Materials Along the Human Ventral Visual Pathway," *NeuroImage* 57, no. 2 (2011): 482–94.

36. Hiramatsu, Goda, and Komatsu, "Transformation from Image-based to Perceptual Representation of Materials."

37. Sathian et al., "Dual Pathways for Haptic and Visual Perception of Spatial and Texture Information."

3. COMPETING INFLUENCES THAT GAVE RISE TO THE MODERN REPRESENTATION OF WOMEN

1. Ernst Gombrich, *The Story of Art* (London: Phaidon Press, 1995), 568–69.
2. Doris Tsao, Sebastian Moeller, and Winrich Freiwald, "Comparing Face Patch Systems in Macaques and Humans," *PNAS* 105, no. 49 (2008): 19514–19, https://www.pnas.org/doi/abs/10.1073/pnas.0809662105.
3. Tsao, Moeller, and Freiwald, "Comparing Face Patch Systems in Macaques and Humans."
4. Winrich Freiwald and Doris Tsao, "A Face Feature Space in the Macaque Temporal Lobe," *Nature Neuroscience* 12 (2009): 1187–96.
5. Sigmund Freud, "Some Psychical Consequences of the Anatomical Distinction between the Sexes," *Internationale Zeitschrift fur Psychoanalyse* 19 (1925): 248–58.
6. David J. Anderson, "Optogenetics, Sex, and Violence in the Brain: Implications for Psychiatry," *Biological Psychiatry* 71, no. 12 (2012): 1081–89.
7. Johann Wolfgang von Goethe, *Faust*, in *Goethes Werke*, vol. 3, ed. Ernst Merian Genast (Basel: Verlag Birkhäuser, 1944), 368.
8. Goethe, *Faust*, 363.

INDEX

Page numbers in *italics* indicate figures.

abstract art, 1; about, 185; actively construing, 197; Construal-Level Theory and, 188–89; as context-invariant, 197; description of, 197; measuring mindset of figurative art and, 190–92, *191*; objects in, 186; processing of representational art and, 186–87; representations and, 196; social distance and, 198; spatial distance and, 193–94; testing temporal distance, 192, *193*

abstract artists, Construal-Level Theorists and, 196–98

Adele Bloch-Bauer I (Klimt), 48, *48, 49*

Adelson, Edward, 121–22, 138

Age of Insight, The (Kandel, 2012), 2, 5, *37*, 55, *82*, 129

Age of Reason, 3

A Hypocrite and a Slanderer sculpture (Messerschmidt), 172–73, *174, 175*

Albert V., Kaiser, 1

Albright, Tom, 140

Allegory of Winter (Tiepolo), 176, 177

Amazon's Mechanical Turk, 192, 193

ambiguity: Empson and, 26; Gombrich's ideas about, 26, 32, 124; Kris's ideas about, 26, 32, 124; in visual perception, Kris and, 26, 120

Ambroise Vollard in His Office with His Cat (Brassai, Gyula Halasz), *146*

Ambroise Vollard (Picasso), 145, *146*

Anderson, David, 110, 111, 206n6

Angel Dumah (Angel of Science), 64–65

Antico's sculpture: *Spinario*, *170*, 171, 172

anti-Semitism: Billroth writings and, 9; in Vienna and Austria, 1, 52–54

Arcimboldo, Giuseppe: *Vegetable Gardener, The*, 125, *126*

205n34, 205n35; as creativity machine, 26, 28–32, 123–24; Gombrich on the, 26; Gregory and, 32; interaction of eroticism and aggression in, 110–11, *111*, *112*; *left hemisphere of the brain, showing four lobes*, 125, *126*; lobes and structure of, *82*, 82–83, 125, *126*; mechanism underlying beholder's share, 33; multisensory tasks of, 87, 205n32; object, multisensory representation of, 87, 205n36; processing and recognizing faces, 33–38, 82–85, 88, 117; response to exaggerated facial expressions, 104–5; response to sculpture and painting, 168–82; visual system, 87, 205n37; Zeki's brain imaging experiments, 31

Brassai (Gyula Halasz): *Ambroise Vollard in His Office with His Cat*, *146*

Brenson, Michael, 136

Breuer, Josef, 11, 52

Brozowski, Peter, 54

Burghers of Calais, The (Rodin), 179, *180*, 181–82

carcass paintings, 69–74

caricature, psychology and history of, 81–82

Carracci, Agostino, 81

Castelfranco, Giorgione da: *Sleeping Venus, The*, *16*, 107

Cezanne, Paul: *Bathers, The*, 179, *180*, 181–82

Chagall, Marc, 203n8; concentration on romantic fantasies of life, 68; *Flayed Ox, The*, 74, *75*; Hasidic family of, 63; ink drawing of the crucifixion, 73; as Jewish painter, 41, 62, 203n7; as *Luftmensch*, 63; *Over the Town*, 63, *64*; of the Paris School of the 1920s, 40; Soutine vs., 62–68, 204n16; *Violinist, The (Fiddler)*, 63, *63*; visions in humanistic expressionism, 62–68; *White Crucifixion*, 74, 74–75, 204n22

Charcot, Jean-Martin, 83

Children Playing (Kokoschka), *100*

Christians: emergence of modernism and, 50–52; interaction of Jews and, 1–50

Close, Chuck, 192

cognitive processes, 185, 186–87

Composition with Violin (Picasso), 142, *142*, 143

Construal-Level Theorists, abstract artists and, 196–98

Construal-Level Theory, 188–89

context, notion of, 196, 197

context-dependent representations, 197

context-invariant representations, 197

contrast, face detection and, 128

Cormon, Fernand, 65–66, 69; *Murder in the Serail*, *66*

Crick, Francis, 130

Crouching Female Nude with Bent Head (Schiele), 102–3, *103*

Cubism: art and, 136, 137, 151; beholder's response and, 151

Cubist(s): art, 185; artist, 136; challenge to beholder's share, 135–51; Picasso as, 136

da Bologna, Giovanni: *Rape of the Sabine Women, The*, 162, *162*, 163, 168